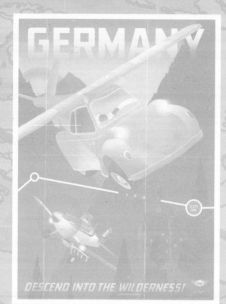

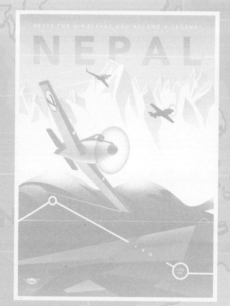

The Art of

BY TRACEY MILLER-ZARNEKE

PREFACE BY JOHN LASSETER
FOREWORDS BY KLAY HALL AND BOBS GANNAWAY

The Art of **Disney PLANES**

CHRONICLE BOOKS
SAN FRANCISCO

Library of Congress Cataloging-in-Publication Data:

Miller-Zarneke, Tracey, author.

 The art of Planes / by Tracey Miller-Zarneke ; preface by John Lasseter ; forewords by Klay Hall and Bobs Gannaway.

 pages cm

ISBN 978-1-4521-2799-6

1. Planes (Motion picture)—Illustrations. 2. Animated films—United States. I. Title.

NC1765.U53P59 2014

791.43'34—dc23

 2013036168

Manufactured in China

Front cover: Ryan Carlson, Digital

Back cover: Rich Tuzon, Toby Wilson, Scott Seeto, and Rick Moser, Digital

Flap: Art Hernandez, Digital

Case: Scott Seeto, Digital

Endpapers: Marty Baumann, Stéphane Kardos, Bret Healey, Scott Fassett, and Toby Wilson, Digital

Page 1: Art Hernandez, Digital
Pages 2–3: Ryan Carlson, Digital

Designed by Stuart Smith

10 9 8 7 6 5 4 3 2 1

Chronicle Books LLC
680 Second Street
San Francisco, CA 94107
www.chroniclebooks.com

CONTENTS

Preface *by John Lasseter*

Planes began during the transformation of DisneyToon Studios. When Ed Catmull and I first came to DisneyToon, we found a studio full of talented artists and filmmakers limited to making one-off direct-to-video sequels of Disney animated films targeted toward younger audiences. In order to lift their artistic spirit, we stopped making sequels and focused on making original films derived from one small aspect of a previous Disney film. In the case of *Tinker Bell*, the filmmakers took a favorite character from *Peter Pan* and asked two simple questions: Where did she come from? Are there more fairies out there like her? The answers presented a whole new world for the artists to research, to explore, to make real. Once the *Tinker Bell* films were going strong, there was a desire to start up a new series of movies that were more "boy" oriented. To be honest, I don't like to categorize films by gender or distribution. They are not made just for "boys" or "girls" or "direct-to-video" or "theatrical." We aim really high with every film we make, no matter what part of Disney is producing them or how they are being distributed. We use all of our best talent and effort to make great animated films for everyone.

Director Klay Hall shares my deep passion for trains, so when we began looking for a new world for the artists at DisneyToon to create, we started working together on a story about steam trains in the Wild West. It was exciting, but my intuition told me there was a bigger idea out there. One day, I was flying from Pixar to Disney and I had an epiphany: Instead of just trains, we could explore all the other vehicles in the "World of *Cars*"—trains, airplanes, boats, construction vehicles. When I got off the plane I called Klay immediately. Mind you, we had a meeting in one week with Disney's CEO and executive committee to pitch our trains story. I told Klay the new idea, and there was a moment of silence. Then he said enthusiastically, "That's awesome! Let's do it."

I drove straight to the studio and got into a room with Klay, Jeff Howard, and Paul Gerard. I assumed Klay would want to start with trains, but instead he said, "Planes. I want to do a movie about planes." Then he told us about his dad. Klay's father was a naval aviator, and when Klay was a child he used to take him to the airport runway to watch the planes take off and land. Planes have always been a part of Klay's life. It's in his blood. So, we thought of the slowest plane we could imagine for our hero: a crop duster. It's a type of plane that flies low and slow and definitely not around the world. We would discover later in our research that crop dusters were not only used for agriculture but also to fight fires. Our new character could fly us through both *Planes* and *Planes: Fire and Rescue*. A week later, we pitched it to the executive committee. It was a huge home run.

I've always believed in doing tremendous research for every movie we do in order to find the truth of the subject matter. The filmmakers embraced this principle and immersed themselves deeply into the world of aviation. Just like *Cars*, all these vehicles are alive and their world has to feel real. So Klay and his team talked to pilots and airplane manufacturers, visited air shows and races. They traveled across Minnesota to explore small airports and interview crop dusters. They flew in all sorts of aircraft. And they filled the story of *Planes* with the love and passion of these pilots and ground crew, inspired by their stories and the rich history of aviation.

At the same time, director Bobs Gannaway engrossed himself in the world of air attack—fighting forest fires from the air. Bobs and his artists connected with air attack bases, firefighters, and organizations like Cal Fire. They discovered that most firefighting airplanes started their lives as something else. Everything at those air attack bases had been repurposed and rebuilt, so there is a grandma's quilt quality to it. The filmmakers were moved by the incredible bravery of the people who go in when everyone else is going out: the people who put their lives on the line to save people they don't even know. *Planes: Fire and Rescue* is a tribute to that bravery.

Many people feel that the *Cars* and *Planes* movies are meant for little boys, but nothing could be further from the truth. This book should dispel that misconception. When you see the artistry that is essential to making these films, you will come to understand that the level of detail, planning, and cleverness is equal to any other animated film made at Pixar or Disney. In these pages, you will discover the tremendous amount of creative effort that has gone into making these films great entertainment for everyone. I hope you enjoy it.

Forewords

I grew up in an aviation family. My dad was a Navy pilot; my grandfather was a pilot as well, and taught my pop to fly when he was twelve. They passed that love of aviation on to me at a very early age. Dad would load up the car, grab some burgers and Cokes, and we'd hang out at the end of the local airfield. As planes would fly in and land, or taxi out in front of us, he'd talk about the characteristics of the different aircraft. I'd often draw the planes while I listened.

Flash forward to May 2009. I had become a friend and coworker of John Lasseter, and we found we shared a common love of all things machine. Fast exotic cars, vintage and streamlined locomotives, and yes, airplanes. As I was exploring one of these ideas for my next film, I received a call out of the blue. It was John. He said he had an epiphany on the flight down from Pixar to Disney, and explained his idea about expanding the "World of *Cars.*" With that amazing canvas laid out in front of me, I realized I wanted to tell a story about planes. I *had* to tell a story about planes. John was completely on board, and we launched into development like a catapult shot off a carrier. You can imagine how I felt, as my lifelong love of aviation and my other love of animation (especially the films of Walt Disney) came together in one amazing project. I would be assisted by John, and my film would be produced and released by The Walt Disney Studios.

Planes is a testament to the army of talent that it took to make it happen. A little over four and a half years and two million film frames of effort went into it, and only a very small portion can be represented in this book. A big heartfelt thanks to John Lasseter, my inspirational leader, and to my producing partner, Traci Balthazor-Flynn. A big thanks as well to the brilliant art direction of Ryan Carlson, without whom this book and the wonderful look of the film would not have happened. And a special thank-you to the hundreds of other folks, cast and crew, who participated in the making of this movie.

—Klay Hall, director

When I was growing up in Oklahoma, there were two things I dreamed of becoming: a magician and a cartoonist. What better way to combine those two ambitions than animation—the illusion of bringing drawings to life. I have been living that dream here at Disney for nearly twenty years.

My dream isn't much different from that of Dusty Crophopper, who had his own small-town aspirations of becoming a racer. Like myself, Dusty pursued and attained his goal. So for the second *Planes* film, I asked: What if Dusty could no longer race? Could he find another dream worth living for? To find Dusty's new ambition, that second chance, I looked to the plane itself. I learnd that cropdusting aircraft are used for wildfire air attack. Known as SEATS, Single Engine Air Tankers, they are the smallest aircraft in the firefighting fleet. I didn't have to create a story, Dusty was creating it for me.

So off I went on the journey, along with art director Toby Wilson, producer Ferrell Barron, co-writer Jeff Howard, head of story Art Hernandez, and others. We traveled to Yellowstone National Park to learn more about the devastating wildfire of 1988, and how the historic Old Faithful Inn survived that massive blaze. We visited air attack and smokejumper bases throughout California. We discovered incredible history—like that of Ed Pulaski whose story inspired the mine sequence in the film. We also found hidden humor—like the "boat rentals" sign at Yellowstone that suggested one of the celebrity cameos in our film, Boat Reynolds. We got a glimpse into a world of courage, strength, humor, and self-sacrifice, as well as amazing aircraft, incredible pilots, and, most of all, dedicated firefighters.

All the talented artists represented herein worked tirelessly to capture this impactful world and bring it to life through the eyes of our hero, Dusty Crophopper. We respectfully present this film and art as a heartfelt "thank you" to all the dedicated firefighters throughout the world who put their lives on the lines to save the lives of strangers.

—Bobs Gannaway, writer-director

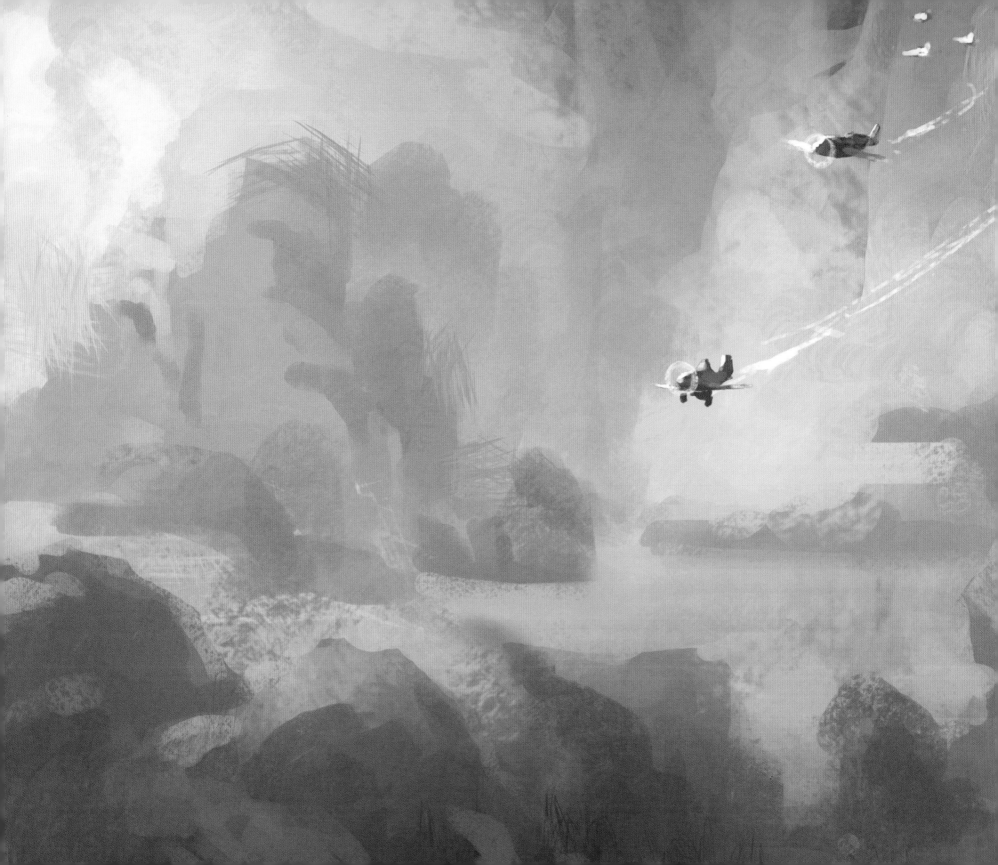

Introduction:
TAKING THE "WORLD OF *CARS*" TO NEW HEIGHTS

*T*he passion for aviation flies high at the DisneyToon Studios: chief creative officer John Lasseter is a fanatic about airplanes; director Klay Hall has flown small planes, and his father flew for the U.S. Navy; writer Jeff Howard aspired to be a pilot until his eyesight foiled his lofty plans; character designer Scott Seeto has obsessively drawn planes for years; pre-visualization flight lead Jason McKinley created a television series about flying . . . the sky's the limit, or rather, the sky's the *unlimited* expanse for this love of airplanes. When the idea to expand Pixar's "World of *Cars*" came along, the creative teams of *Planes* and *Planes: Fire & Rescue* harnessed this passion for aviation to tell the story of Dusty Crophopper, the crop dusting airplane who aspires to do more than what he was built to do.

Building upon the friendly realism established in the *Cars* environments, the DisneyToon art team thoughtfully developed a "plane-ified" look for their films. It was a matter of building a naturalistic landscape that subtly incorporates aviation elements. For example, a landscape may involve a rock formation, but upon closer examination, that formation may resemble the silhouette of an airplane's cowling or piston. The production design team faced a bit of a challenge in finding different shapes of planes to use in this manner, as there are relatively fewer recognizable models of airplanes than cars, and even more importantly, audiences are generally more familiar with shapes that suggest parts of a car than shapes found on a plane.

Plein air painting cast a clear influence on the approach to light and color in the *Planes* environment. "The main focus is the effect of light on its subject. Local color becomes secondary to environmental color, and atmosphere is used to create depth," explains *Planes* art director Ryan Carlson. Great care is taken to cast shadows that have color and tone in them, not just by using a darker shade of what color is already on the surface of the texture in shadow, or by simply using black.

To create the appropriate atmosphere above the "World of *Cars*," the most prominent visual effect in the *Planes* world is the use of clouds. Aircraft fly above, below, around, and through numerous types of clouds, which are designed to be as volumetric as possible so that they may immerse the characters and audience in their billowy glow. Mainly used for compositional purposes, clouds also provide a sense of speed and majestic scale in whatever frames they appear. Art direction allows that clouds may even be sculpted into subtle aviation shapes, playing upon the favorite sky-gazing game of "what do you see in the clouds?" but always keeping the audience's perspective aligned with a plane-centric world.

To enhance the feel of authenticity in the *Planes* world, cinematography is reflective of real-world cameras. Jonathan Roybal, pre-visualization lead of *Planes*, says, "The most important rule that the crew follows regarding how to frame the airplanes is that when planes are on the ground, they are treated as characters, but when planes are flying, they are treated as true planes." For example, when conversing on the runway, staging might involve a classic three-quarter shot of one plane talking to another, and due to wingspan and the upward angle of a plane's face if it is a tail-dragger, such a camera setup can be quite a challenge. Add stereography on top of that and it becomes even trickier, since characters with long noses—or in this case, the span from windshield to cowling—tend to look intrusive and

Ryan Carlson, Digital

strange if not properly dialed in for stereo viewing. In some shots, stereo lead Jason Carter had to combine the work of two or more different camera setups to make sure the characters were being shown with the most appealing angles and lens work.

"The flying shots feel realistic because our planes fly at the speed of real airplanes, in relationship to the metrics of our world," explains Roybal. The cinematography crew was careful to provide audiences with a true sense of parallax in the flying shots, using sets in real-world scale and planning composition to make sure that objects such as trees or clouds come through the shot at the appropriate distance from the camera to help the viewer's eye orient itself properly. "We also followed the true flight dynamics of each type of plane to the best of our ability," adds pre-visualization flight lead Jason McKinley. That's where detailed research pays off, learning from real-world flight patterns so as not to reinvent the wheel—or rather, the propeller.

The DisneyToon crew sought experts high and low to educate themselves in the world of aviation. They attended air shows, toured airports, visited aerial firefighting bases, consulted with plane builders, and flew 150 miles out to sea to tour the U.S.S. *Carl Vinson* aircraft carrier. They talked to pilots whose experience ranged from crop dusting to being a Blue Angel from flying commercial airliners to hauling cargo,

and from handling airdrops on brushfire to knowing how to flip a helicopter upside down. "The end result really shows, adding a level of legitimacy to your subject matter after you've gotten out there and talked to the folks that live the life of your characters in your world," says *Planes* director Klay Hall. The filmmakers found no better way to understand aircraft design and mechanics, to learn the lingo, and most importantly, to get to the heart and soul of flying than by immersing themselves in that aeronautical culture.

One of the edicts that John Lasseter established in the "World of *Cars*" is that of "Truth to Materials." What it means is that vehicles should look and move like vehicles . . . outside of the fact that they can talk, of course. Maintaining proper scale was a big concern in production design, making sure sets and props relate to the characters in a visually logical sense. Modeling had to study the way planes and other vehicles are built in order to re-create mechanically sound yet pleasantly caricatured machines. Animation had to learn how each vehicle operates—for example, front-wheel drive vs. rear-wheel drive, or how the rudder and flaps work—and how to balance the need to make characters emote without over-animating them to the point that they would look disturbingly human.

Aircraft shapes are reflected in the landscapes to keep us in an airplane-centric world. Even though there are other vehicles in the movie, we are ultimately telling the story of an airplane, so we want to see the world from an airplane's point of view.

—*Ryan Carlson*, art director

Lin Hua Zheng, Digital

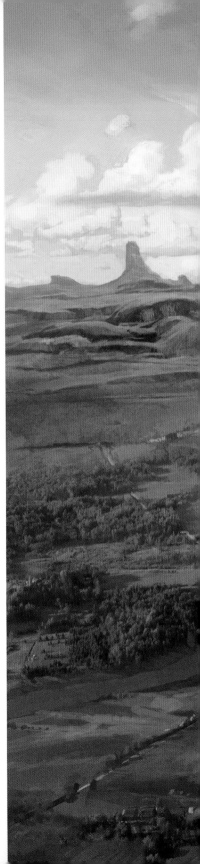

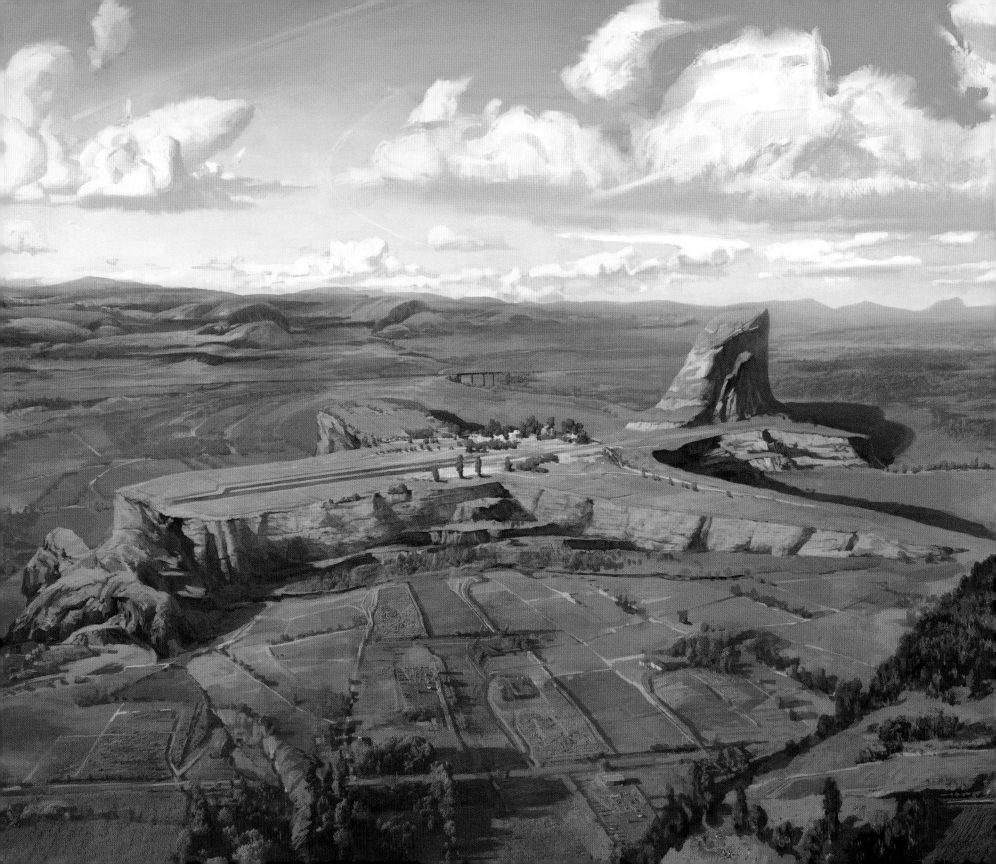

"Truth to Materials" proved to be a delicate balancing act for the art direction team, charged with ensuring that textures on the planes looked authentic but also served to support character appeal. For example, rivets and panel seams on a plane were downplayed around the face and not as prominently placed as down the fuselage. "It's a stylistic choice in those sections because when we see those areas tightly framed, the planes are characters and such details would be distracting from the performance. If the planes are shot from a profile or from a distance, that's aircraft doing cool aircraft stuff, and all those details are preserved there, including the working ailerons and flaps," explains Toby Wilson, art director of *Planes: Fire & Rescue*. As a general look development rule, "the way the light reacted to the materials was pretty important, to make sure that chrome really felt like chrome on your car and not the chrome on your son's toy, with a plastic sort of look," notes *Planes* art director Ryan Carlson.

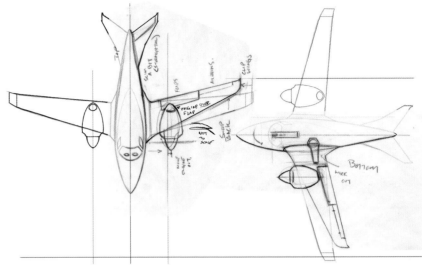

Ritsuko Notani and Ryan Carlson,
Digital and graphite

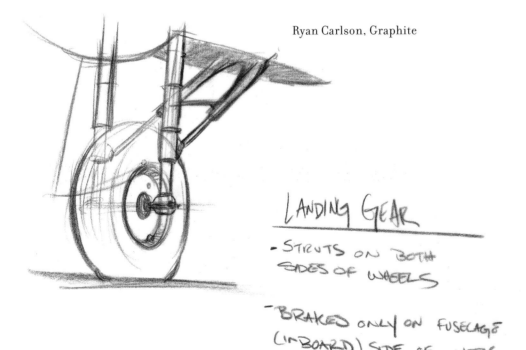

Ryan Carlson, Graphite

LANDING GEAR

- STRUTS ON BOTH SIDES OF WHEELS

- BRAKES ONLY ON FUSELAGE (INBOARD) SIDE OF WHEELS.

Ryan Carlson, Digital

The mechanical parts of the planes are very close to their real-life counterparts and need to actually work. All the parts are there, but the overall shapes have been caricatured and simplified.

—*Ryan Carlson*, art director

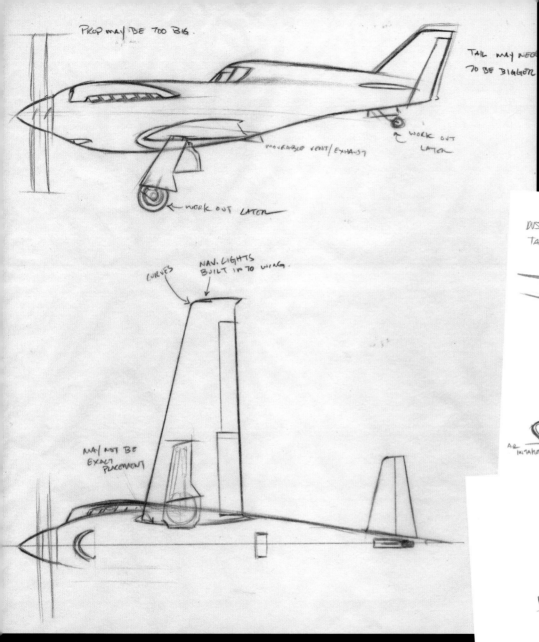

PROP MAY BE TOO BIG.

TAIL MAY NEED TO BE BIGGER

MOVEABLE VENT/EXHAUST

WORK OUT LATER

WORK OUT LATER

CURVES

NAV. LIGHTS BUILT INTO WING.

MAY NOT BE EXACT PLACEMENT

Because of the size of most airplanes, we are used to looking up at them. A low camera angle instantly reads "large and heavy," and once we establish this, we can move into more eye-level shots.

—Ryan Carlson, art director

Christian Lignan and Ryan Carlson, Graphite

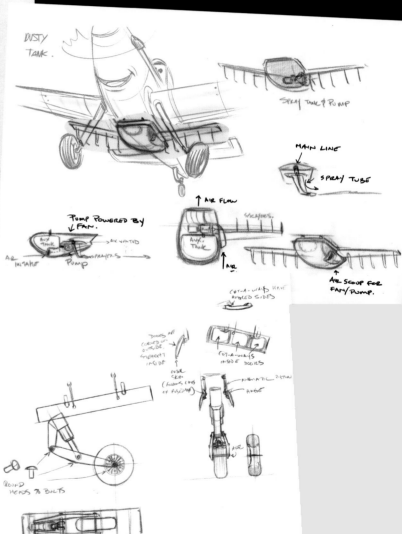

DUSTY TANK.

SPRAY TANK & PUMP

MAIN LINE

SPRAY TUBE

AIR FLOW

PUMP POWERED BY FAN.

AUX. TANK

AIR VENTED

AIR INTAKE

PUMP

SPRAYERS

AUX. TANK

AIR

AIR SCOUP FOR FAN/PUMP.

CUT-A-WAYS HAVE ANGLED SIDES

DOORS ARE CURVED ON OUTSIDE, STRAIGHT INSIDE

CUT-A-WAYS INSIDE DOORS

OUTER SKIN (FOLLOWS LINES OF FUSELAGE)

PNEUMATIC PISTON

ROUND HEADS TO BOLTS

Ryan Carlson, Graphite

Ryan Carlson, Graphite

1

Welcome to Propwash Junction

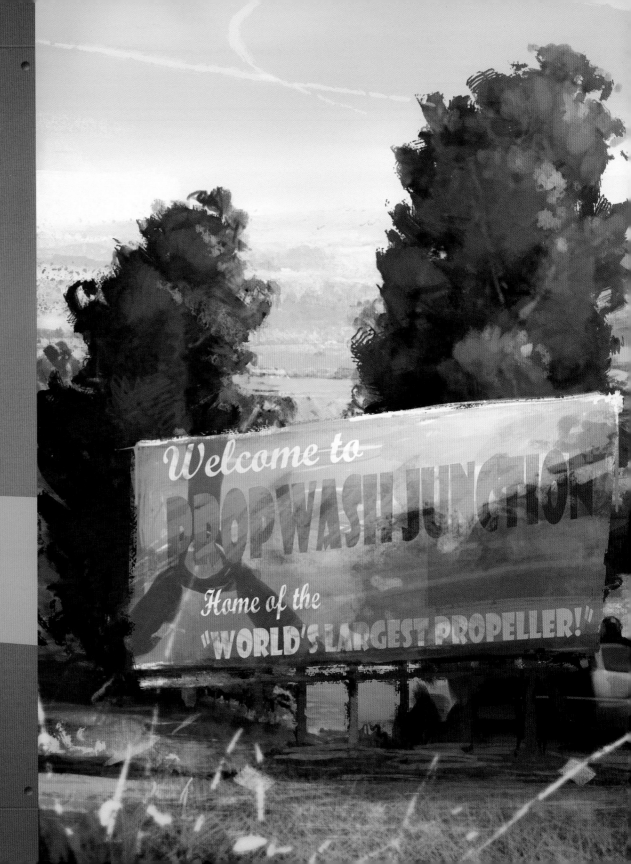

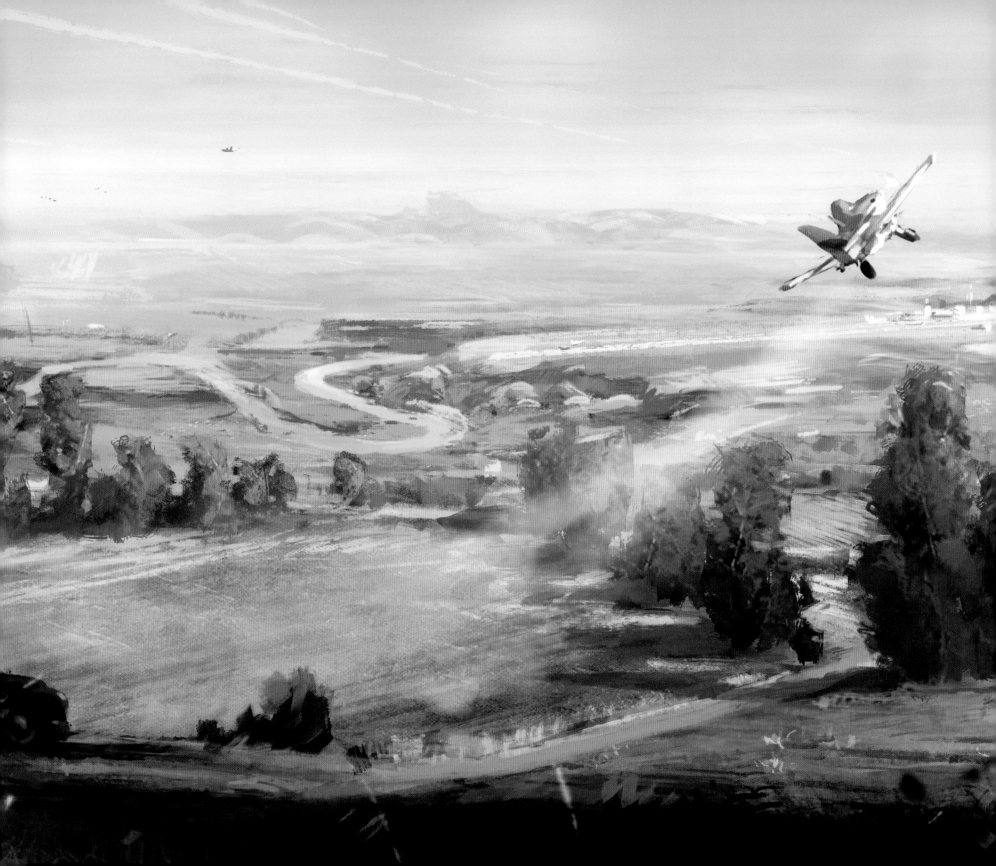

*H*ome base for Dusty is Propwash Junction, a small Midwestern town collaboratively created by *Planes* and Pixar artists, first featured in the 2011 *Air Mater* short. "Working in the 'World of *Cars*' with John Lasseter, it was all about authenticity," says *Planes* director Klay Hall, so in order to properly build Propwash Junction, Hall and his development crew embarked on a road trip from Fargo, North Dakota, to Minneapolis, Minnesota, hoping to experience what life in the Midwest region was really like. "Sure enough, we stumbled upon an abandoned airfield cut right out of the middle of a cornfield," recalls Hall.

Once back in the studio, the creative team developed a backstory for Propwash Junction, charting all the way back to the town's inception in 1933. While incorporating aviation shapes into the visual language of landscape and architecture, *Planes* art director Ryan Carlson was careful to not go over the top to give the town a "theme park" feel.

Most importantly, the design team asked themselves questions like, "What is an airport, and how do we make it feel like a small town? And what can we do to make a hangar feel like a home?" notes Carlson. Combining a warm-toned color palette with soft, diffused lighting, the *Planes* artists crafted a pleasant, nostalgic feel in Propwash Junction, welcoming planes and audiences alike.

Pages 14–15: Ryan Carlson, Digital

Opposite: Ryan Carlson, Digital

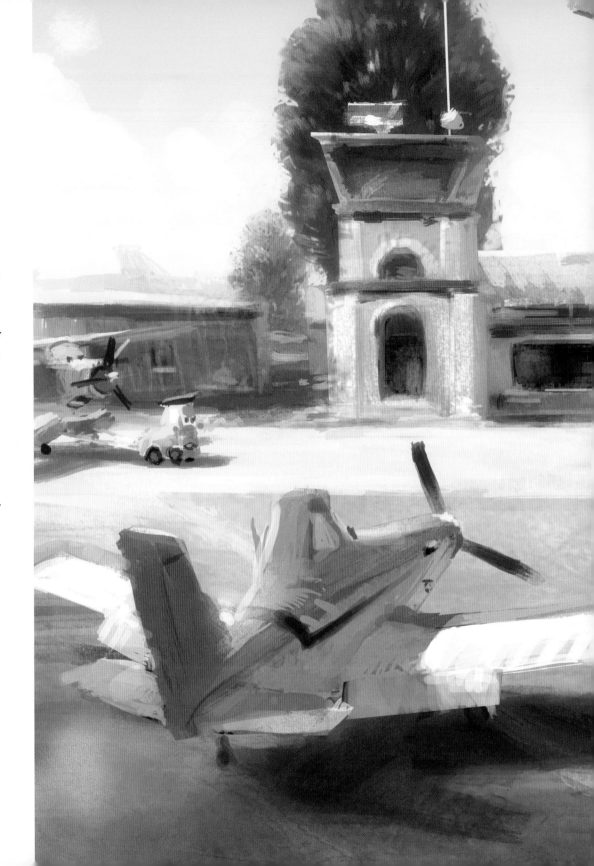

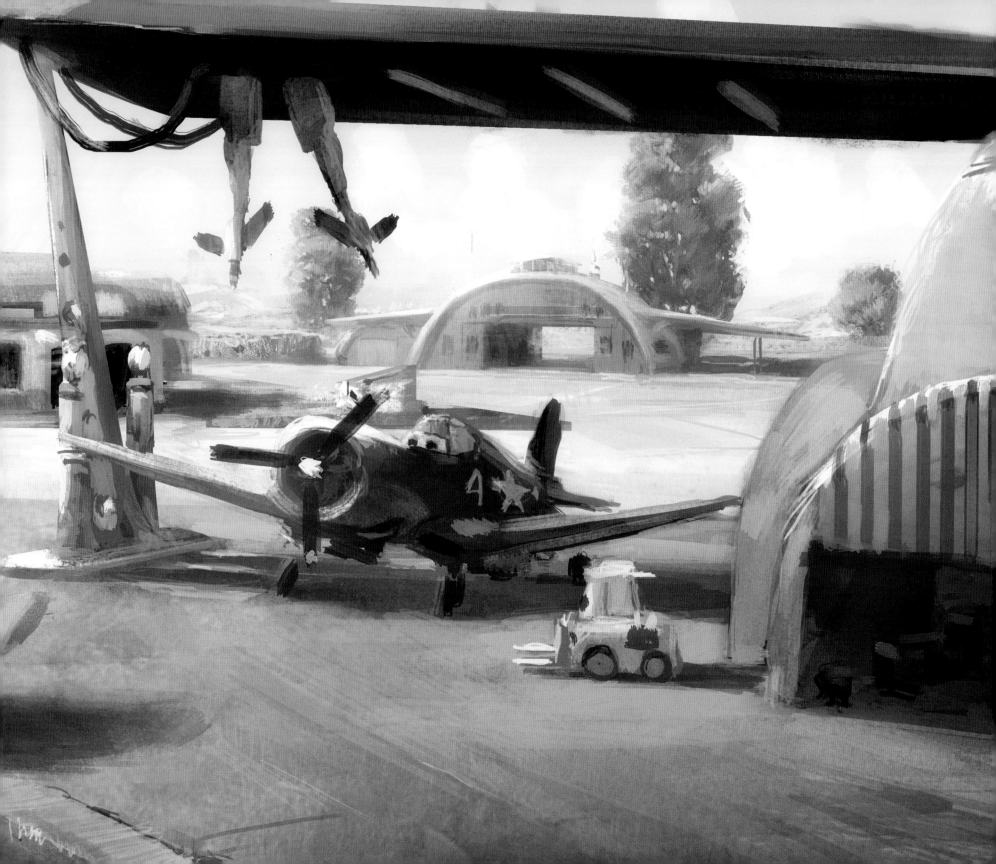

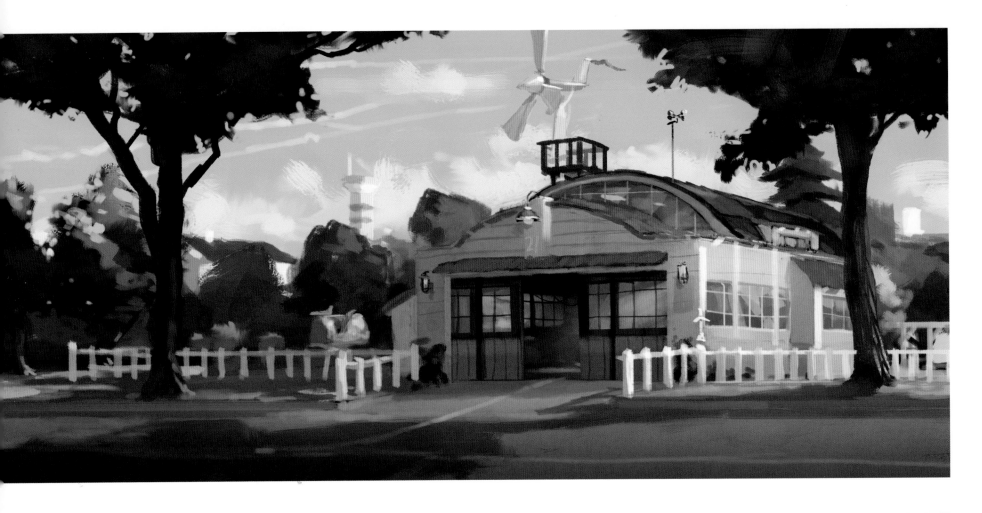

Ryan Carlson, Digital

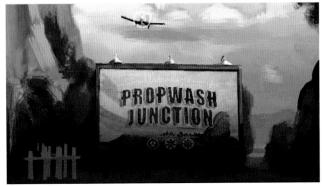

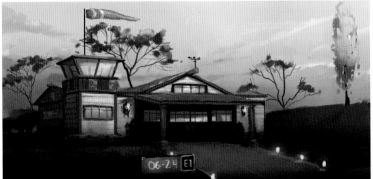

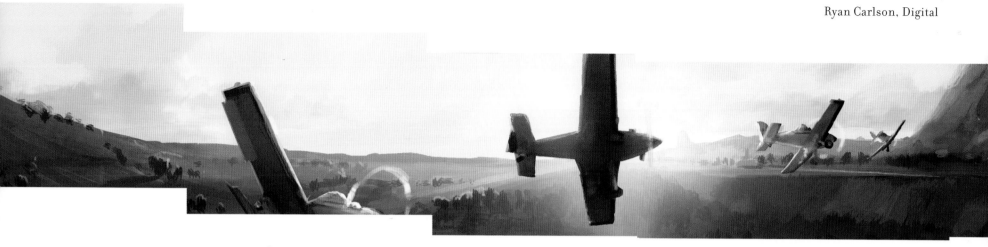

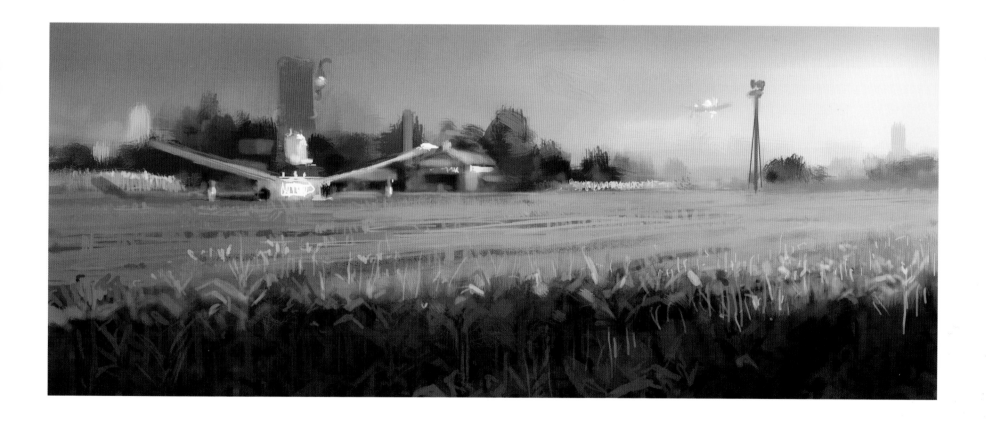

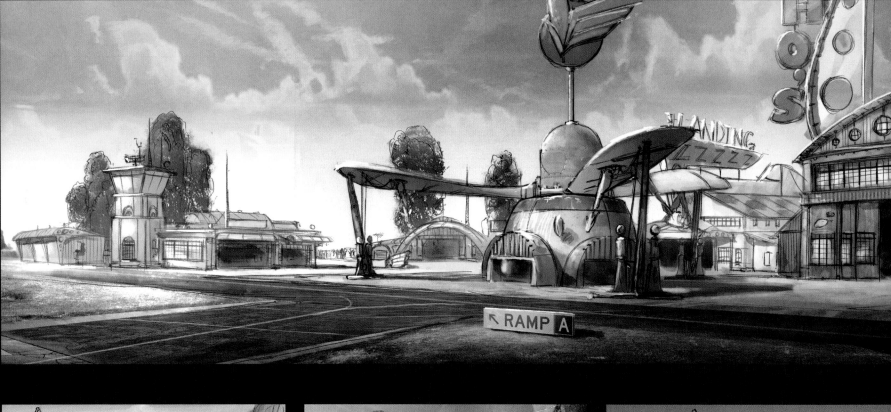

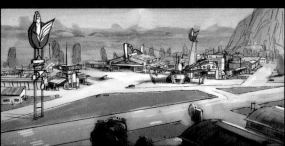

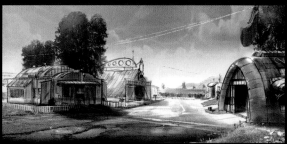

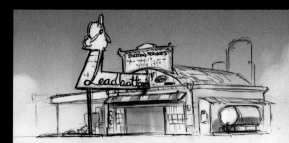

Ryan Carlson, Graphite, pen, and digital

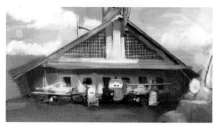
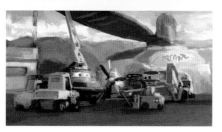

Lin Hua Zheng, Digital

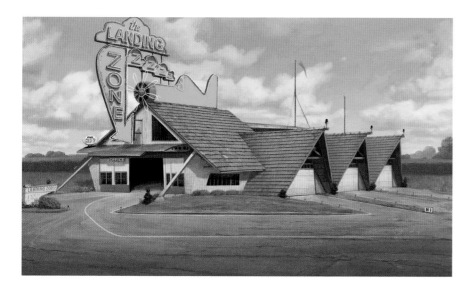

Lin Hua Zheng, Digital

I like the sense of community here in Propwash Junction, that the residents are all supportive of Dusty, cheering him on from start to finish.

—Traci Balthazor-Flynn, producer

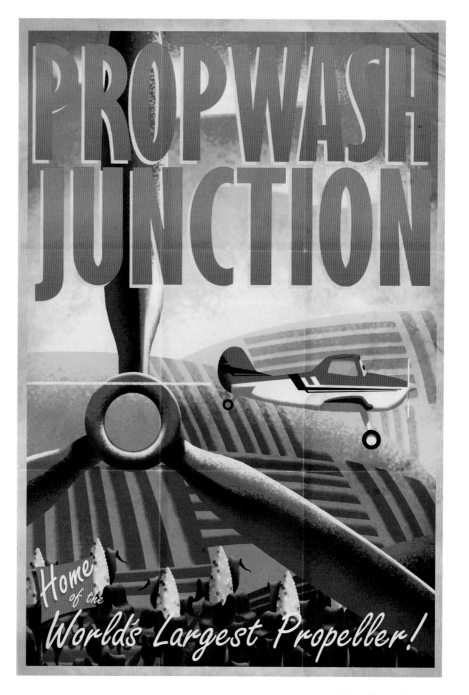

Scott Seeto, Digital

Ryan Carlson, Digital

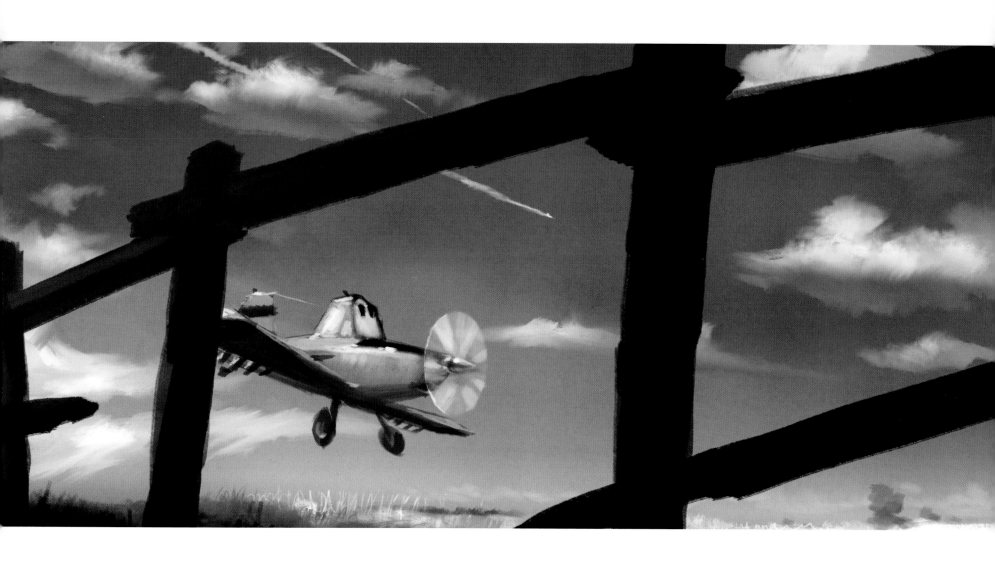

Ryan Carlson, Digital

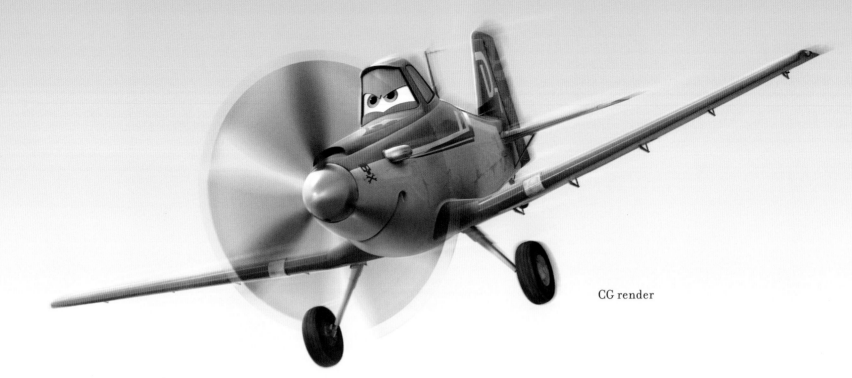

CG render

Dusty Crophopper

Dusty Crophopper embodies the humble, honorable, hardworking Midwesterner who can't help but wonder if there's something more to life than what he's been living. "He enjoys what he does in his job, but he's got this burning desire to do more," explains *Planes* director Klay Hall. Dusty, a plane built for crop dusting, has a deep desire to spread his wings in the realm of international racing, being a longtime fan of the "Wings Around The Globe" rally competitors.

Dusty was inspired by the AT-502 Air Tractor, the Dromader M-18, and the Cessna 188 whose design characteristics were combined—or as the crew calls it, "kit-bashed"—for visual appeal and personality. Being a crop duster, "it's the plane equivalent of being stuck in your hometown. Dusty has been flying back and forth across these same fields his entire life, having flown thousands of miles . . . but he's never been anywhere," says writer Jeff Howard. Dusty's enthusiasm to finally get somewhere

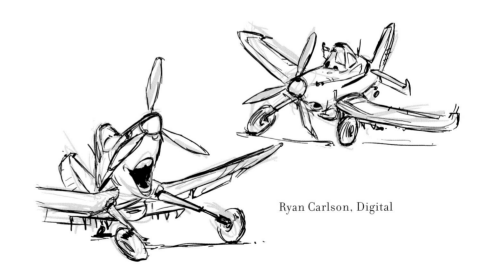

Ryan Carlson, Digital

by winging into racing overtakes his concern about the basic challenges he will face in attempting such a feat. "My analogy is he's kind of like a Ford. Those other guys are like Ferraris. They're carbon fiber, high-performance aircraft, and Dusty doesn't really belong in the air with them," notes Hall. Dusty's a plane with a fear of heights, never having flown over one thousand feet in altitude. It's an FAA regulation that crop dusters cannot fly above that height, and it makes for an ironic character twist in a plane that has lofty desires to soar. But as his story shows, Dusty's physical shortcomings are more than compensated by his winning spirit and deeply charged sense of motivation.

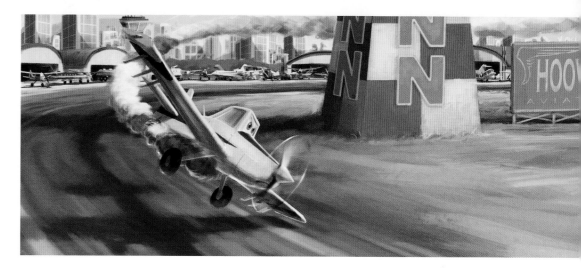

Art Hernandez, Digital

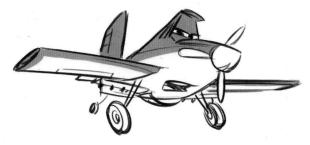

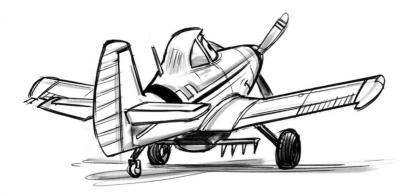

Top: Ryan Carlson, Digital Bottom: Scott Seeto, Digital

Christian Lignan, Digital

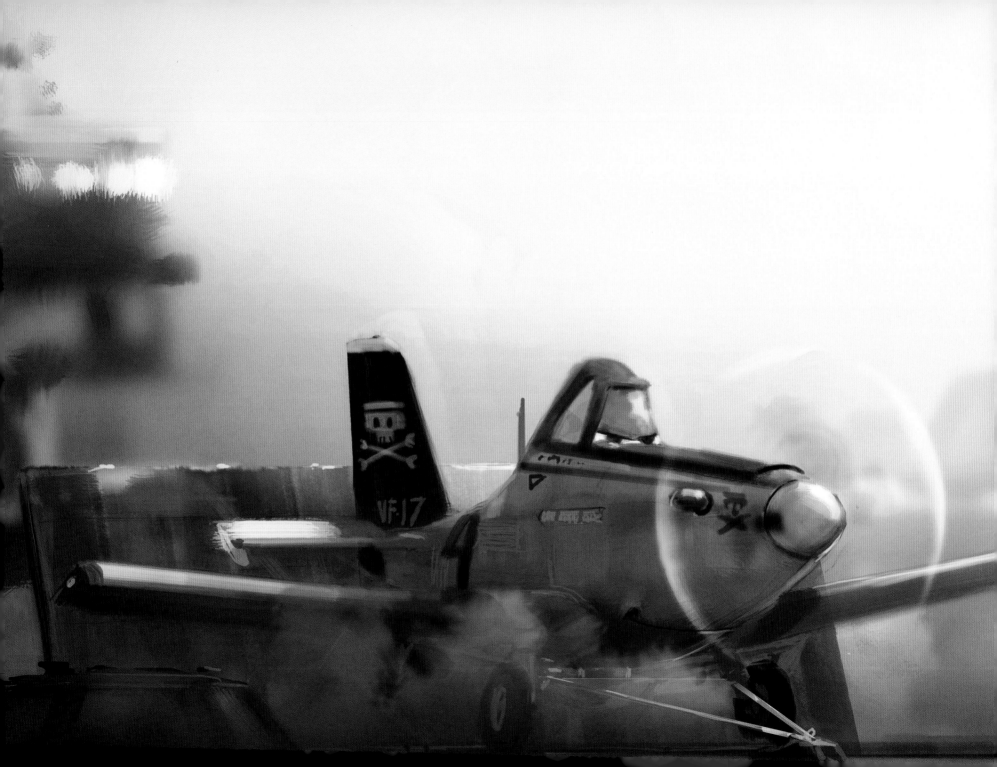

Ryan Carlson, Digital

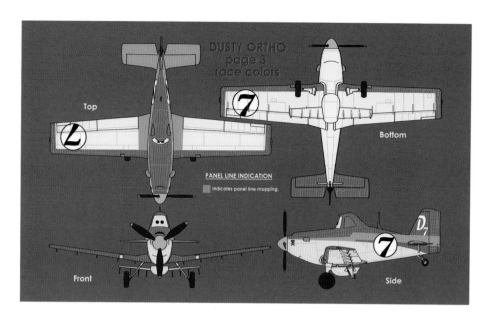

Scott Seeto, Digital

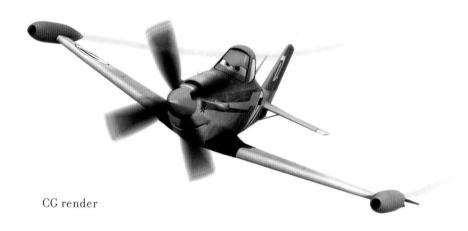

CG render

For a lot of people from all walks of life, it's an identifiable thing: having a dream and, despite what people tell you, going after it and trying to make it come true.

—*Jeff Howard,* writer

Chug

Dusty's best friend is a gas-guzzling fuel truck with a heart as big as his tank. He's an avid supporter of Dusty's racing dreams; he epitomizes loyalty and longevity. Chug's roots are deep in this small town, and his design inspiration was just as deeply rooted, as writer Jeff Howard recalls. "On our research trip, we stumbled upon a little airfield that had sort of an aircraft and automotive graveyard near it—there were lots of smashed parts and things like propellers that were bent all the way back. We even saw a Hudson Hornet in that junkyard, which of course made us think of Doc from *Cars*. And while there were a number of old fuel trucks, one in particular had such character that we were all immediately drawn to it." That very heap provided the development team with some rich details for Chug's shape, its influence proving to be surprisingly vital, just as Chug's friendship is for Dusty.

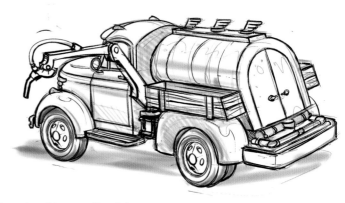

Christian Lignan, Graphite

Chug loves his buddy Dusty, wishes him the best, and tries to help him out in every way he can.

—*Klay Hall*, director

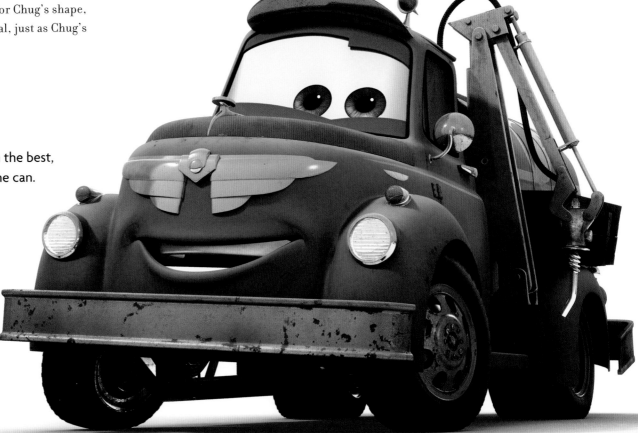

CG render

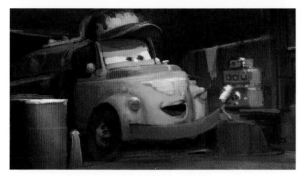

Cristy Maltese and Ryan Carlson, Digital

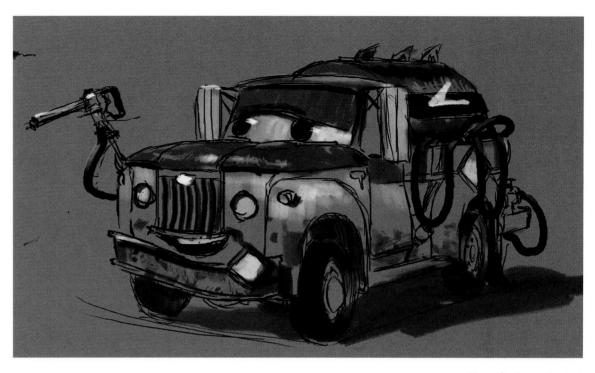

Ryan Carlson, Digital

Chug has a lot of energy. He's got the fuel arm, which really helps with acting, but we were careful to use it more for mechanical action than for gestures so that it didn't start to feel too unreal with our "Truth to Materials" approach to animation.

—*Sheryl Sackett*, animation director

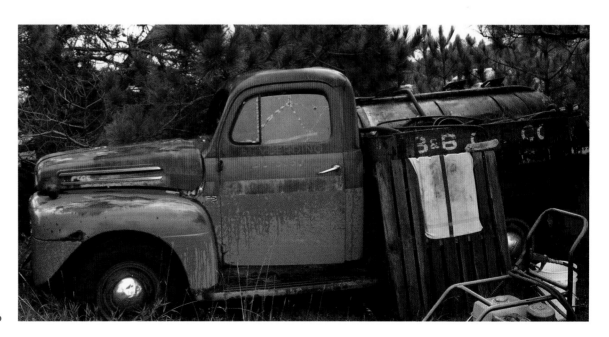

Ryan Carlson, Photo

Dottie

Dottie is the expert mechanic in town, always the realist and constantly concerned about Dusty's well-being. She is part pitty, part airport tug, and very much a challenge when "trying to make a utility vehicle look feminine. We had to soften her edges, but still make her feel hard enough to be a mechanic," recalls character designer Scott Seeto.

Dottie is part owner of Chug and Dottie's Fill 'n' Fly, the gas station that happens to be the first structure built in Propwash Junction. "We imagined that the gas station is the oldest building in Propwash Junction, set at the first crossroads and airway in the area, and then the small town popped up around it," says *Planes* art director Ryan Carlson. To create the iconic look of this structure, set designer Ed Li drafted a number of versions of Chug and Dottie's Fill 'n' Fly before the team agreed on the final design, which echoes a rotary engine and propeller in its aesthetic.

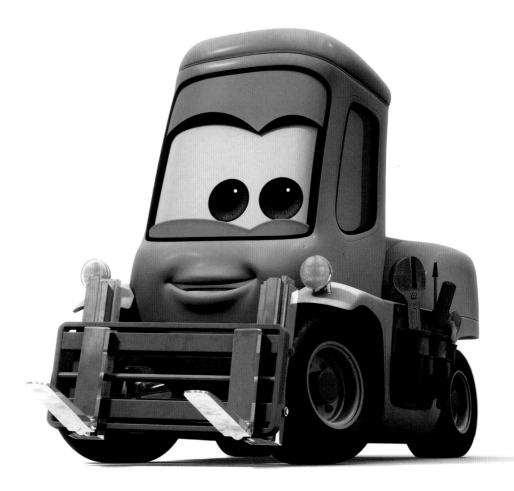

CG render

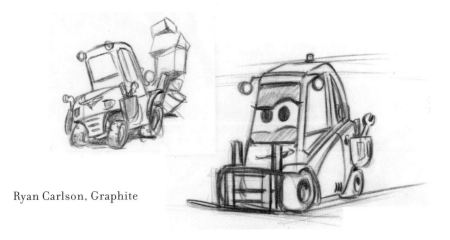

Ryan Carlson, Graphite

Dottie was more abrasive in her original versions, inspired by some of the early female aviators like Pancho Barnes, who was known as a real tough, no-nonsense kind of woman in the early days of aviation.

—Jason Hand, story artist

Dottie and all the pitty-type vehicles are a challenge in animation because animators naturally think, "Ooh, I finally have hands, I can gesture with them." But I'd have to remind them, "Hold on, they're still forklifts, and they have to feel like forklifts."

—Ethan Hurd, animation lead

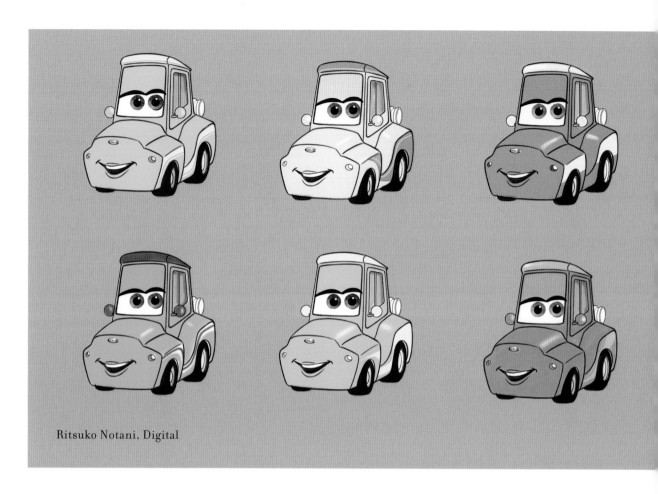

Ritsuko Notani, Digital

Art Hernandez, Digital

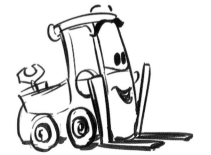

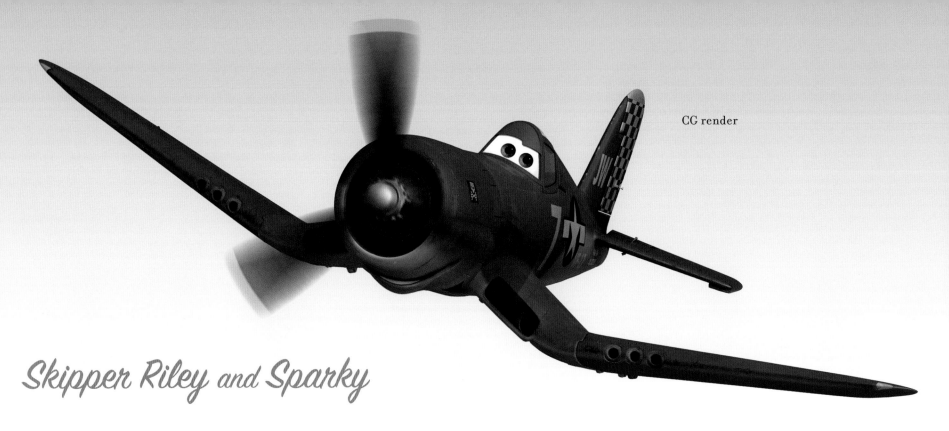

CG render

Skipper Riley and Sparky

At first glance, Skipper Riley seems like the winged equivalent of "the old guy who lives at the end of the block that yells things like 'Get off my lawn!'" says Dan Abraham, head of story on *Planes*. An old Navy war bird based on the F4U Corsair, Skipper has been a reclusive resident of Propwash Junction since his return from the battlefield. Skipper's reputation as a trainer for the Jolly Wrenches squadron has grown to legendary levels over the years, perpetuated by his silence. When Chug convinces Dusty to seek Skipper's expertise in preparing to enter the racing world, Skipper is not interested. When Dusty approaches Skipper, "it's an intimidating scene, set at night with Skipper backlit in his hangar, creating an ominous presence," explains *Planes* art director Ryan Carlson. Cinematography enhances Skipper's formidability by using cameras that position Skipper looming over Dusty, heightening his aura of empowerment. To really deliver the grumpy old man personality, "Skipper's brows are often positioned down low over his eyes, and he's got a downturned jowly mouth, in great contrast to Dusty," explains animation director Sheryl Sackett.

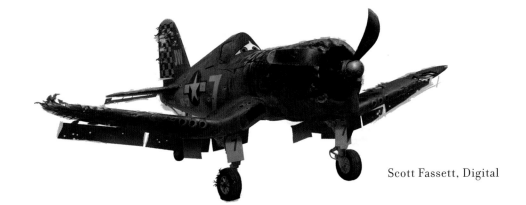

Scott Fassett, Digital

Once Skipper realizes that there's no way Dusty can survive in the midst of true air racers, he comes around to the idea of training the enthusiastic young plane, even though the last thing Skipper wants "is to take anyone else under his wing, due to his traumatic wartime experiences," explains writer Jeff Howard. While Dusty and Skipper prove to have a complicated relationship, both benefit from it and eventually find the figurative (and literal) blue skies in their friendship.

CORSAIRS CLIMB RIGHT INTO THE FIGHT!

GET ´EM UP-FOR YOUR NAVY!

VF-17

Jason Hand, Digital Ryan Carlson, Digital

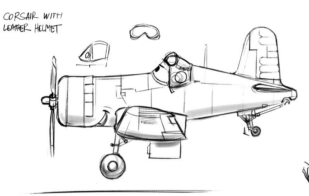

CORSAIR WITH LEATHER HELMET

Christian Lignan, Digital

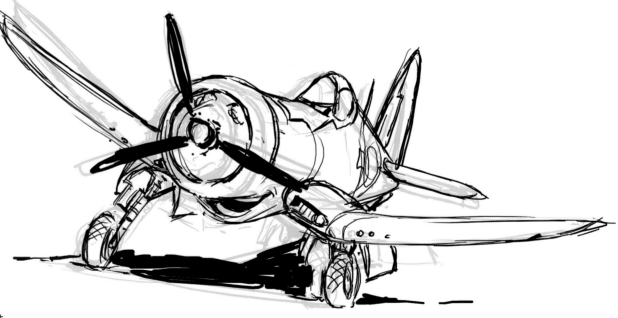

For a while in story development, we had Skipper flat-out boasting that he had been on all these missions, really puffing out his chest and bragging about his successes. It set up the dynamic for an "I was just lying to get you here. Look how far you've come, I've done it for your own good" sort of thing. But it came off as just unlikable, not something we'd want a mentor to do.

—*Dan Abraham,* head of story

Ryan Carlson, Digital

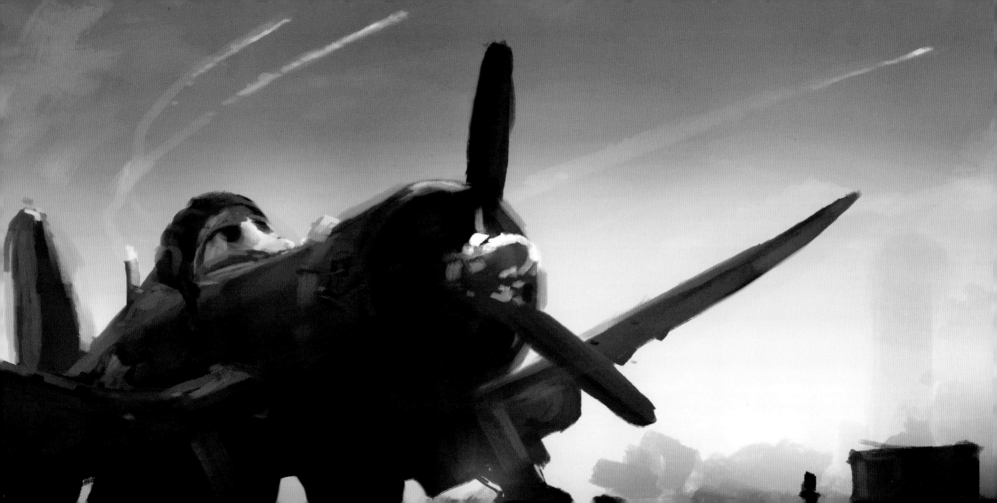

Skipper is accompanied by a rather unassuming airport tug named Sparky, who wields a pneumatic tool that helps Skipper move around, as if Skipper suffers from a debilitating war injury and cannot maneuver himself. Sparky is often hidden behind Skipper's large fuselage and remains generally silent, unless he and Chug happen to wind each other up about random topics of conversation. "Sparky is into the details and Chug is right there to root him on," adds *Planes* producer Traci Balthazor-Flynn.

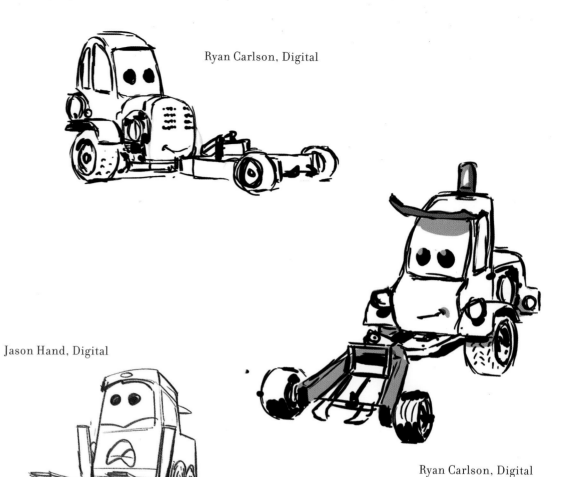

Ryan Carlson, Digital

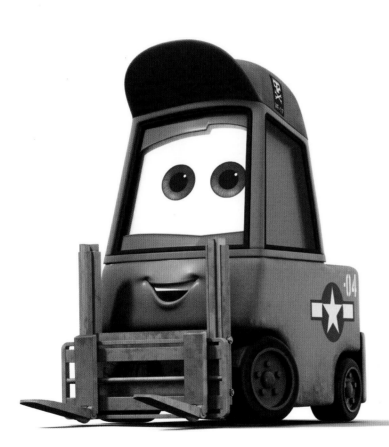

CG render

Jason Hand, Digital

Ryan Carlson, Digital

Ryan Carlson, Digital

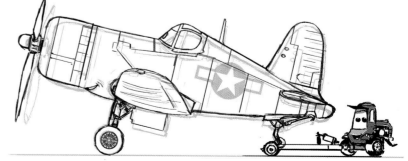

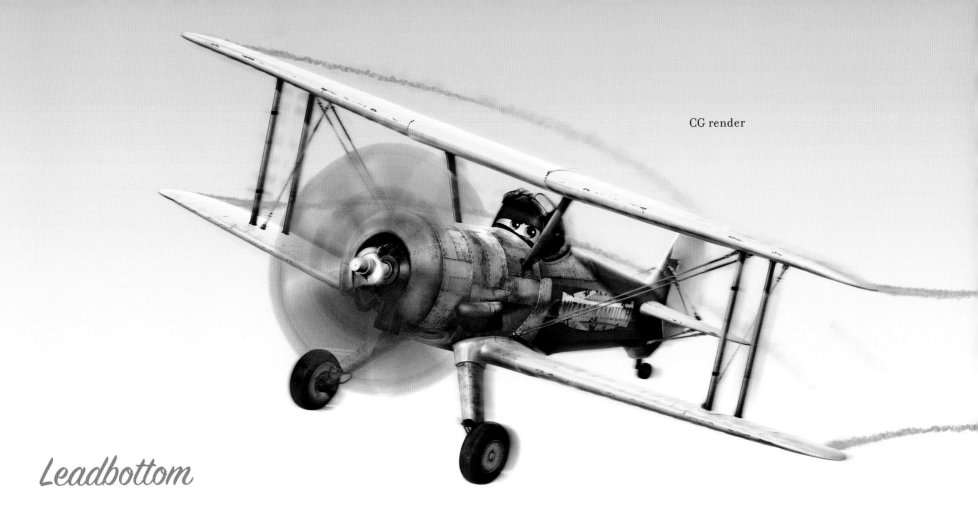

CG render

Leadbottom

Leadbottom is Dusty's "tank-is-half-empty" boss, the purveyor of the aerially applied agricultural supplement Vita-minamulch, and a crop duster through and through. "He's the future Dusty— covered in pungent Vita-minamulch and flying back and forth, back and forth over the same fields—if Dusty doesn't achieve his dream of being a racer," says Dan Abraham, head of story. From the earliest days of development, the crew knew that the right plane for this role was a classic Stearman biplane, a military trainer that shifted into crop dusting duty after its wartime services ended in the 1940s. "I found a picture of an old Stearman that was missing the bottom part of its cowling. Seeing the exposed cylinders made it look like an airplane with a mustache, and that was a fun, natural choice to portray this crotchety old guy," recalls *Planes* art director Ryan Carlson.

Art Hernandez, Digital

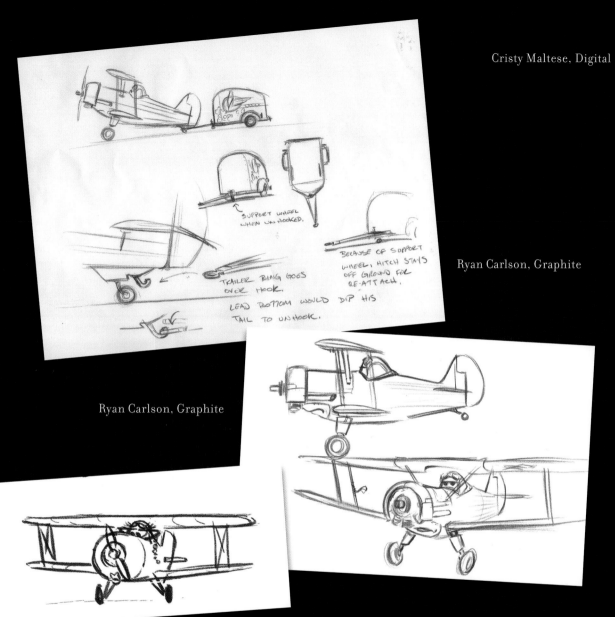

Cristy Maltese, Digital

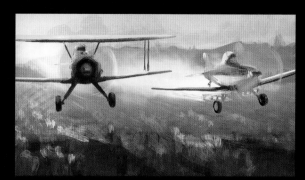

Ryan Carlson, Graphite

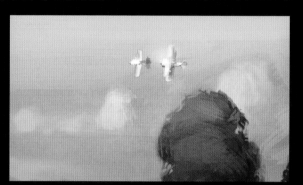

Ryan Carlson, Graphite

Chris Hubbard, Digital

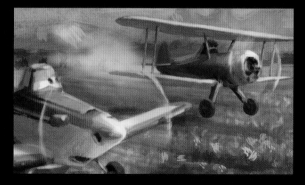

At one point in our story development, there was a big argument between Leadbottom and Skipper, with Skipper saying that Dusty should be a racer. And Leadbottom's position was that "he's not built for that, you're going to get him killed out there, having Dusty chase after your dreams."

—*Dan Abraham,* head of story

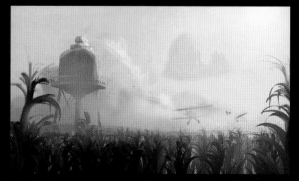

2

Wings Around The Globe

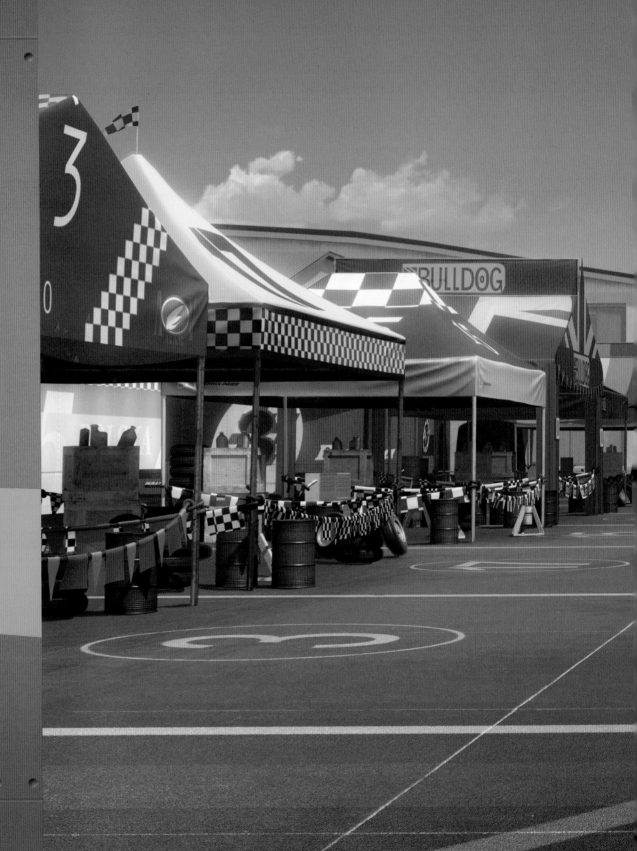

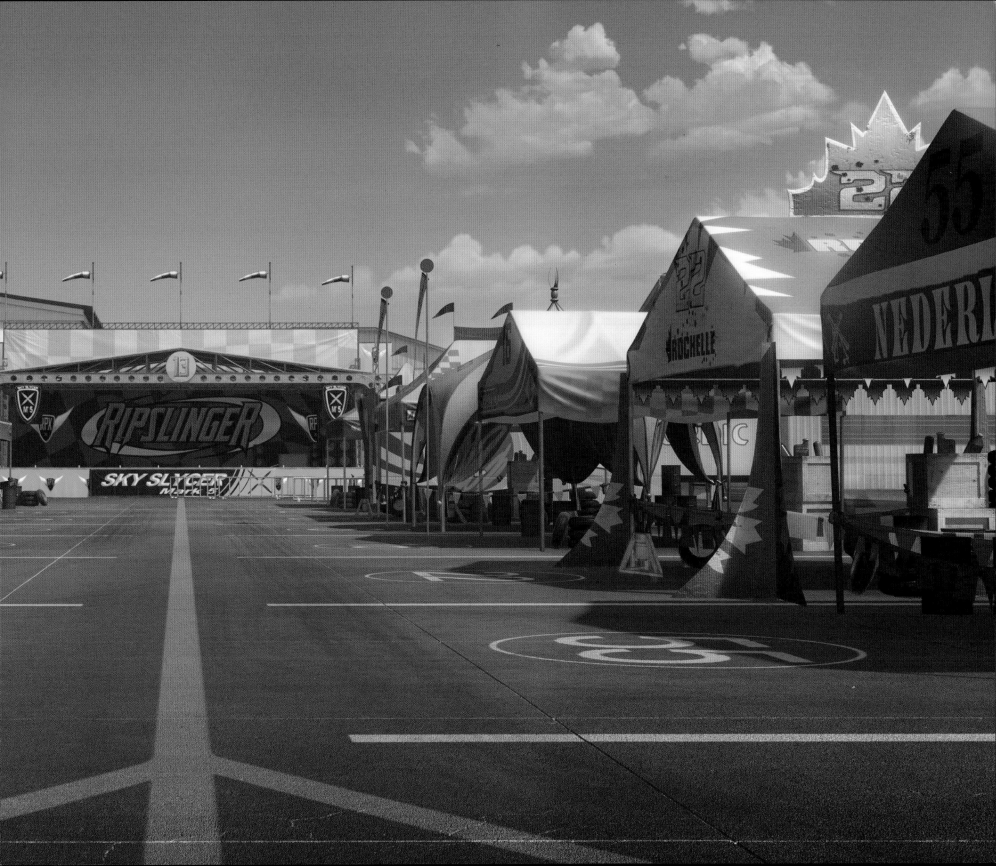

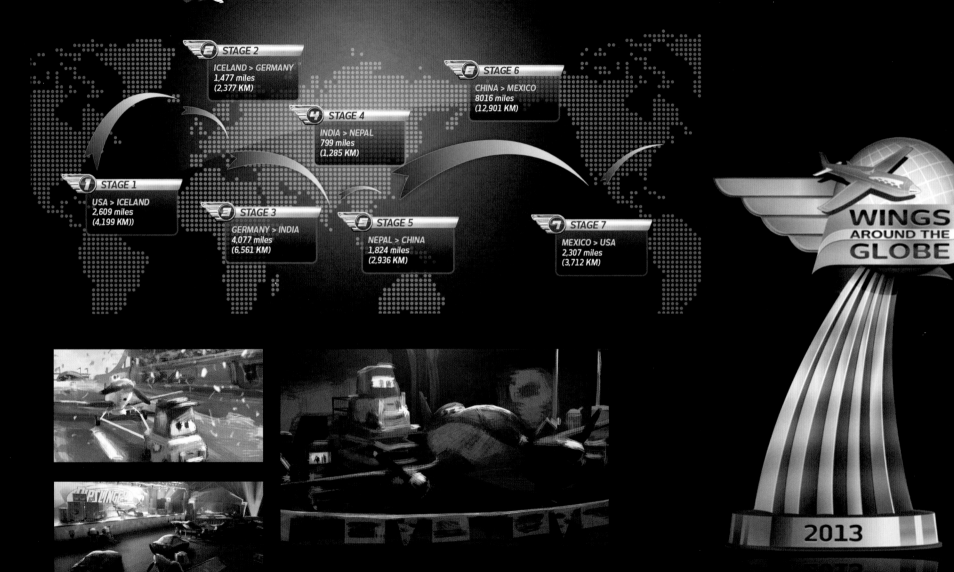

GLOBAL MAP 2013

WINGS AROUND THE GLOBE

STAGE 1
USA > ICELAND
2,609 miles
(4,199 KM))

STAGE 2
ICELAND > GERMANY
1,477 miles
(2,377 KM)

STAGE 3
GERMANY > INDIA
4,077 miles
(6,561 KM)

STAGE 4
INDIA > NEPAL
799 miles
(1,285 KM)

STAGE 5
NEPAL > CHINA
1,824 miles
(2,936 KM)

STAGE 6
CHINA > MEXICO
8016 miles
(12,901 KM)

STAGE 7
MEXICO > USA
2,307 miles
(3,712 KM)

WINGS AROUND THE GLOBE
2013

Ryan Carlson, Digital

Pages 38–39: CG render Page 41: Marty Baumann, Digital

*D*usty aspires to earn a position in the most prestigious international air race, the Wings Around The Globe (WATG) Rally. Essentially an airborne grand prix, the rally features twenty-one racers who must first qualify for a spot. The American planes compete in time trials that take place in Lincoln, Nebraska, just a hop away from Propwash Junction. The race itself involves flying over thirty-three thousand kilometers in seven legs and traversing some of the most daunting natural obstacles, including the coldest snowstorms, the highest mountains, the deepest oceans, and the heaviest rainstorms.

Wings Around The Globe is a highly polished sports organization that has a presence not unlike NASCAR. Designer Everett Campbell helped develop the branding and motion graphics used for the televised race coverage, taking the original WATG logo and design and "making it 3-D and shinier, kind of 'in your face,' the way sports graphics really are." The intent of the graphics package is to be more entertaining than realistic, incorporating maps and arrows to inform the audience with a clear and simple read.

Rally Racers

The Wings Around The Globe Rally hosts the top air racers on the international circuit . . . and one lucky newcomer from Propwash Junction. While some plane designs were based upon combinations of real-world models, most of the racers were handcrafted by character designer Scott Seeto and art director Ryan Carlson, using three different body types and three different wing types, intermixed and squashed or stretched to add variation. Here's an overview of the competition Dusty faces in his racing debut.

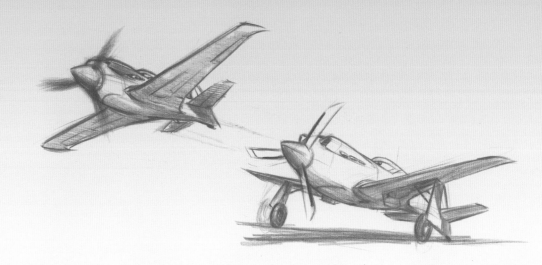

Scott Seeto, Graphite

Ripslinger, USA

We use stereography to subtly support the good guy/bad guy dynamic. If you take a close-up of Dusty and the exact same close-up of Ripslinger at any point in our film, you'll notice that Dusty's just a little bit closer to you than Ripslinger is, just to help emphasize intimacy and closeness with the main character versus distance and alienation from the bad guy.

—Jason Carter, stereographer

CG render

Ryan Carlson, Digital

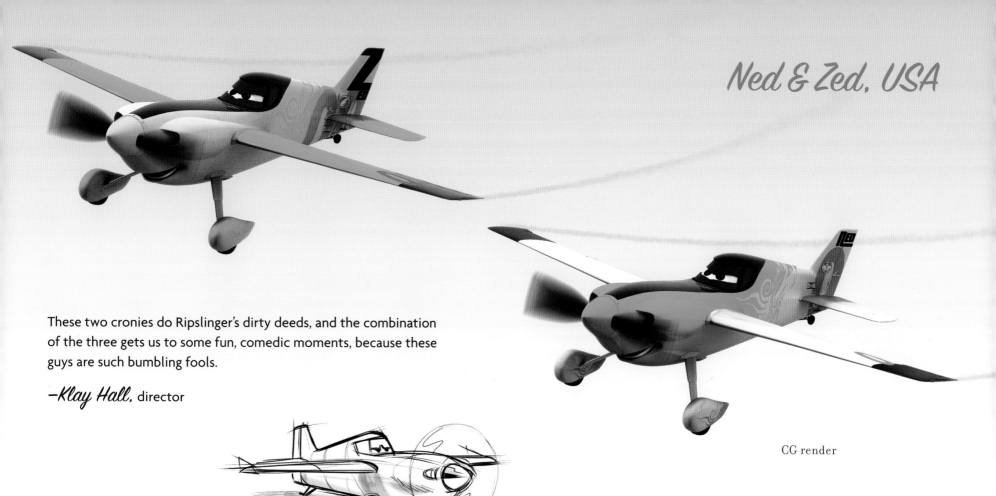

These two cronies do Ripslinger's dirty deeds, and the combination of the three gets us to some fun, comedic moments, because these guys are such bumbling fools.

—Klay Hall, director

Christian Lignan, Digital

CG render

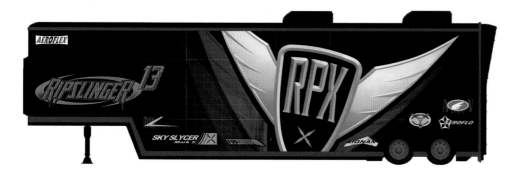

Scott Fassett, Digital

Ryan Carlson, Digital

El Chupacabra, Mexico

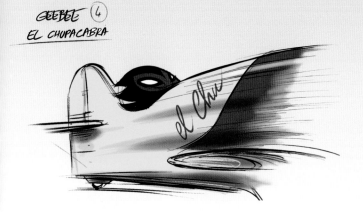

GEEBEE ④
EL CHUPACABRA

Christian Lignan,
Graphite and digital

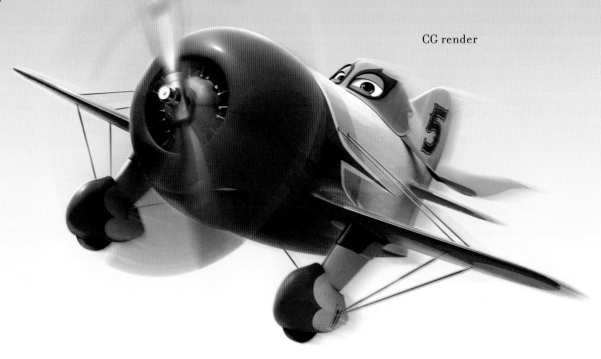

CG render

What's fun about El Chu is, although he's famous in his country—besides being the indoor racing champion, he stars in his own telenovela, he's a writer, a singer, a bullfighter, and all kinds of stuff—he hasn't raced around the world before, so it puts him and Dusty on a common ground from the start, giving Dusty an ally right up front.

—Klay Hall, director

COWLING NOT AS TAPERED

MORE UP-RIGHT CANOPY.

MORE GRACEFUL CURVE

LIP AT BOTTOM OF LANDING GEAR BOOT.

NEEDS TO LOOK FLY-ABLE

Ryan Carlson, Graphite and digital

Art Hernandez, Digital

Chris Hubbard, Digital

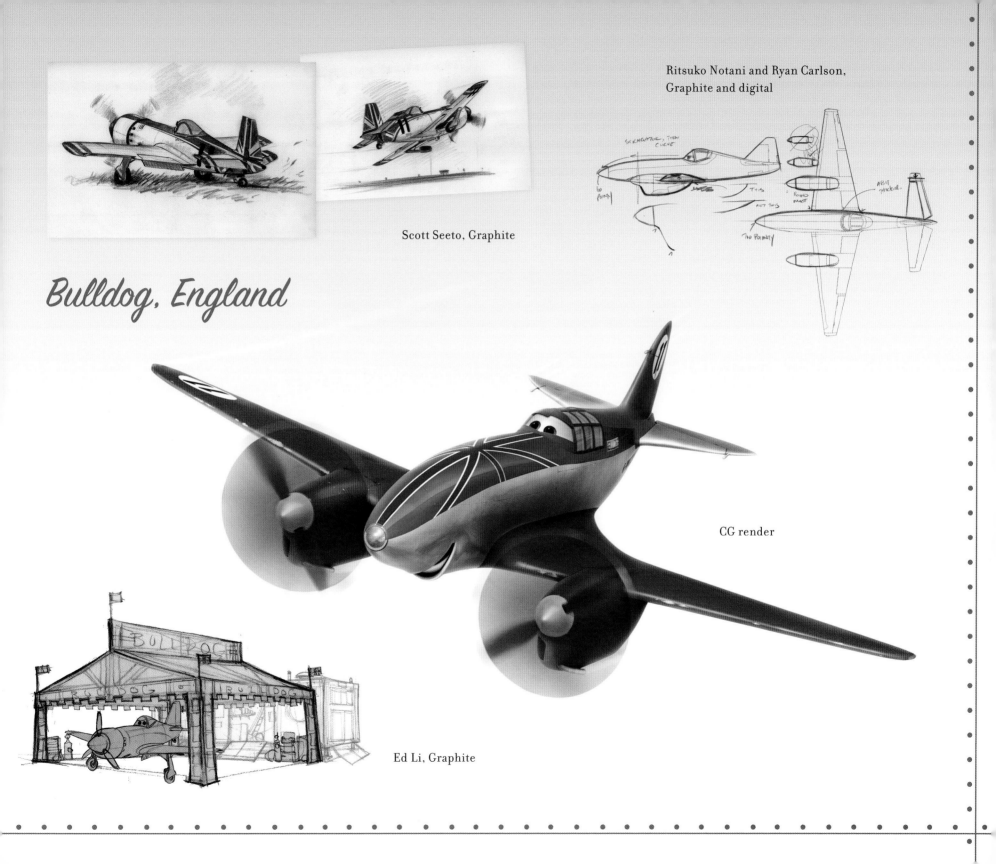

Scott Seeto, Graphite

Ritsuko Notani and Ryan Carlson,
Graphite and digital

Bulldog, England

CG render

Ed Li, Graphite

Rochelle, Canada

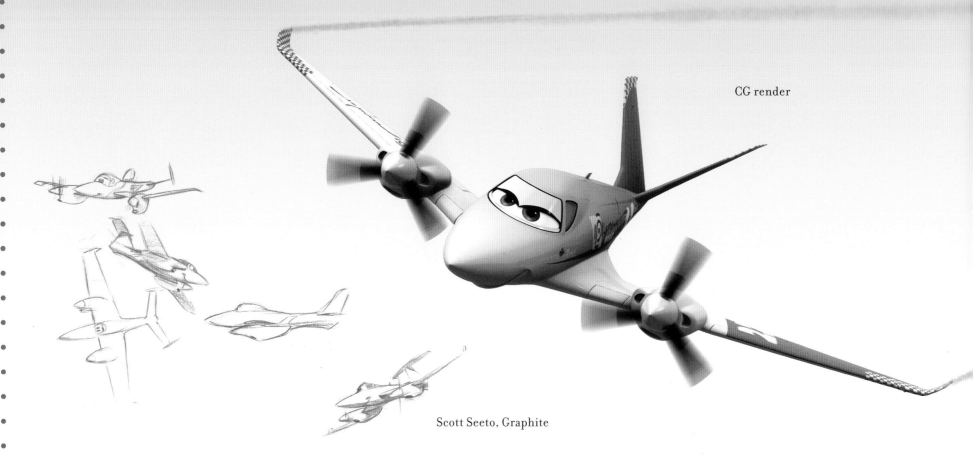

CG render

Scott Seeto, Graphite

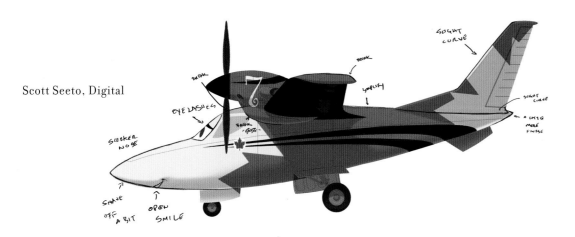

Scott Seeto, Digital

Rochelle first started out as a Russian flying boat, but we knew we wanted her to be a twin engine, so she's actually a bunch of different airplanes, all kind of put together. Most importantly, we wanted a nice, sleek, simple form on her. On the guy airplanes you can have a lot of different intakes and bulbous things on them, but the girls needed to be nice and soft and clean.

—Ryan Carlson, art director

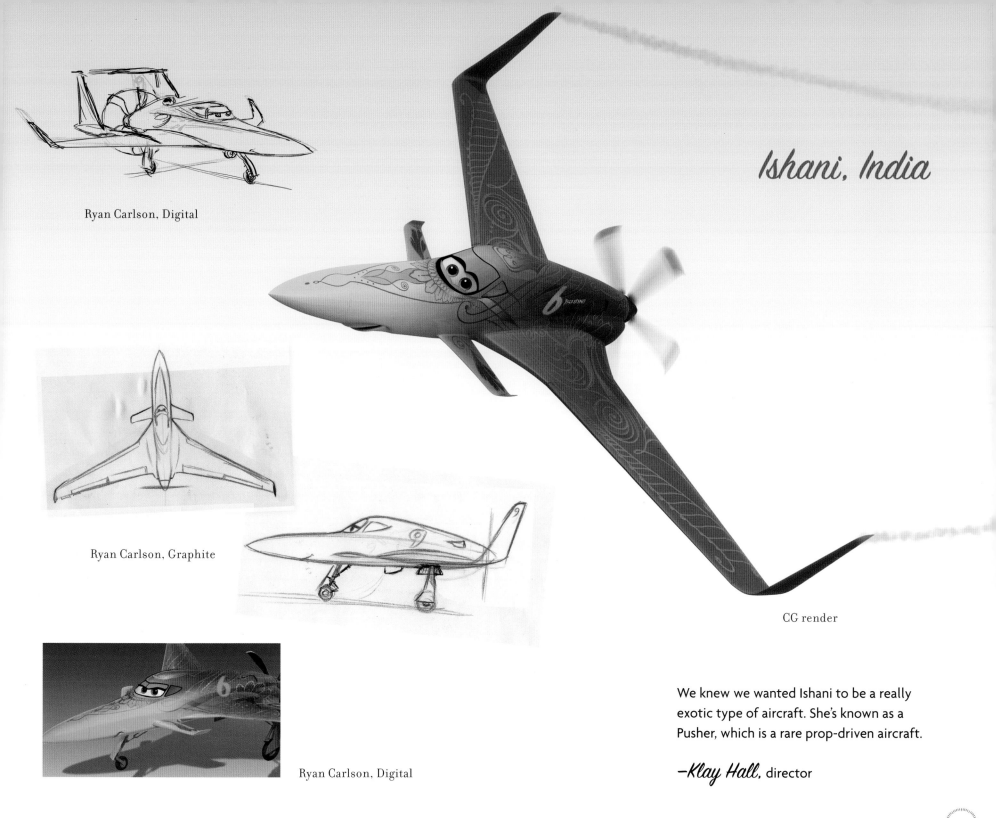

Ryan Carlson, Digital

Ishani, India

Ryan Carlson, Graphite

CG render

Ryan Carlson, Digital

We knew we wanted Ishani to be a really exotic type of aircraft. She's known as a Pusher, which is a rare prop-driven aircraft.

—Klay Hall, director

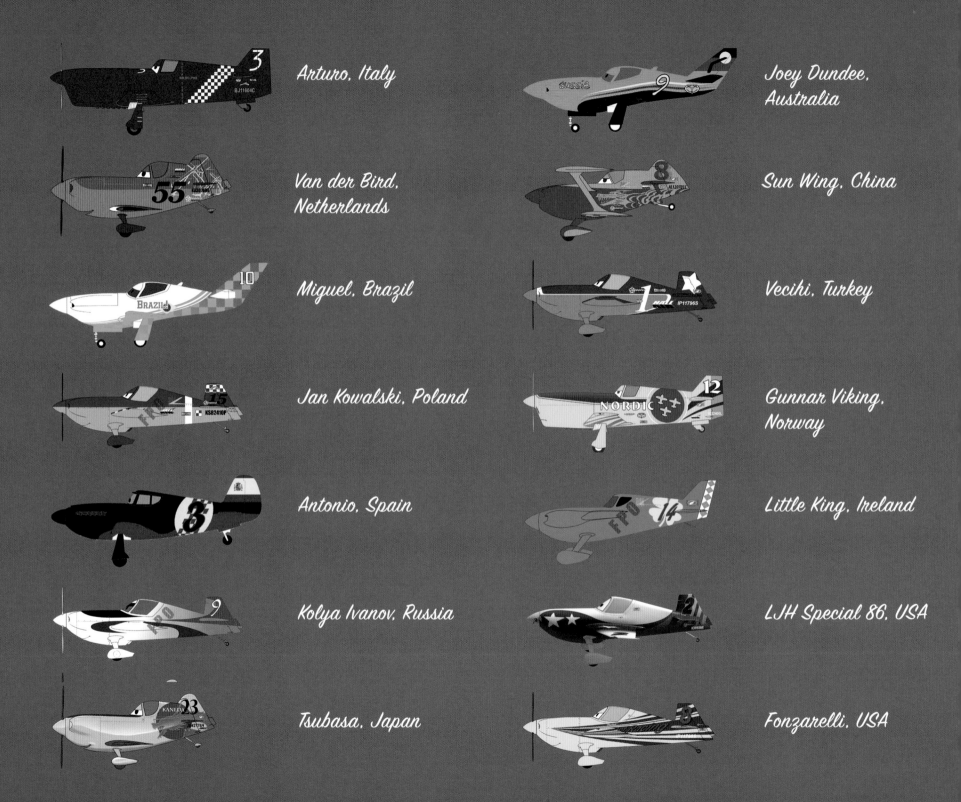

Arturo, Italy

Joey Dundee,
Australia

Van der Bird,
Netherlands

Sun Wing, China

Miguel, Brazil

Vecihi, Turkey

Jan Kowalski, Poland

Gunnar Viking,
Norway

Antonio, Spain

Little King, Ireland

Kolya Ivanov, Russia

LJH Special 86, USA

Tsubasa, Japan

Fonzarelli, USA

Scott Seeto and Scott Fassett, Digital

The Racing Sports Network

The WATG progress is televised by the Racing Sports Network (RSN), previously featured in the *Cars* race scenarios. Brent Mustangburger, a 1964 ½ Ford Mustang, is once again the on-camera reporter for RSN, and this icon in sports broadcasting delivers his analysis of the competition as a narrative guide for audiences both on and in front of the big screen.

Announcer Colin Cowling serves as the RSN "Eye in the Sky" for the WATG rally. After attending the prestigious Zeppelin Broadcasting School in Cheney, Washington, Cowling did play-by-play announcing for the Coast Balloon Races before he was recruited to cover WATG in 1998. If Cowling looks vaguely familiar, it's because he and Al Loft from the "World of *Cars*" share the same model, but Cowling is painted to fit in with the Racing Sports Network team.

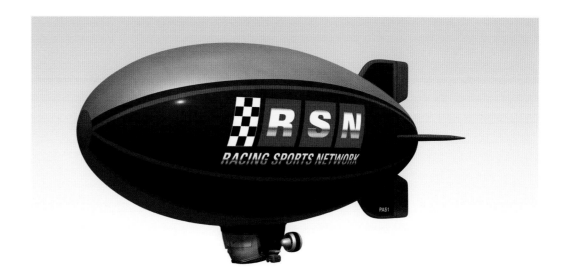

CG render

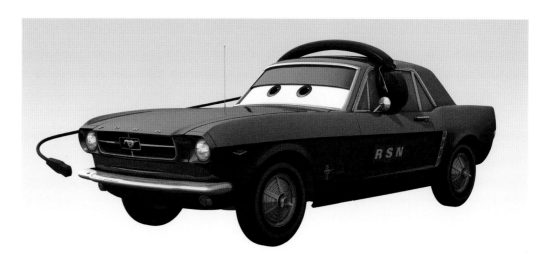

CG render

 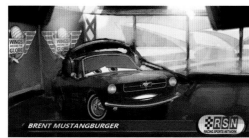

Left: CG render Right: Ryan Carlson, Digital

Officials

To coordinate a race as grand as the Wings Around The Globe Rally, countless pitties, tugs, helicopters, and other vehicles must work together. One of the more notable personalities in this crew is Roper, the Race Official Pitty who is charged with running the time trials as well as the main race. Roper is clearly a city pitty, quite out of his element when he is forced to travel to the far reaches of the countryside to find Propwash Junction to tell Dusty he has earned a spot in the WATG after all. "At one time, Roper sported a black-and-white-striped paint job inspired by the crew that fought on D-Day in World War II, but we shifted his colors to fall more in line with the whole WATG team," recalls *Planes* art director Ryan Carlson.

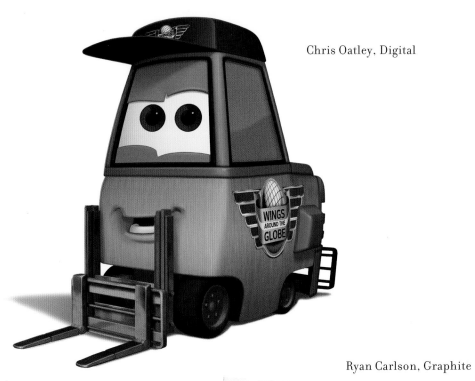

Chris Oatley, Digital

Ryan Carlson, Graphite

Ryan Carlson, Digital

Ryan Carlson, Graphite

Fans Around the World

Comparable to the Olympics, fans around the world are captivated by the Wings Around The Globe Rally. Courtesy of televised coverage by RSN, the leader board and other important race details are watched through anxious windshields on vehicles that gather in sushi bars, cantinas, department stores, and, thanks to mobile technology, any random street intersection around the world. Those fans lucky enough to get tickets to the start or finish events crowd into grandstands in New York. "Designing a grandstand that accommodates all vehicle types was a bit of a challenge, trying to figure out how to get them to enter the arena and pack in enough to look crowded," recalls set designer Ed Li. Runway and highway access, along with ramps and hidden freight elevators, made the venue accessible to fans of all makes and models, aeronautically able or wheel-bound.

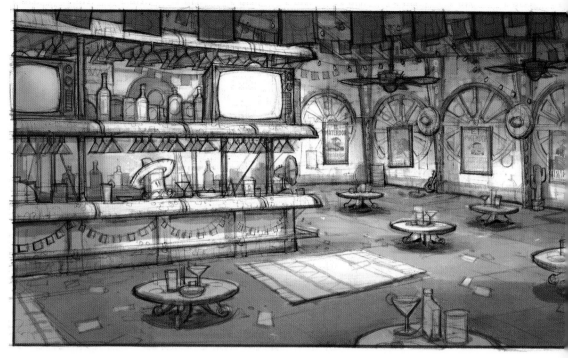

Ed Li, Graphite

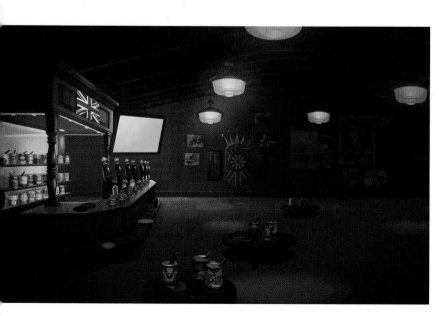

Jim Schlenker, Graphite; Akiko Crawford, Digital

Ryan Carlson, Digital

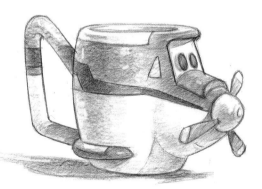

Jim Schlenker, Graphite

New York

The big race begins and ends at John F. Kennedy International Airport (JFK) in New York City, a location that couldn't be any more different than Propwash Junction. Flying in before the start of the rally, Dusty experiences the wide-eyed wonder of a country boy discovering the big city: mesmerized by the skyline and utterly confused by the fast-talking air traffic control jargon, he is clearly out of his element. To literally overwhelm the plane from a small town, the artists chose tall buildings, vibrant colors, and bright lights to convey a stark contrast to what Dusty's ever seen. "On the tarmac, we really played up the scale of huge jumbo jets towering over him, and he's scooting under their wings, trying to make his way around a place with which he is totally unfamiliar," adds *Planes* art director Ryan Carlson.

Once Dusty finds his way to pit row, he continues to be awestruck by all the famous aircraft against whom he will race. The brightly colored tents exhibit the unique persona and culture of each racer, and none is more flashy and big-time than that of Ripslinger.

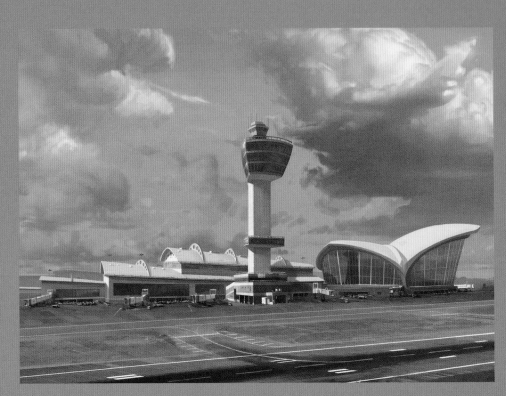

Ed Li, Graphite; Lin Hua Zheng, Digital

Ryan Carlson,
Graphite

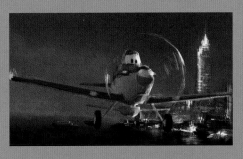
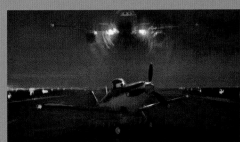
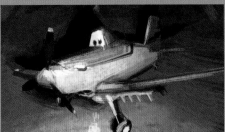
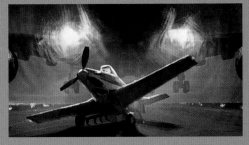

Ryan Carlson, Digital

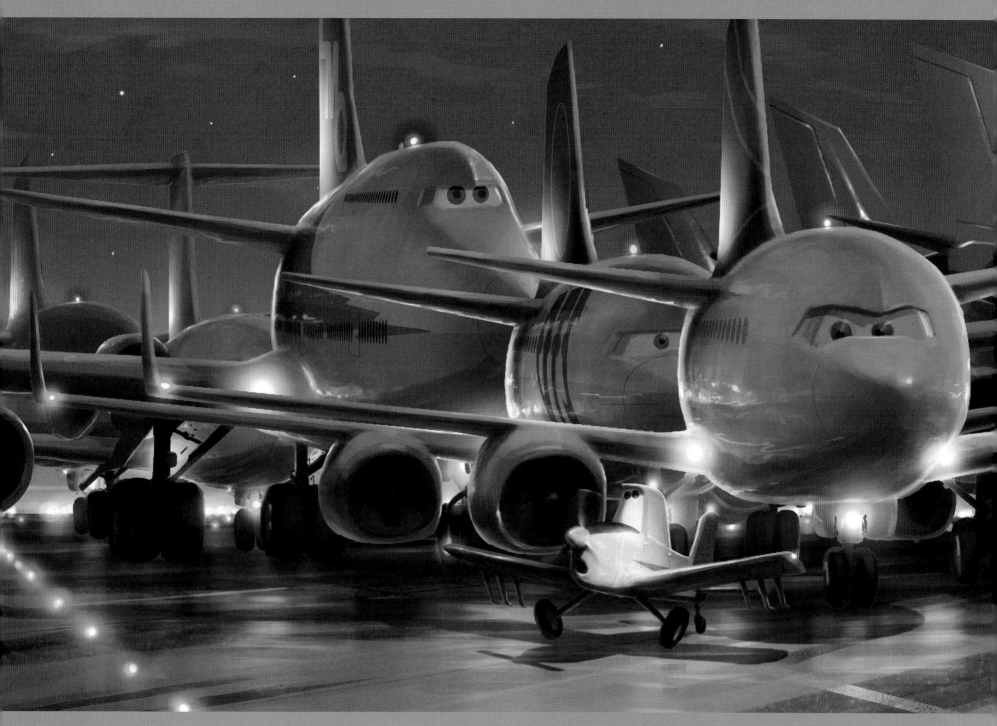

Scott Seeto, Digital

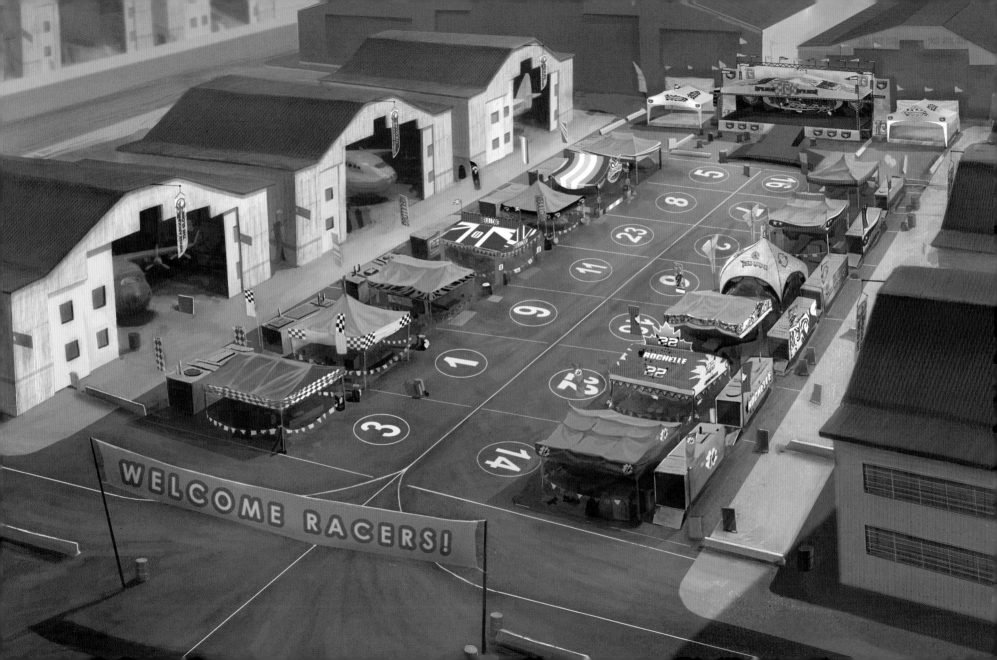

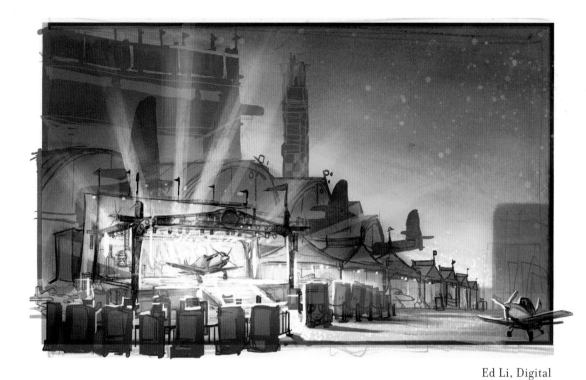

Ed Li, Digital

We designed Ripslinger's pit row setup to be like a concert venue to host his legions of fans. We even included a little pitty DJ in the background. It was fun to blow it up over the top, really catering to how narcissistic he is.

—Ed Li, set designer

Ed Li, Graphite and digital

Jim Schlenker, Graphite

1. Chris Hubbard, Digital

2, 3 & 4. Art Hernandez, Digital

1

2

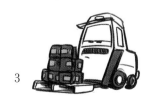
3

4

Iceland

The first leg of the rally lands the racers in Reykjavik. In this location, the production team utilized the first instance of a generic airfield set that was repurposed and redressed in a few locations around the world. "In Iceland, the hangar décor is Viking inspired. But whereas Viking architecture often features dragon heads and shield motifs, we plane-ified everything and incorporated propellers, airfoils, and other aviation shapes into our designs," explains Ryan Carlson, art director of *Planes*.

To get to Iceland, Dusty has to endure weather conditions he's never before experienced, namely icy sleet and snow. To get the right look for a frozen Dusty, the art direction team went back and forth between "making it realistic, which didn't translate very well in animation, and going all the way to making him look like a complete ice cube, which was just way too cartoony for our film," recalls Carlson.

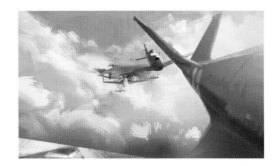

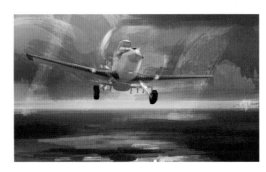
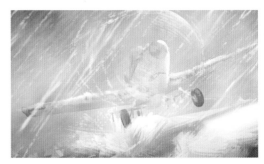

Ryan Carlson, Digital

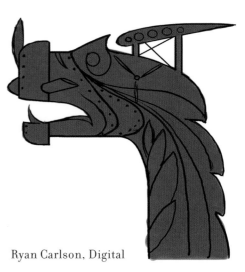

Ryan Carlson, Digital

Ed Li, Graphite; Akiko Crawford, Digital

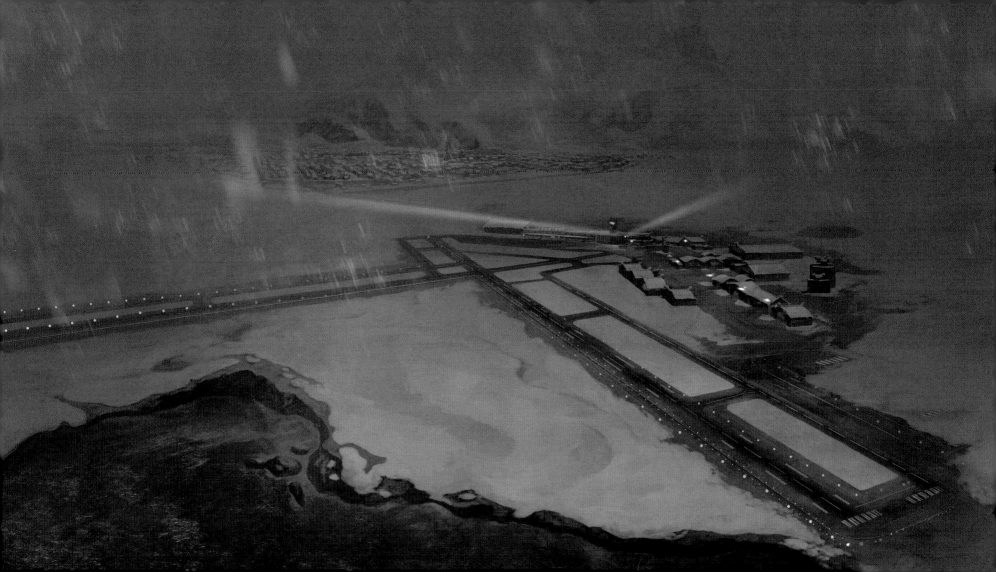

Germany

Coming into Germany, the racers fly over the Hurtgen Forest, the Elbe River, and a castle that will look familiar to Disney fans: "It's our caricature of Neuschwanstein Castle, which is also the inspiration for Sleeping Beauty's castle at Disneyland," explains set designer Jim Schlenker. It is during this leg of the rally that Dusty saves Bulldog from crashing, surprising the racing scene with such a selfless act but ending up in the "nice guys finish last" place because of it.

Architecture in this location skews to the Bavarian, using wooden beams, stonework, "and even a cuckoo clock feel in some instances," says *Planes* art director Ryan Carlson. Plane shapes are incorporated along the rooftops and within the "oil haus," where the racers gather after their long journey. This is where Dusty meets Franz/Fliegenhosen. This unique German vehicle is a minicar with wings, a cross between the Aerocar from the 1940s to the 1960s and super compact cars like the Isetta and the Messerschmitt KR. Franz reminds Dusty how encouraging his "do more than you were built to do" anthem is, which lifts Dusty's spirits much higher than his last place standing in the race left them. At one time, this sequence also included a lively musical number by Franz and friends, much inspired by the oom-pah performance the *Planes* crew enjoyed during their research trip to Germany.

Page 59: Jim Schlenker, Graphite; Ryan Carlson, Digital

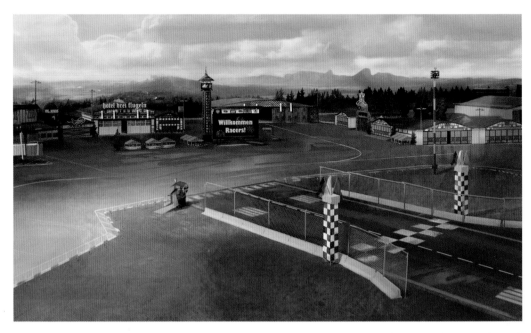

Ryan Carlson, Digital

Jim Schlenker, Graphite

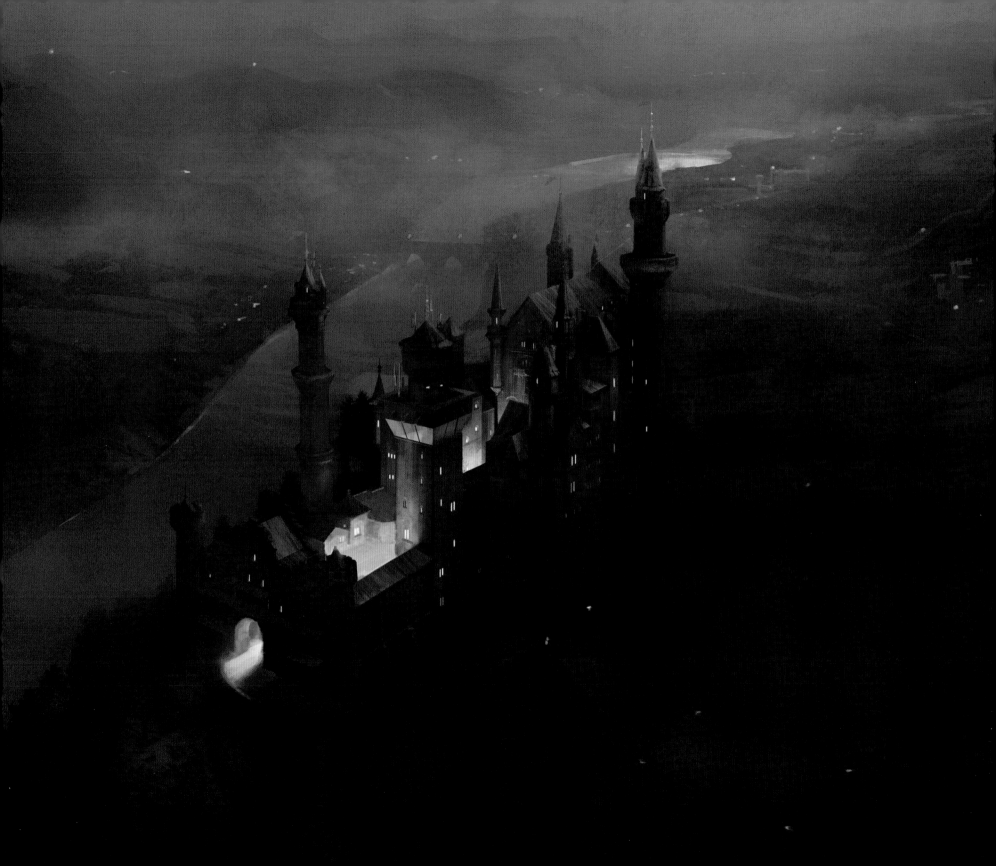

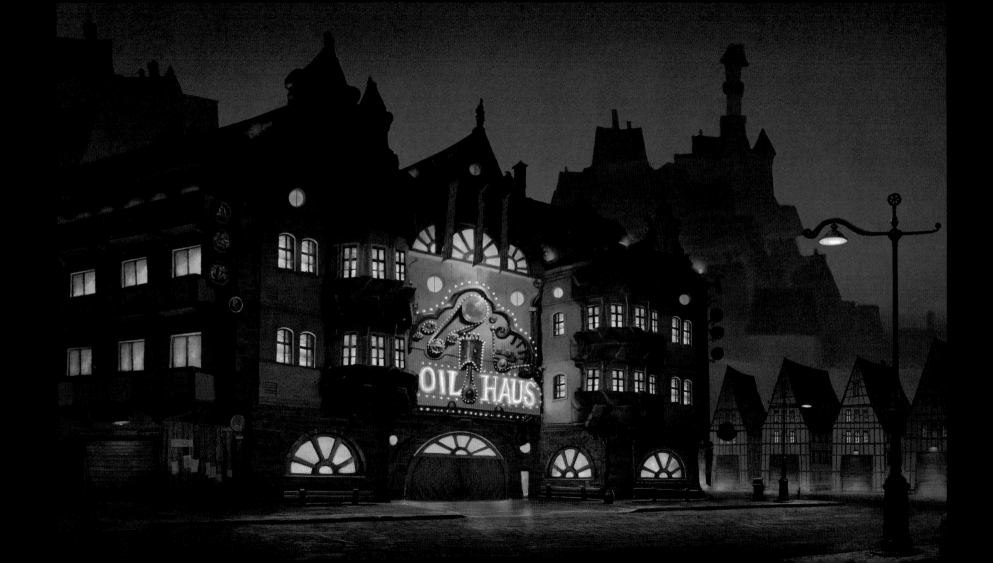

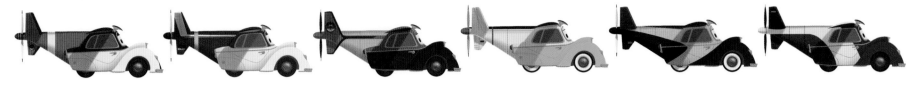

Scott Seeto, Digital

CG render

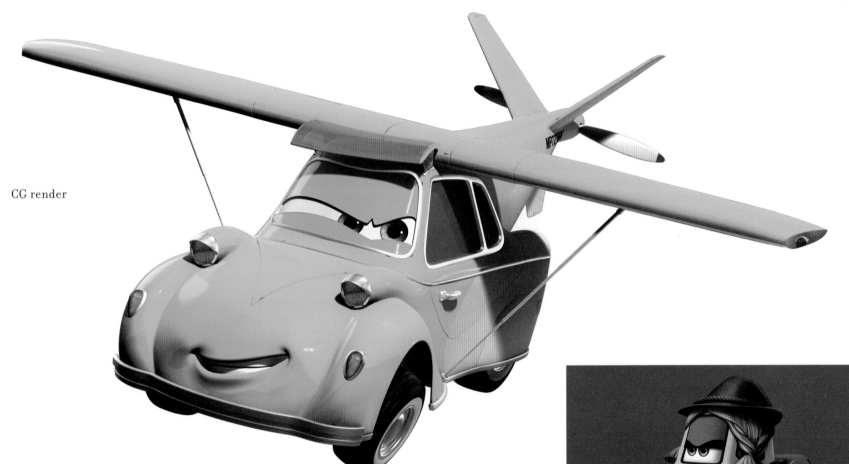

Franz/Fliegenhosen is German but there isn't any real German flying car like this—they're all made in the United States. I styled the car along the lines of a Messerschmitt, which actually made cars plus some pretty famous World War II fighters.

—Ryan Carlson, art director

Scott Fassett, Digital

Dubai and Middle East Flybys

The rally continues over the Middle East, featuring a caricature of the Dubai skyline. "The iconic Burj Hotel gives the audience an immediate read on the location, but we've definitely plane-ified the overall look for this flyby," says set designer Ed Li. The mountains are roughly based on those in Afghanistan, "but taller and featuring more craggy rock structures to create an obstacle course for the racers," explains *Planes* art director Ryan Carlson.

- OBSERVATION
- DECK SCHEMATIC.

Ed Li, Graphite and digital

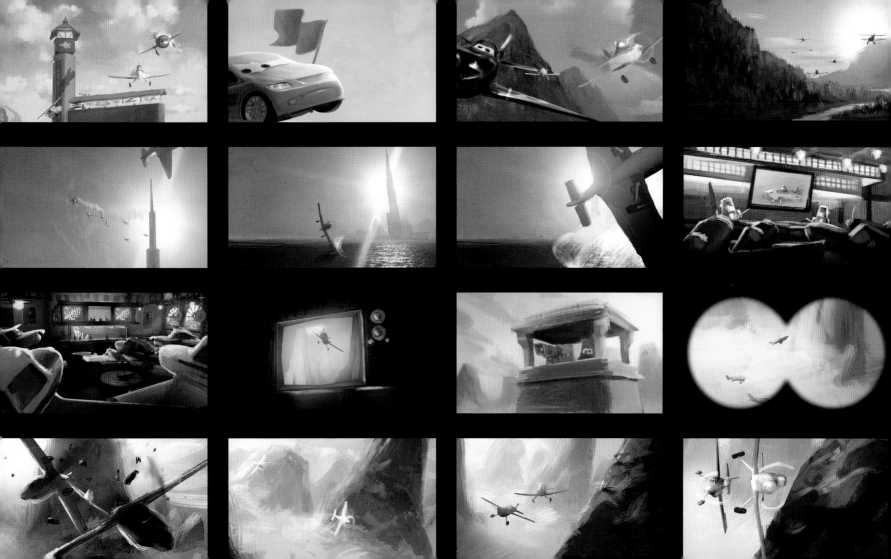

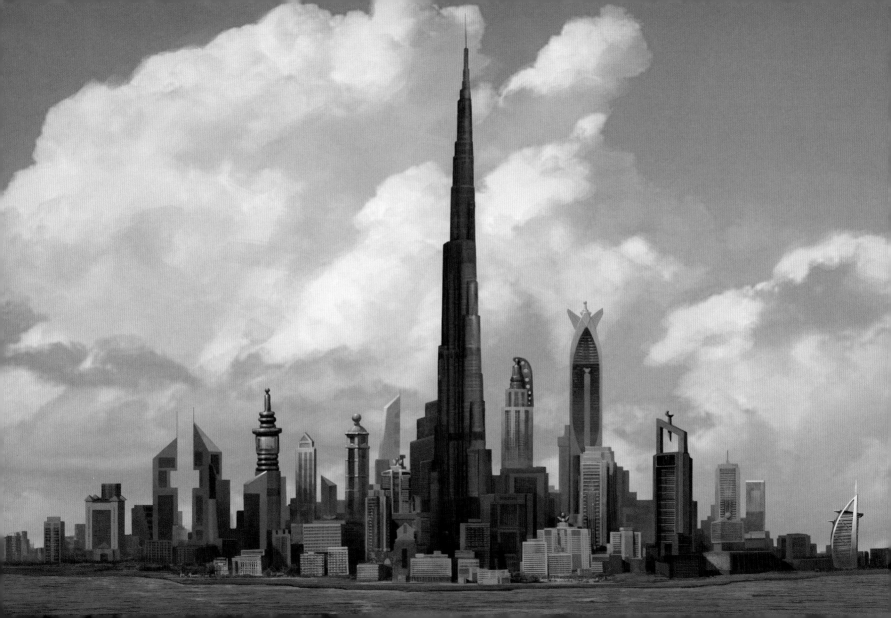

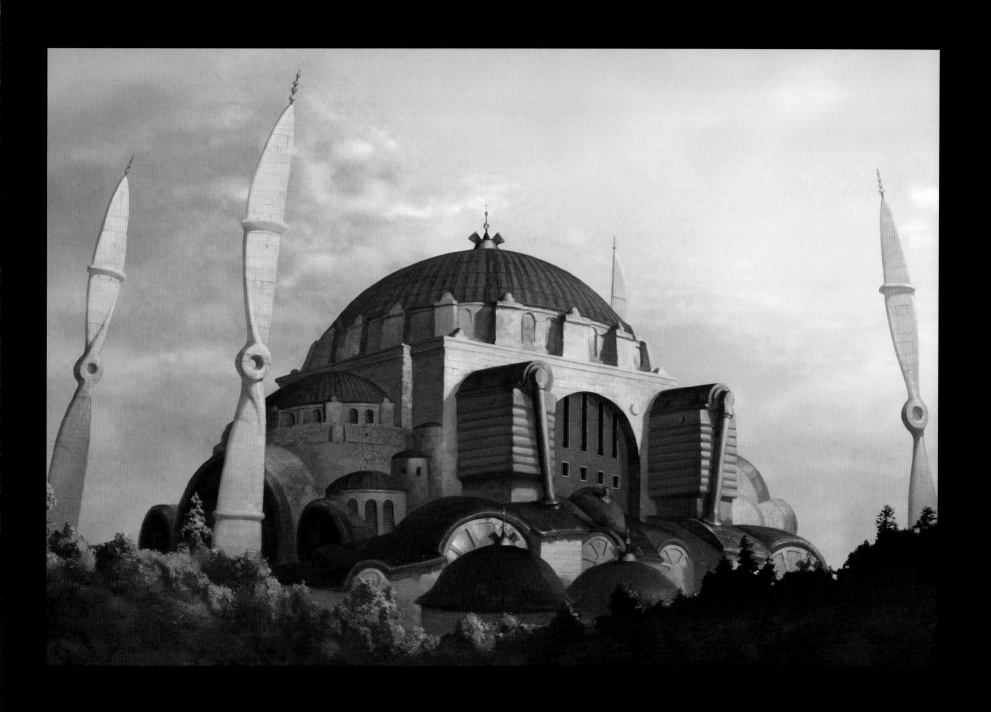

Ed Li. Graphite: Lin Hua Zheng. Digital

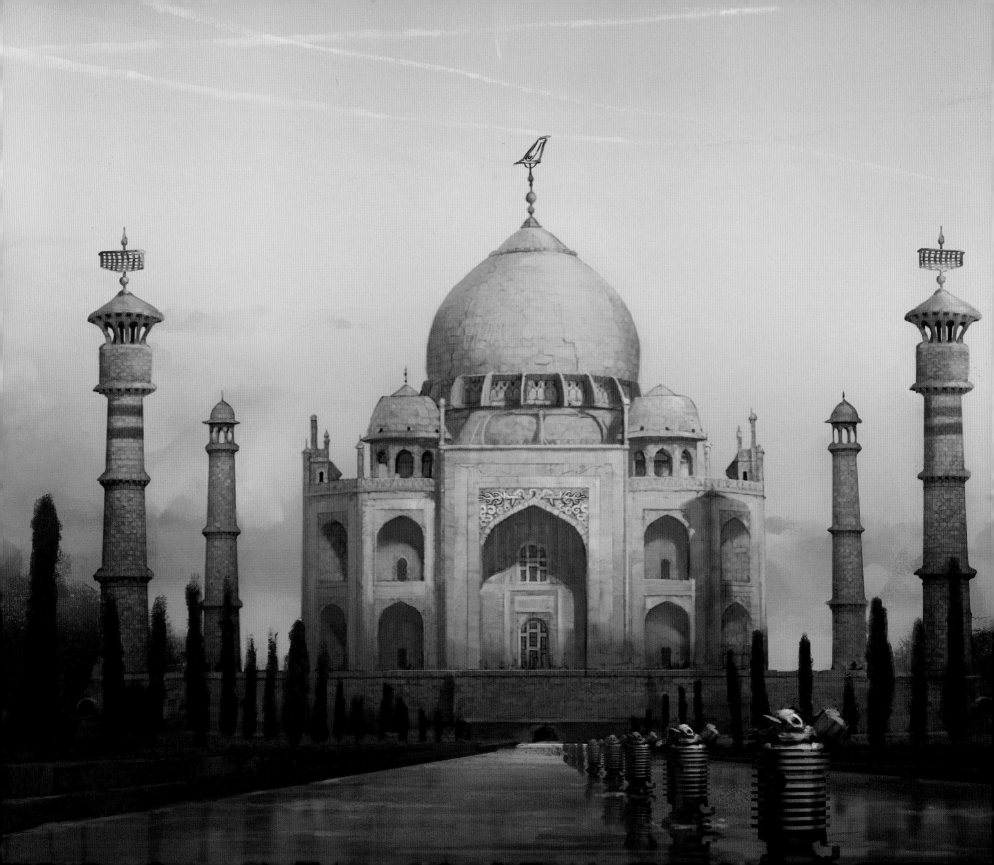

India

When the Wings Around The Globe Rally lands in India, the beauty and majesty of that location feels like an oasis of a rest stop for the racers. "The original concept for this sequence was much shorter, but then our director, Klay Hall, had an idea to make it an homage to *Out of Africa*, and that really inspired our crew to create a beautiful countryside for us to explore," recalls *Planes* producer Traci Balthazor-Flynn. "We needed to make this like a date sequence, almost like how Lady and the Tramp stroll through the park in that classic Disney film, but we had to figure out how exactly to do that with planes," explains Hall. The answer came in the form of magic hour lighting over sweeping vistas, including a flyby of the Taj Mahal. "We really enjoyed the challenge of taking that deeply symbolic building and bringing it into the *Planes* world," says set designer Jim Schlenker. The domes echo the lines of a cowling, the four towers have a lug nut shaping to them with control tower tops, the reflecting pools house fountains shaped like rotary engine cylinders, and the grounds are filled with shrubbery groomed into propeller shapes.

While in her homeland, Ishani plays to her feminine wiles, romanticizing her time with Dusty while giving him some "helpful" advice, or so he believes. To enhance her attractiveness, character designer Scott Seeto designed a beautiful henna tattoo wrap for her body, enhancing the sleek line work that *Planes* art director Ryan Carlson crafted into her silhouette. Her weather stripping and lashes are played up to give her eyes a smoky Indian look, perfect for her femme fatale persona.

Ryan Carlson, Digital

Ryan Carlson and Sai Ping Lok, Digital

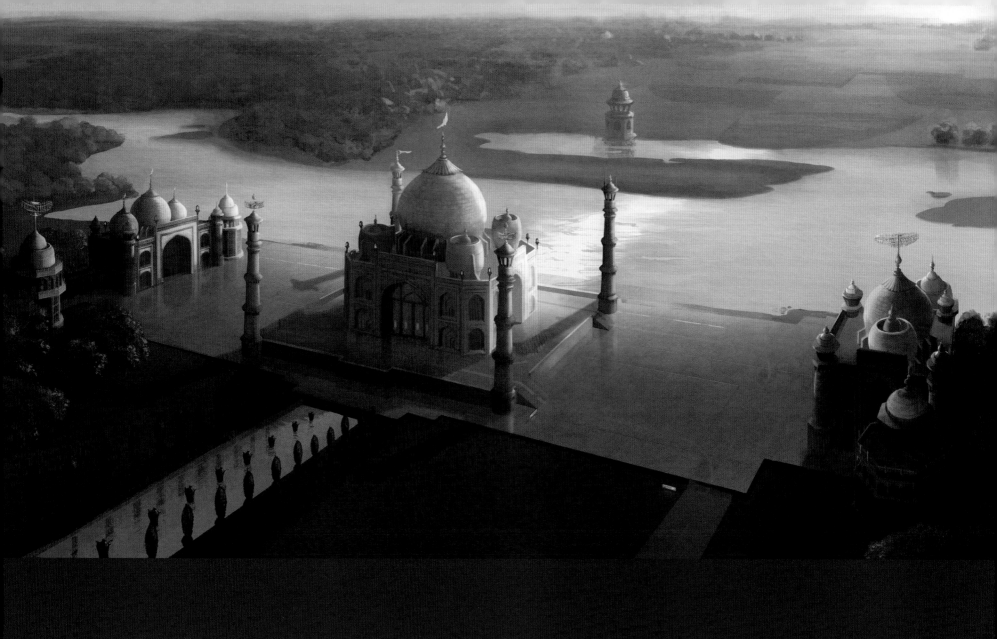

Jim Schlenker, Graphite; Akiko Crawford, Digital

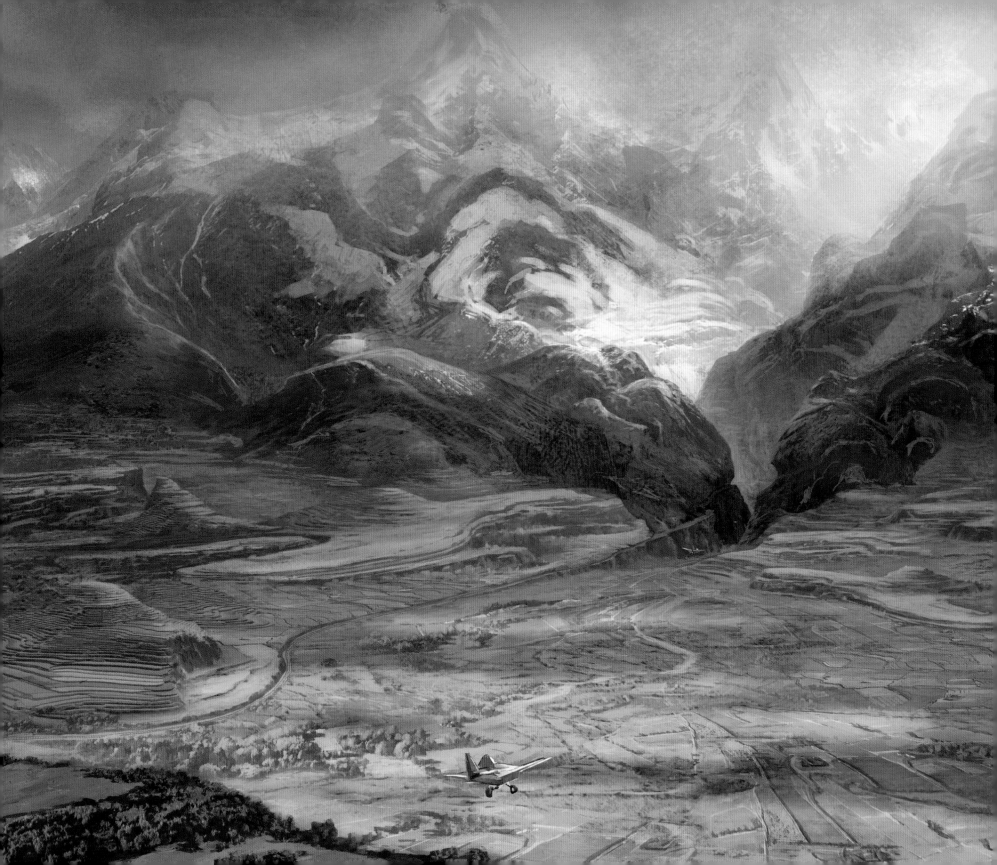

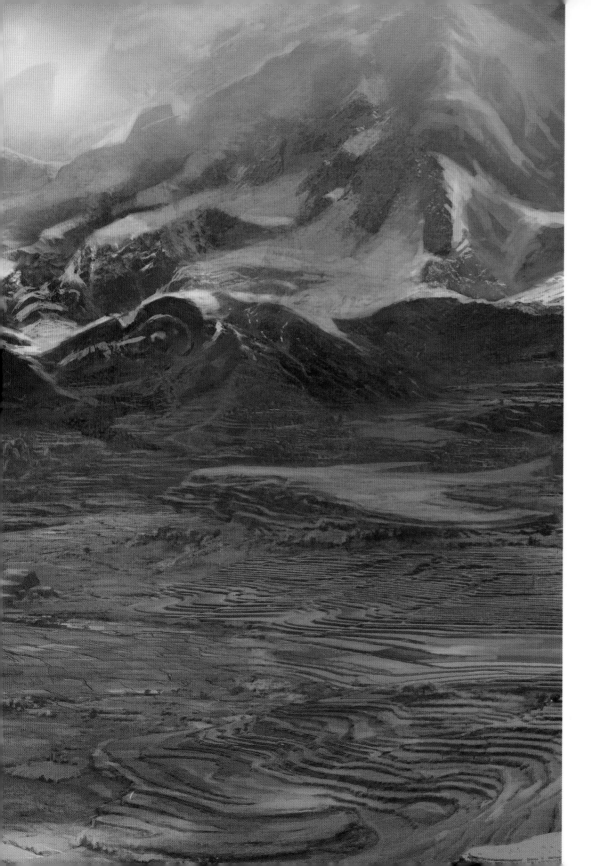

Himalayas and Nepal

As Dusty flies through the plane-ified Himalayas, he takes to heart the advice Ishani gave him about navigating via the "Iron Compass." That term hearkens back to earlier aviation days, "before GPS and radio beacons and all that, when planes would fly from city to city visually following the railroad tracks. Our research led us to the old gag that ends with the line 'I followed the Iron Compass, but nobody told me about the tunnel,'" notes writer Jeff Howard. And thus Ishani's betrayal of Dusty found its appropriate conclusion as well.

"Coming into Nepal, we wanted to create a sort of Shangri La moment, a fun mislead for the audience," says *Planes* director Klay Hall. Coming out of a flash of white and the absence of sound into harp music, soft focus, and glorious lighting that reveals a breathtaking Tibetan monastery–inspired airport really lands the surreal experience. "I especially love the symbolism of having a spark plug shape on top of the monastery structure, as if it represents the 'spark of life,'" notes *Planes* art director Ryan Carlson.

Ed Li, Graphite; Barry Atkinson, Digital

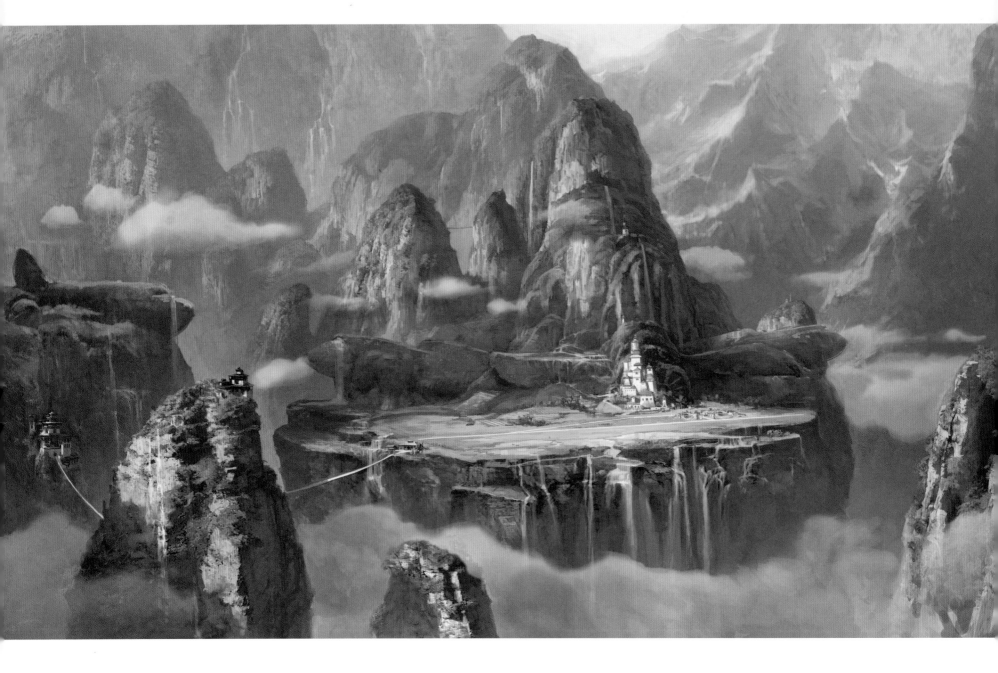

The airplane shapes that appear in the mountains are P-40s, better known as the Flying Tigers, which flew in Burma and China during World War II.

—*Ryan Carlson*, art director

Ed Li, Graphite; Lin Hua Zheng, Digital

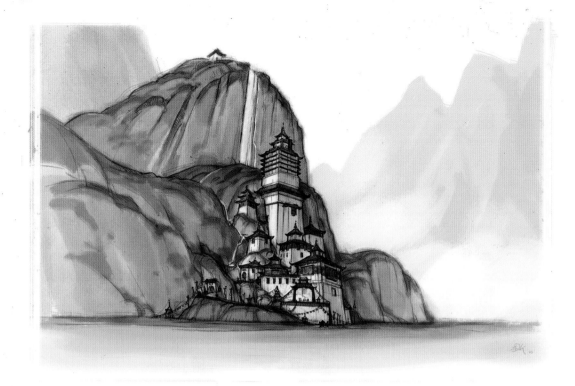

Ed Li, Graphite and digital

We drew our inspiration from Nepalese design, so there are prayer flags, and the hangars are like yurts. In the main structure, based on a temple that blends beautifully into the Asian mountain landscape, we plane-ified the architectural details with motifs that feature airplane fins and jet turbines.

—*Ed Li*, set designer

Scott Seeto, Graphite

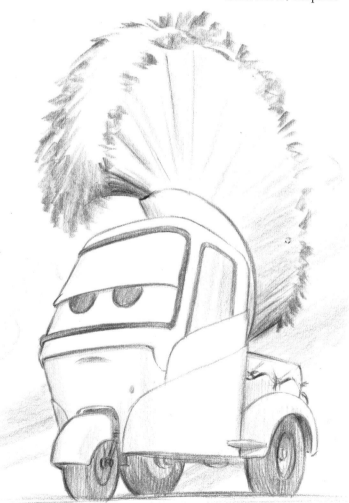

Ed Li, Graphite; Lin Hua Zheng, Digital

China

The natural landscape of karst topography along the Yangtze River lends itself to easy translation into the *Planes* shape language. The caricature of the Great Wall incorporates rotary engine motifs, the rice paddies feature propeller patterns, and the airport structures exhibit wooden rafters that mimic airplane wing ribs and paper screens that resemble airplane windows. "We really wanted to make it feel like Chinese architecture first, and plane-ified locations second," notes *Planes* art director Ryan Carlson.

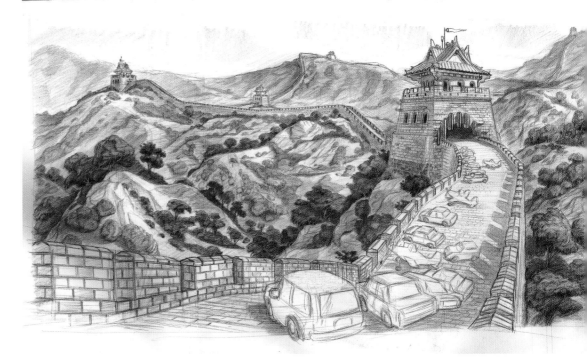

Jim Schlenker, Graphite

Jim Schlenker, Graphite;
Lin Hua Zheng, Digital

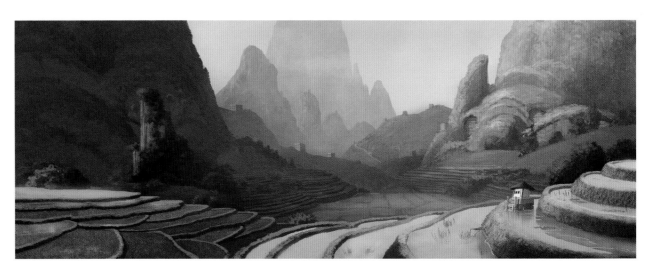

Ed Li, Graphite;
Akiko Crawford, Digital

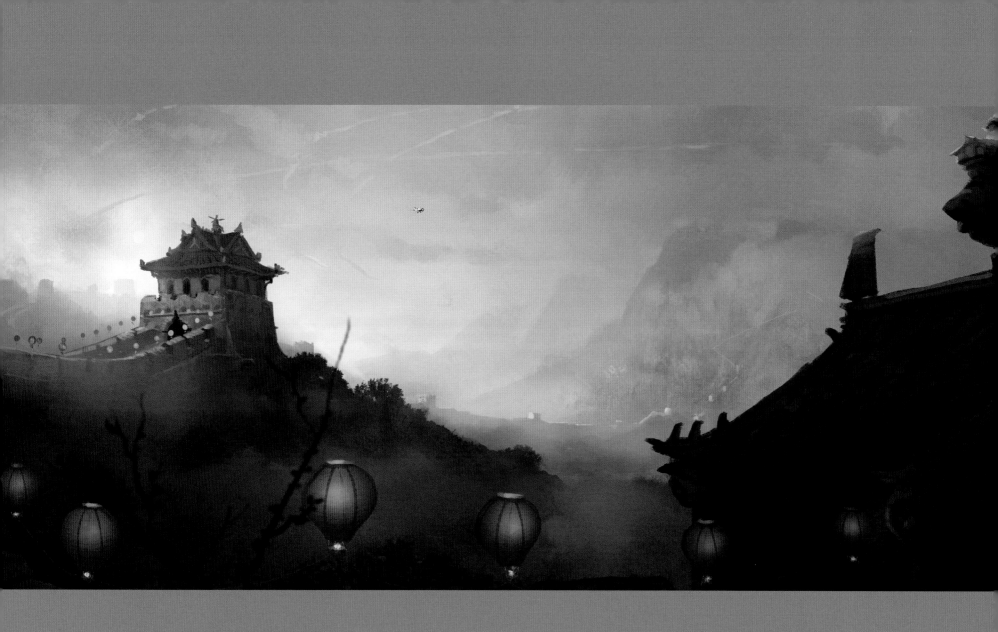

Ryan Carlson, Digital

It is in China where El Chu's character truly finds its chance to shine. The big personality of the Latin superstar fits perfectly in the Gee-Bee model, "known for being an all-engine, barrel-chested, really dangerous airplane to fly," explains *Planes* director Klay Hall. The traditional paint scheme of the 1920s–1930s Gee-Bees was red and white, and adding the green and yellow gave El Chu his Mexican flair. The ultimate flash for El Chu's look comes from the Luchador craze, of which Hall is a big fan. "I wanted to put a cap, a mask, and a little cape on him. And then John Lasseter suggested that we do little stripes on his wheels to make them look like wrestling boots. Every once in a while El Chu even tilts a little to show he's wearing gym socks," adds Hall.

Rochelle plays nicely against El Chu's character, "representing the cold and frozen Northwest versus the warm and southern Mexico," says Hall. She's a v-tailed twin-engine, with "an airbrushed look of white blending into a sort of blushy pink, green eyes, thick eyelashes, and eyeliner to really embrace her femininity." While her role in the story remains the same, Rochelle has the unique honor of changing paint jobs and names in international versions of the movie to localize her in each specific film market. "John Lasseter was really passionate about doing that, on a much larger scale than they did with a secondary racer in *Cars*," recalls *Planes* producer Traci Balthazor-Flynn. To complement her shifting persona, "we created new designs for her, specialized to reflect the different regions or national colors, for no less than eight individual looks," adds character designer Scott Seeto.

When El Chu pulls out all the stops to woo Rochelle, he digs deeply into his Latin culture and whips out a mariachi performance, which happens to come from one of director Klay Hall's other interests. The musical interlude also gives Dusty an opportunity to give his highly energetic friend some advice, telling him that perhaps low and slow is sometimes the better way to go.

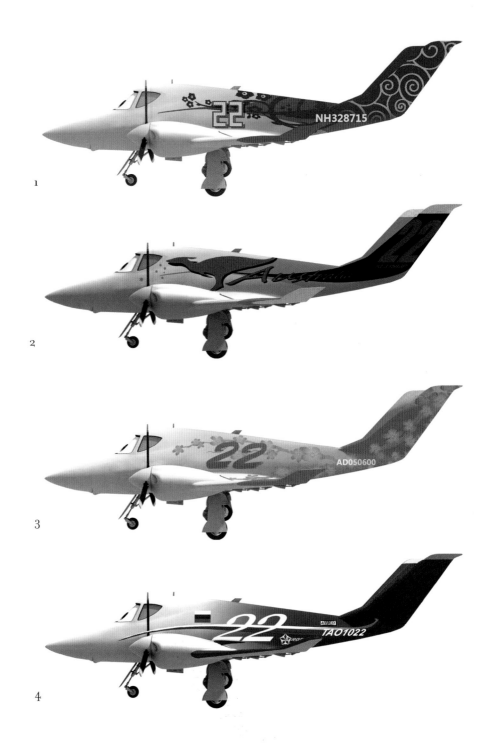

1

2

3

4

1, 2 & 3. Scott Seeto, Digital 4. Ryan Carlson, Digital

Pacific Ocean

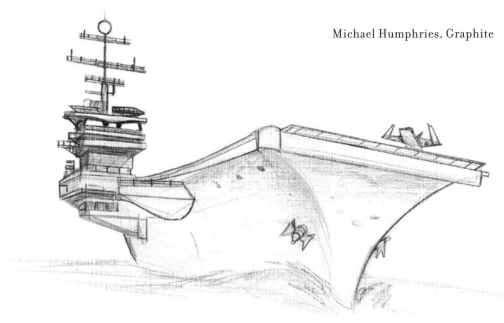

Michael Humphries, Graphite

In the sixth and longest leg of the rally, the planes must endure a flight over the Pacific Ocean, which also proved to be quite a test of endurance for the artists who created that impressive body of water. "Lightning, wind, rain, waves that are about forty feet high, and our main character nearly drowning add up to the biggest special effects sequence in *Planes*," recalls computer graphics supervisor Doug Little. Harnessing the brainpower of the team at Pixar that conceptualized the ocean in *Cars 2*, as well as that of visual effects supervisor Dale Mayeda, Little helped set the scene for where Dusty meets the current-day Jolly Wrenches aboard the U.S.S. *Dwight D. Flysenhower*. "The jet fighters were a team effort between Ryan Carlson and me, and we ended up taking an F-18 and an F-14 and sort of smashing them together into an original model of Navy aircraft," recalls character designer Scott Seeto.

The aircraft carrier was another interesting challenge to build, considering it's a character that also serves as a set. In terms of making it a character, "the biggest questions were where to put the mouth so that it could appear in frame with other characters on deck, and how to design the island, which is where the eyes and admiral's caplike structure are located," Seeto continues. The carrier also houses a whole crew of pitties and tugs needed to keep the naval operation shipshape.

Ryan Carlson, Graphite and digital

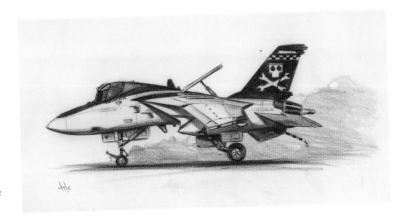

Scott Seeto, Graphite

Paul Baribault, Photo

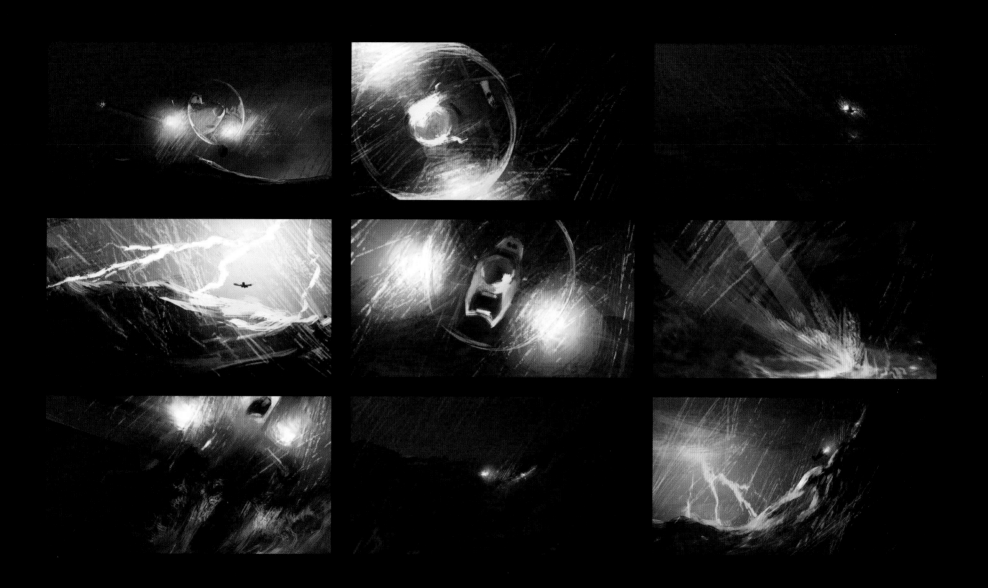

Ryan Carlson, Digital

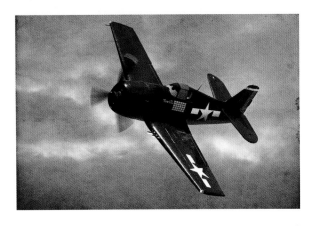

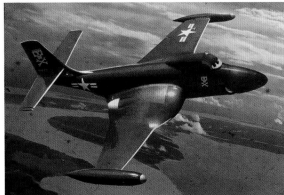

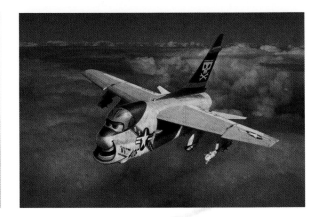

1

2

3

The excitement I had when I was actually walking the deck of the U.S.S. *Carl Vinson*—some one hundred fifty miles out at sea, something I never thought I'd do in my life—is what I tried to get into the expression and the acting of Dusty experiencing such a unique opportunity.

—*Klay Hall*, director

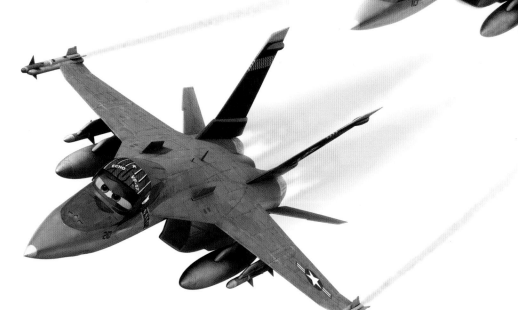

CG render

1 & 3. Scott Fassett, Digital

2. Christy Maltese, Digital

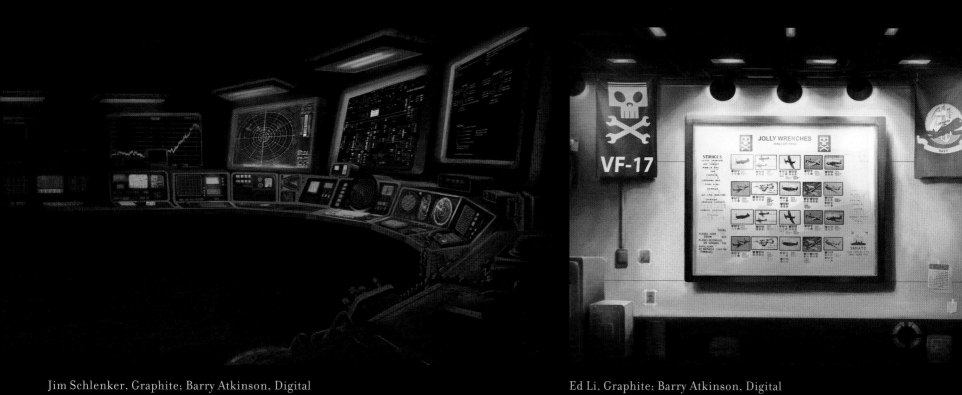

Jim Schlenker, Graphite; Barry Atkinson, Digital

Ed Li, Graphite; Barry Atkinson, Digital

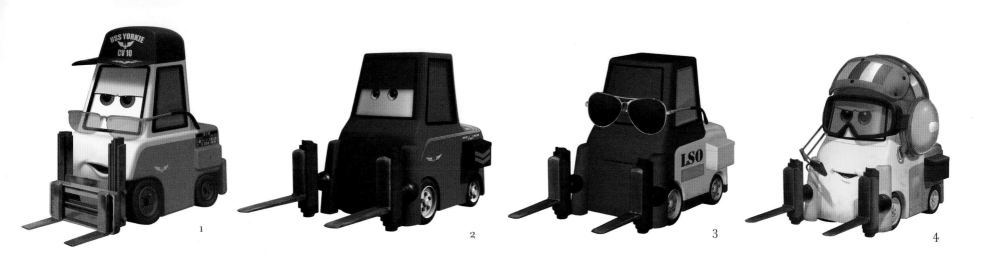

1 & 4. Scott Seeto, Digital 2. Scott Fassett, Digital 3. Chris Oatley, Digital

Mexico

After great mental and physical trauma, Dusty eventually finds himself in Mexico, the last stop before the finish of the race. Crushed by the discovery of the truth about Skipper's history and broken by the storm at sea, Dusty feels hopeless until he has a *Rudy* moment: El Chu brings him a set of T-33 wings, telling him about how the American T-33s came and helped the Mexican air force when they needed it. Then more of Dusty's fellow racers follow that lead by donating various other parts to rebuild Dusty so he can finish the race. On top of this rally of support, Dusty's hope is further renewed when Dottie comes around to believing he can actually succeed in his lofty dream. In terms of art direction, "it's a moment where we go from very somber and dark in the hangar, and then Dusty is illuminated by a shaft of light as Dottie enters to tell him, 'You're not a crop duster, you're a racer, and the whole world knows it,'" explains art director Ryan Carlson, who slowly brought back the color and light into the sequence to reflect Dusty's rejuvenating spirit.

Ed Li, Graphite

Ed Li, Graphite; Lin Hua Zheng, Digital

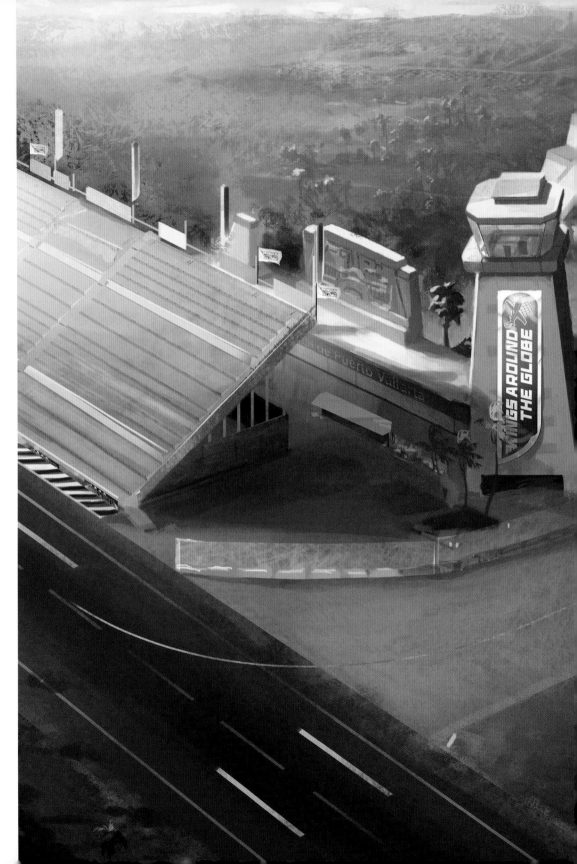

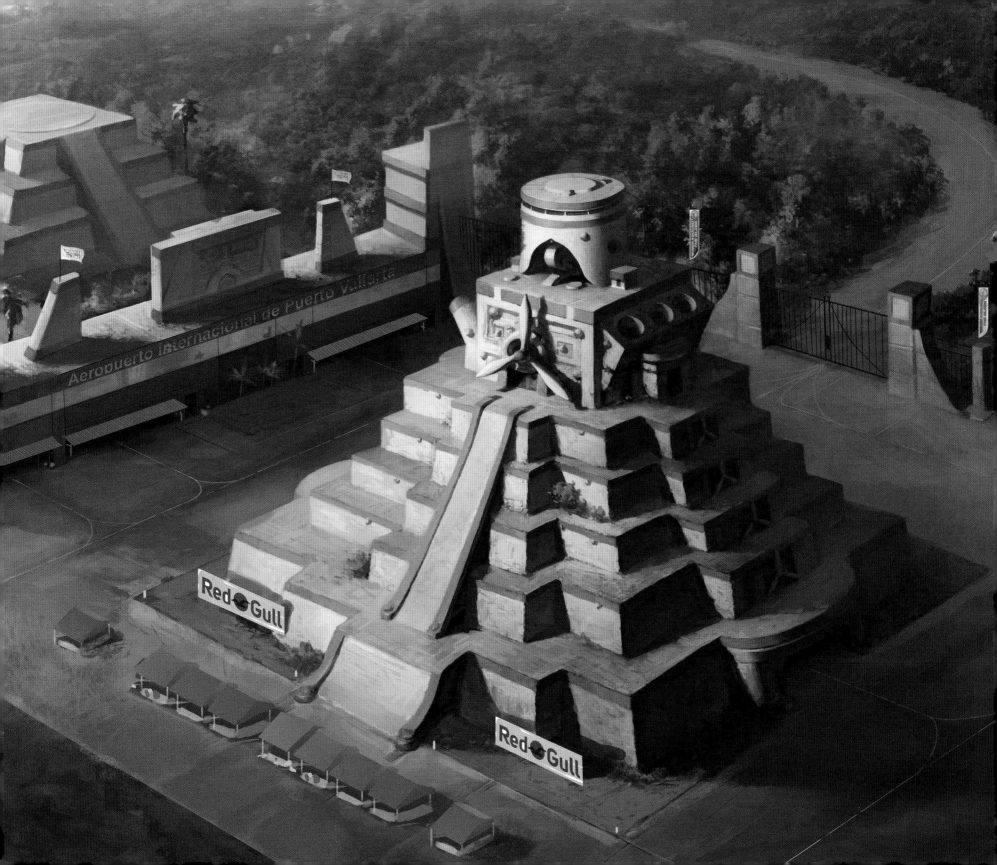

Ryan Carlson, Digital

Ed Li, Graphite and digital

Ryan Carlson, Digital

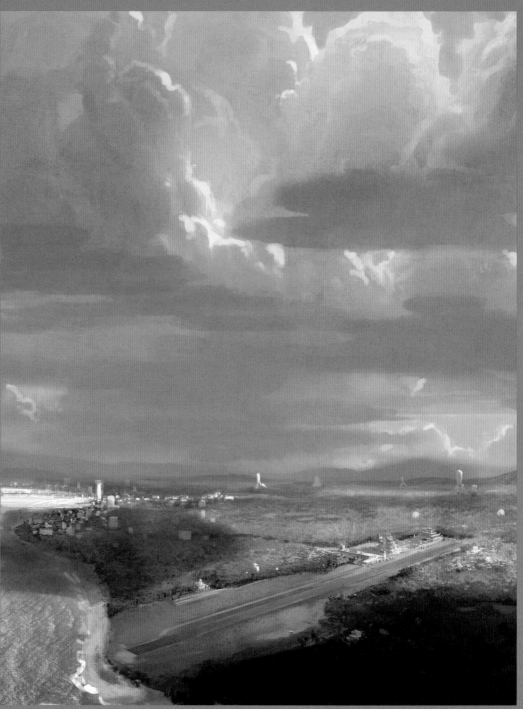

Ryan Carlson, Digital

The Mexican hangar is inspired by the Mayan pyramids. Along the top is decorative detail with airplane shapes that are actually very similar to designs we saw in early Mayan jewelry, which some conspiracy theorists think was inspired by spaceships. And that fits into our aviation shape language as well.

—*Ryan Carlson*, art director

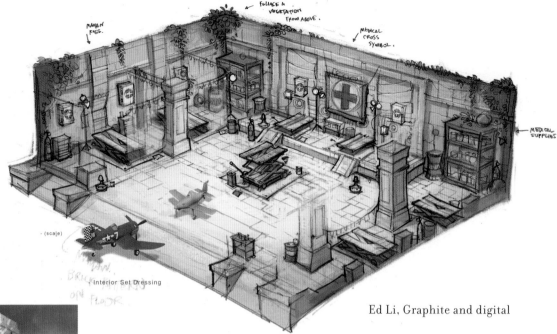

Ed Li, Graphite and digital

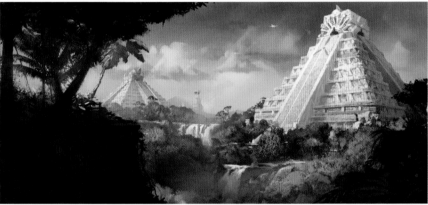

Ryan Carlson, Digital

Ed Li, Graphite and digital

Ed Li, Graphite

A really cool influence of the humility of Dusty is that the race is very competitive, with everyone out for himself, but by the end everyone there is helping him and cheering him on, and only rooting for the best for Dusty.

—*Klay Hall*, director

Southwestern United States

Dusty comes out strong for the last leg of the race, confronting Ripslinger before he takes flight. "We designed this shot to be highly dramatic, with backlighting, crisp silhouettes, and such sharp focus that you can see the heat coming out of their engines, like two boxers going toe-to-toe," explains *Planes* art director Ryan Carlson. Dusty even warns Ripslinger with a "check six"—a naval term for "watch your back"—that suggests that Dusty has taken Skipper's teachings to heart, even if his heart has been broken by finding out the truth behind Skipper's story.

A classic dogfight sequence takes place over Dead Stick Desert, a location that covers more than one hundred square kilometers and features a multitude of pinnacles and canyons to make for an exciting obstacle course. The complexity of the aerial combat actually informed the building of the set, courtesy of the expertise of the pre-visualization team. Play with light and shadow enhances the drama with great contrast, and there are also subtle shapes in the rock that suggest crashed airplanes—"not too graphic to be macabre, but enough to suggest that this is a dangerous environment," adds Carlson.

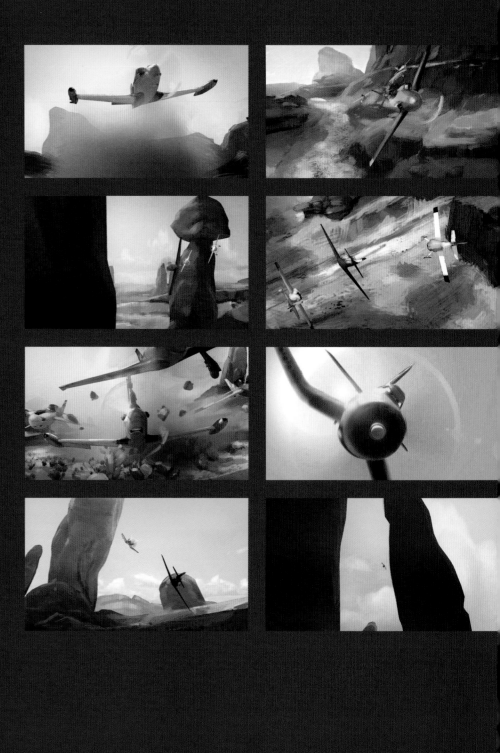

Ryan Carlson, Digita

86

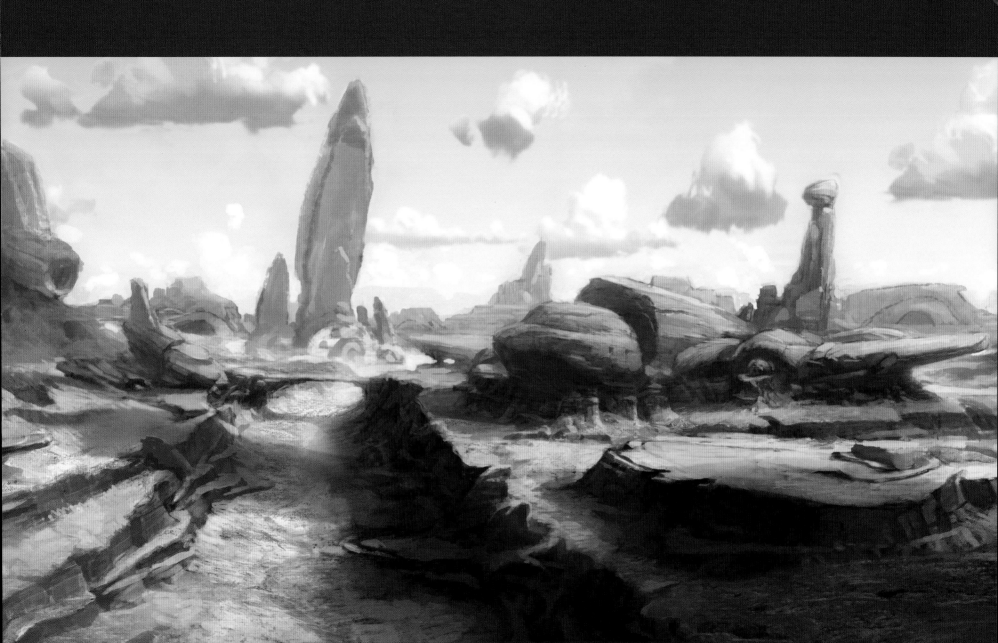

The Finish in New York

In the final stages of the race, the bright green hills of Appalachia and the Pennsylvania countryside reinforce the vibrant life and spirit in Dusty as he faces his fear of heights and takes to the "cloud streets" for the win. The clouds part and the sky is bluer than ever before as Dusty's dream comes true.

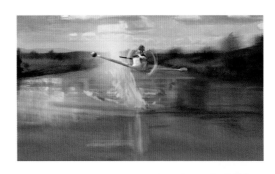 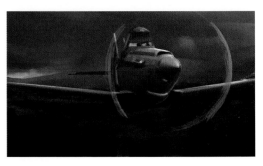

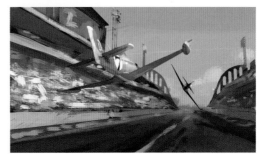 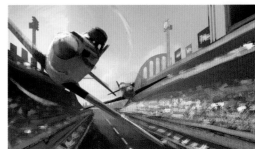

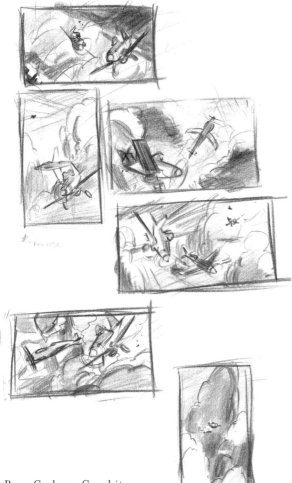

Ryan Carlson, Graphite

Ryan Carlson and Sai Ping Lok, Digital

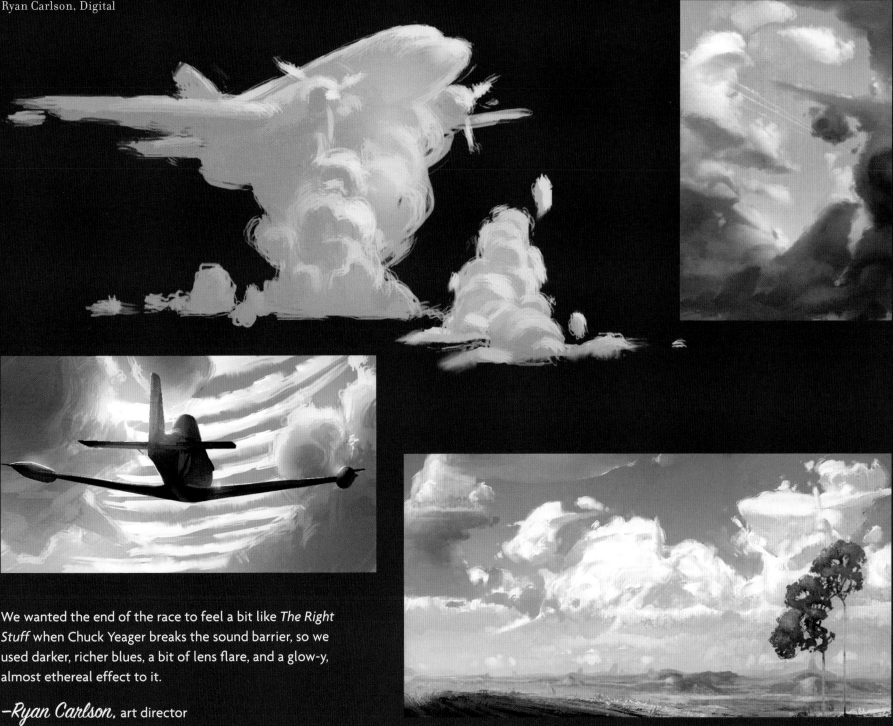

Ryan Carlson, Digital

We wanted the end of the race to feel a bit like *The Right Stuff* when Chuck Yeager breaks the sound barrier, so we used darker, richer blues, a bit of lens flare, and a glow-y, almost ethereal effect to it.

—*Ryan Carlson*, art director

03

RACING TO THE NEXT ADVENTURE

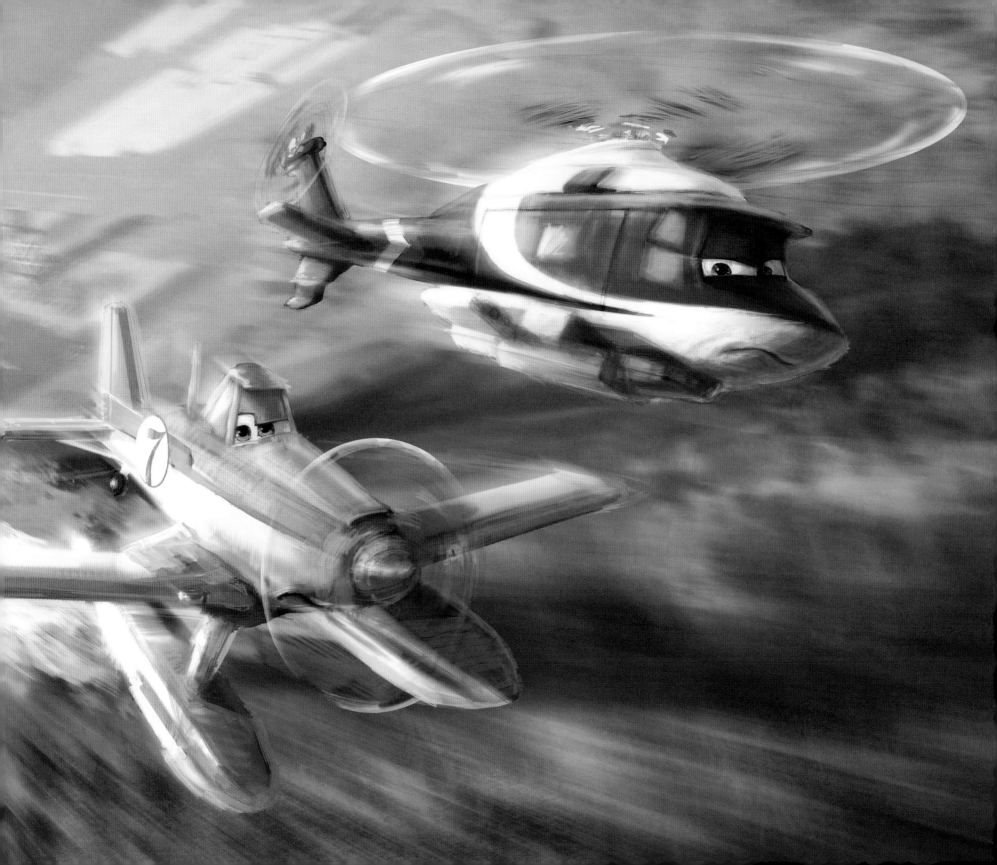

After winning the Wings Around The Globe Rally, Dusty continues to find success in the world of racing. "We celebrate that he is living his dream with a montage of continuing victories," says *Planes: Fire & Rescue* director Bobs Gannaway. From the high deserts of Reno, to the green hillsides under the Jet Sky race on the European circuit, to the Red Bulldozer races off the shores of Manhattan, Dusty is flying high on the wings of happiness.

Dusty's hometown of Propwash Junction is also reveling in his success. The whole town is gearing up for its biggest Corn Festival ever, an annual celebration of their eco-friendly fuel source. The event is now national news due to Dusty's celebrity presence, and preparations are underway as Dusty continues his race training in the skies overhead. All is flying along as planned, until Dusty encounters some technical difficulty.

"In the earlier drafts of *Planes 2*, we were focusing a lot on Dusty as a famous racer and his struggle between his public persona and his home life. It was really a family or fame kind of thing, but didn't seem very emotionally resonant for people. So then Bobs came up with the emotional hook of 'What if Dusty finds out he's never going to race again?' That idea immediately sparked for all of us," recalls writer Jeff Howard.

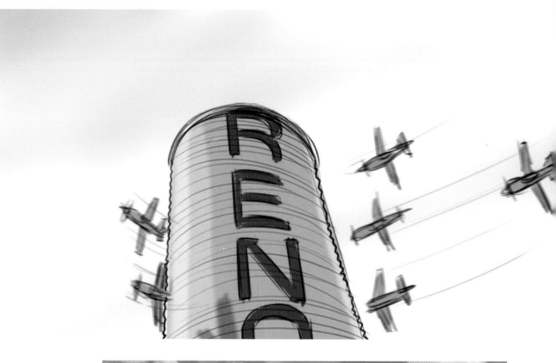

Volkswingon

Top: Piero Piluso, Digital

Bottom: Toby Wilson, Graphite; Akiko Crawford, Digital

Pages 92–93: Toby Wilson, Digital

Left: Marty Baumann, Digital

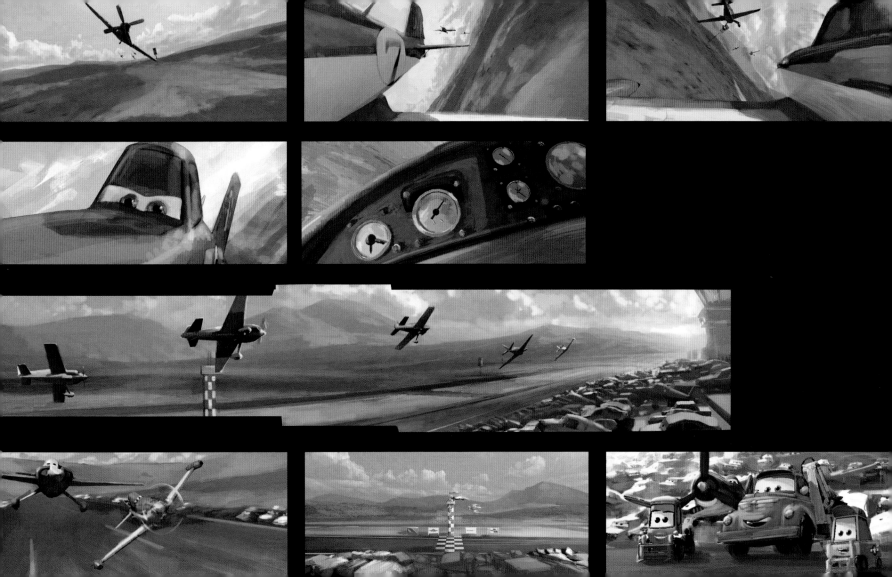

PROPWASH JUNCTION CORN FEST

50TH ANNUAL COMMUNITY CELEBRATION!

I ♥

Marty Baumann, Digital

CORNFEST SPECIAL OFFER

Kernel Co. CORN OIL

BUY 2 GET 1 FREE!

SOLD BY
FILL 'N FLY, INC.
and other leading dealers everywhere

Kernel Co.
Aviation Fuels
MULTIVISCOSITY
CORN OIL
20W-50

Marty Baumann, Digital

Corn Cob on a Stick

Ed Li, Digital

When we were breaking the story, we wondered what could be big stakes for a small town? Well, since Propwash Junction grows corn to make ethanol, it would be natural for them to have an annual Corn Festival—a big corn-themed event where all the local businesses make their money. And with Dusty performing at this year's festival, it's gonna be even bigger, so they've pulled out all the stops. Don't miss the deep-fried corn cob on a stick!

—BOBS GANNAWAY, director

Marty Baumann, Digital

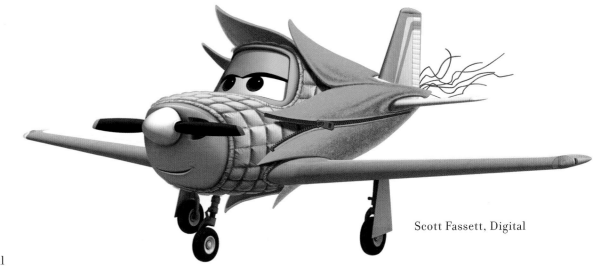

Scott Fassett, Digital

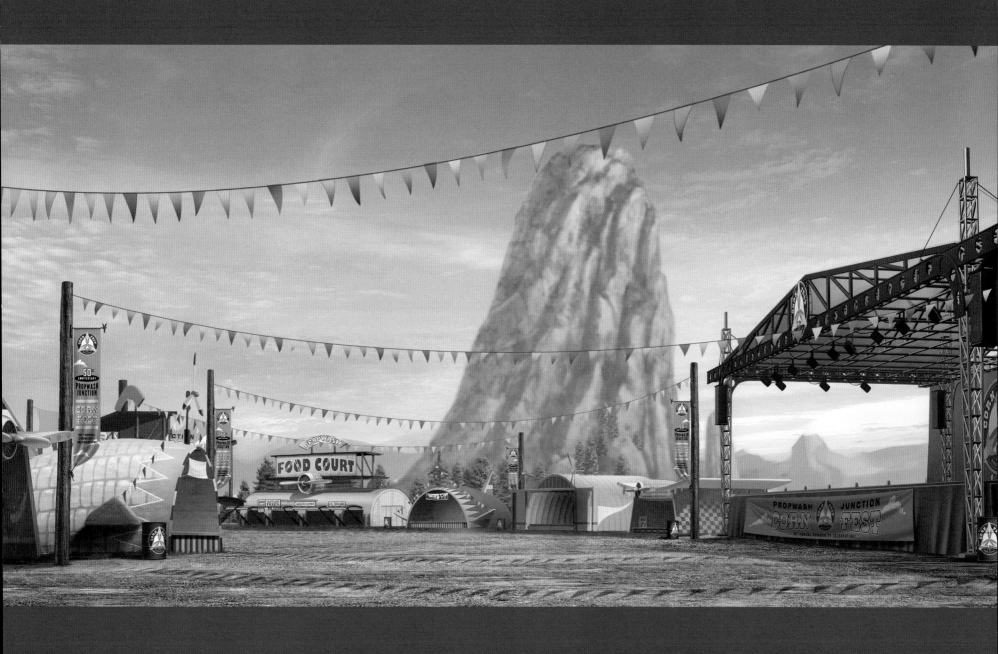

Ed Li and Scott Fassett, Digital

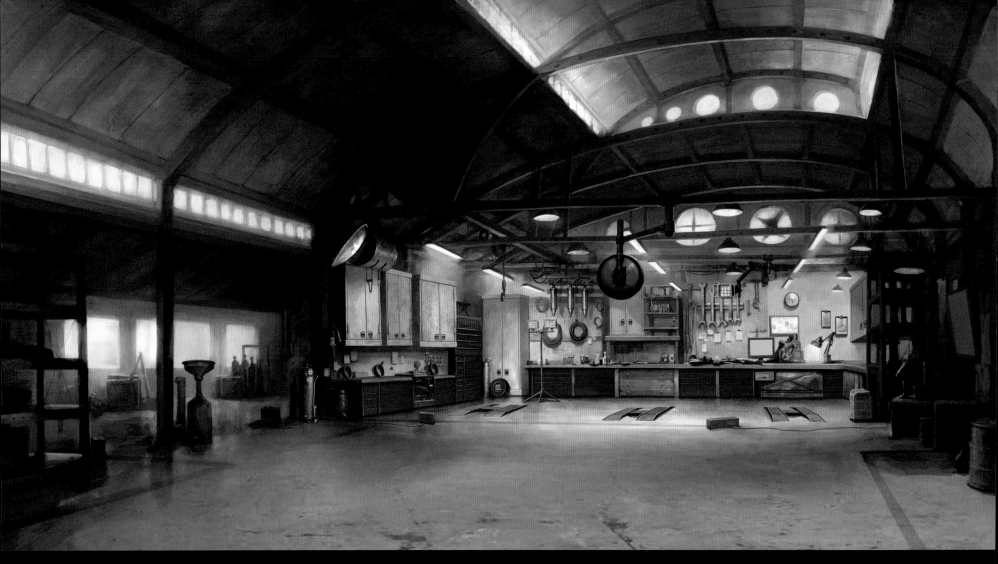

Ed Li, Graphite; Lin Hua Zheng, Digital

DOTTIE'S GARAGE

Inside of Dottie's garage at the Fill 'n' Fly, Dusty is told his gearbox is damaged and there is very little chance of finding a replacement. "In the 'World of *Cars*,' if you're a mechanic, then you're a doctor, so we tried to make this set feel like a doctor's office. We wanted it to have a clinical feeling, so we included reflector mirrors and lights on medical arms that appear in operating rooms, but we also wanted to give it a bit of small town warmth," explains *Planes: Fire & Rescue* art director Toby Wilson.

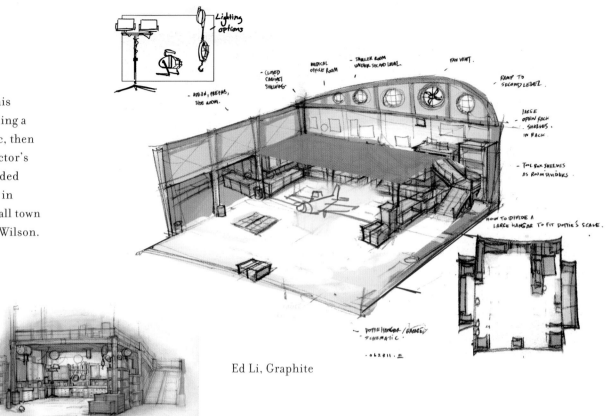

Ed Li, Graphite

Ryan Carlson, Digital

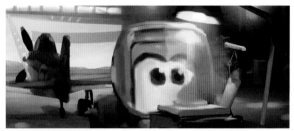

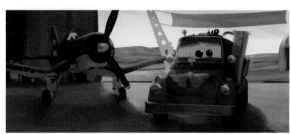
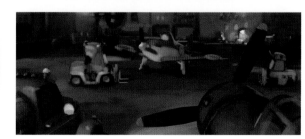

Lin Hua Zheng and
Toby Wilson, Digital

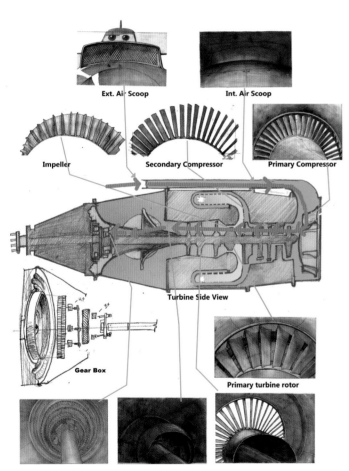

Ext. Air Scoop

Int. Air Scoop

Impeller

Secondary Compressor

Primary Compressor

Turbine Side View

Gear Box

Primary turbine rotor

Ron Roesch, Graphite

We spoke with an oil analyst who explained how certain tests of the engine and transmission oil could determine which specific part of an airplane's engine and/or gearbox was failing. It was surprising how similar these tests were to blood tests. We also spoke to a mechanic who explained that while an aircraft engine could be repaired, the reduction gearbox is so complex, having so many moving parts, that it might be impossible to repair. It would need to be replaced, and if there was no replacement gearbox available, your options ended there.

—BOBS GANNAWAY, director

Jim Schlenker, Graphite

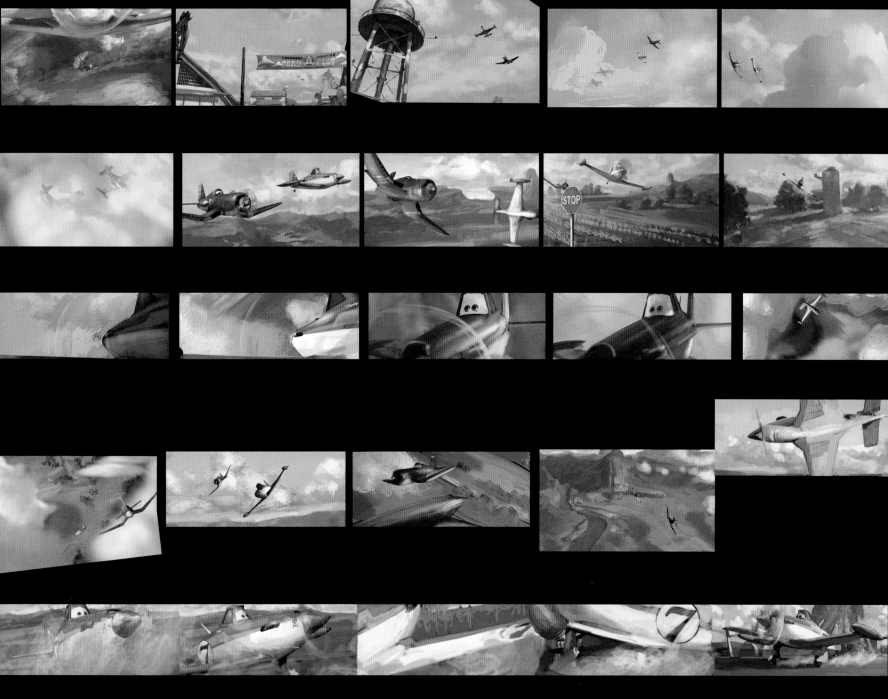

Lin Hua Zheng and Toby Wilson, Digital

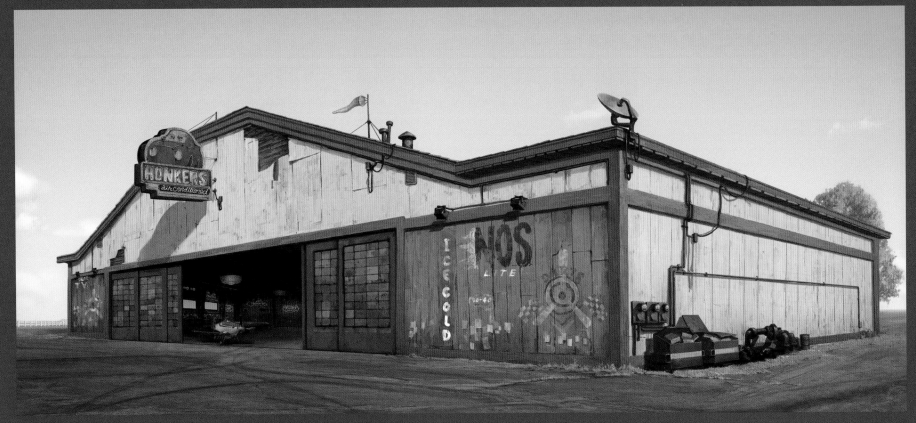

Jim Schlenker, Graphite; Lin Hua Zheng, Digital

 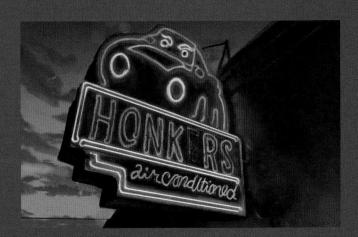

Left: Jim Schlenker and Akiko Crawford, Digital Center: Ron Roesch, Graphite, CG render Right: Toby Wilson, Digital

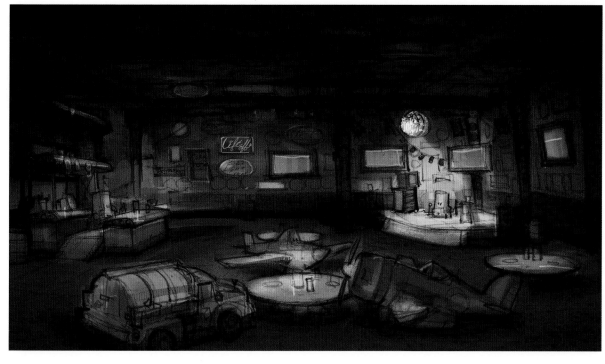

CORN FEST
50TH ANNIVERSARY

Specialty Drink!

Have a refreshing brake! Try our

CARTINI

Only during
CORN FEST

A refreshing blend of Corn Fest oil and tropical spices!

HONKERS

HONKERS

With his future in racing compromised due to a mechanical challenge that can't be easily repaired, Dusty's outlook drops to its all-time lowest altitude. He seeks the company of friends at the local oiling hole, Honkers. "It's the local honky-tonk dive bar, serving all the appropriate petroleum refreshment options like Carona, Heinecar, and Airsahi. Décor includes aviation flags and a good dose of neon," says *Planes: Fire & Rescue* art director Toby Wilson. But even those spirits aren't enough to lift Dusty's, so he heads out to prove to himself that he's still got it, no matter what Dottie's diagnosis says.

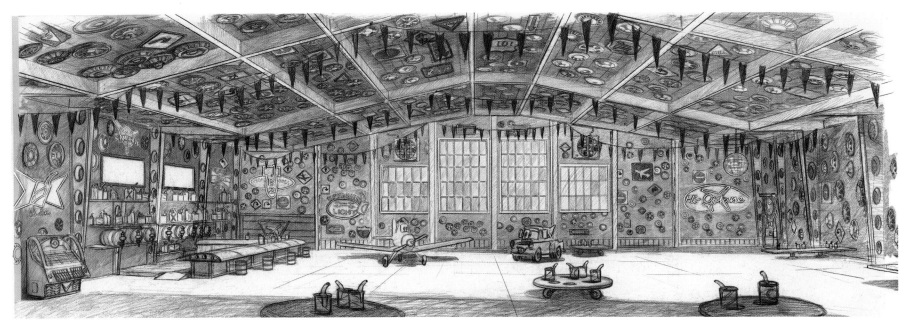

Jim Schlenker, Graphite

Scott Fassett, Digital

Ron Velasco, Graphite

WATER TOWER

Dusty takes to the skies to test his mettle, and it doesn't go well, literally turning into a crash and burn situation. To put out a fire, he helps pull down the town's water tower that had proudly been painted: "Propwash Junction, Home of World Racing Champion Dusty Crophopper." A physical representation of the fact that his career is washed up, Dusty also washes away the town's hopes to thrive with the upcoming Corn Festival.

Ed Li, Digital

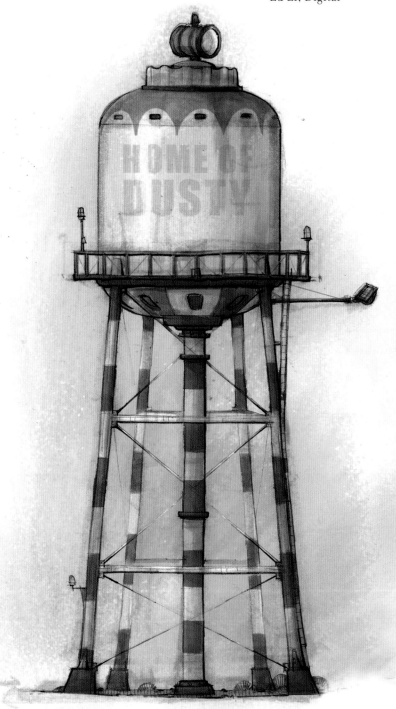

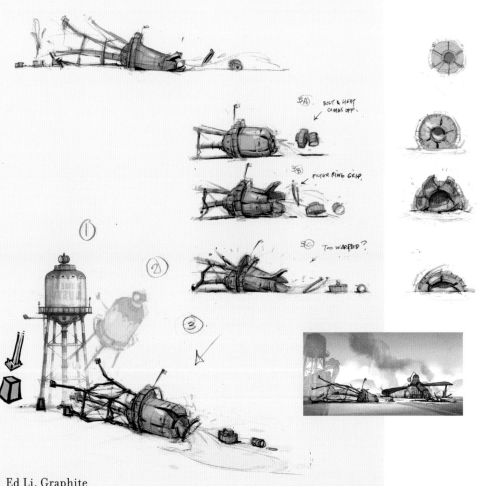

3A) BOLT & LIGHT COMBES OFF.

3B) FILTER RING GRIP.

3C) TOO WARPED?

①

②

③

Ed Li, Graphite

With such a major disaster at an airport, the Transportation Management Safety Team comes to investigate. Enter the most modern aircraft rescue and firefighting vehicle on the road, Ryker. "He's all bells and whistles, brand-new and shiny with lots of LED flashing lights," describes *Planes: Fire & Rescue* art director Toby Wilson. "He's got nozzles where there aren't supposed to be nozzles and strobes cranked to the max." Along with his sidekick pitty, Kurtz, who jots down every single word spoken during the federal interrogation, Ryker declares Propwash Junction closed for business because its firefighting abilities are outdated and understaffed.

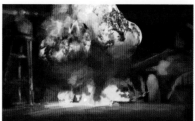 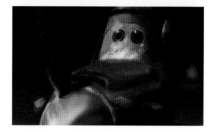

Lin Hua Zheng and Toby Wilson, Digital

Ryker's sidekick pitty is named after our associate producer, Melissa Kurtz, who always has her clipboard and her pen handy and she's always jotting down notes.

—TOBY WILSON, art director

Marty Baumann, Digital

CG render

FIRE STATION

Like the ideal small-town structure in everyone's imagination, the Propwash Junction Fire Station is a double-decker that features a fire pole. "In this case, it's a hydraulic platform that lifts the resident fire truck itself up or down along a center piston shaft, which looks just like a fire pole and serves the same purpose," explains art director Toby Wilson. Other aesthetics of the fire station suggest antiquity: "The facade looks a bit like a Model T, especially the front grille," explains set designer Ed Li. Wainscoting and a decorative ceiling motif further express an old-fashioned appeal.

The "non-compliance of rescue and firefighting regulations" news and the resulting shutdown is devastating to the town, but to no vehicle more so than its trusty old fire chief, Mayday. The exact opposite of what Ryker represents, Mayday is a classic-looking kit-bashed Ford Tender, vintage 1940s. "He's got the bumper lip, much like Doc or Sheriff in *Cars*, which gives him an older feel and a mustached look. The headlights on his fenders look a bit like spectacles, and at the end of the film he has a prescription windshield," explains Wilson. Up until Propwash Junction's recent population growth, Mayday had been able to handle the few emergency situations in town, but now that he's a little slower and his hoses a little leakier, he can't keep up with the latest emergency ordinances. "The shutdown of Propwash Junction ages Mayday nearly twenty years in a day," says *Planes: Fire & Rescue* director Bobs Gannaway, as seen when Dusty visits him at the fire station to apologize for causing all the trouble.

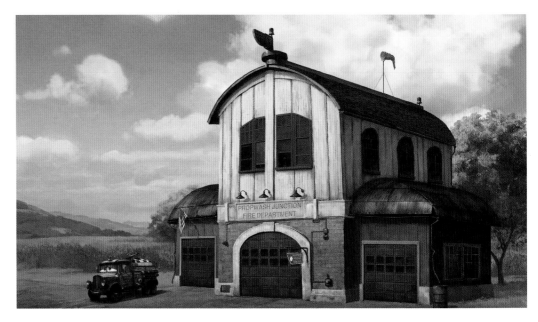

Toby Wilson, Graphite; Lin Hua Zheng, Digital

Toby Wilson and Lin Hua Zheng, Digital

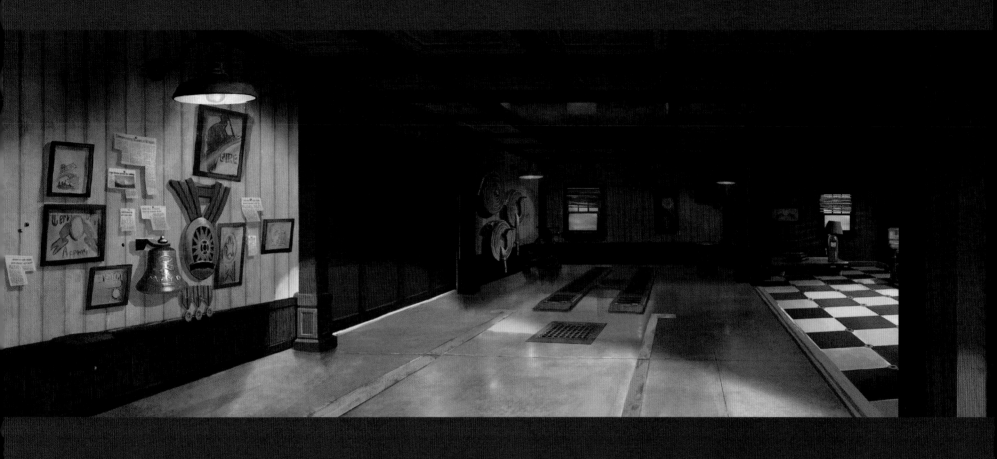

Jim Schlenker, Graphite; Akiko Crawford, Digital

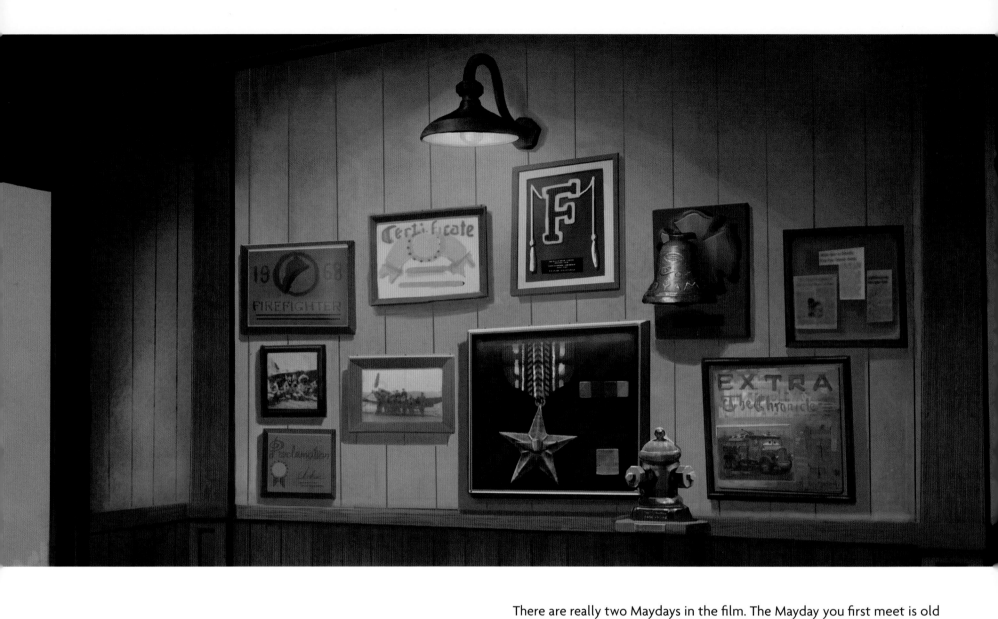

There are really two Maydays in the film. The Mayday you first meet is old but very young at heart—he's got parts that rattle but he's still very peppy and energetic. But once Mayday is told he can't handle the town by himself anymore, he acts very differently: we pose him down lower, almost sagging, and we make his movements a lot slower. His bolts really, really rattle, and now he clearly feels his age.

—ETHAN HURD, animation lead

Jim Schlenker, Graphite;
Lin Hua Zheng, Digital

Jim Schlenker, Graphite;
Scott Fassett, Digital

CG render

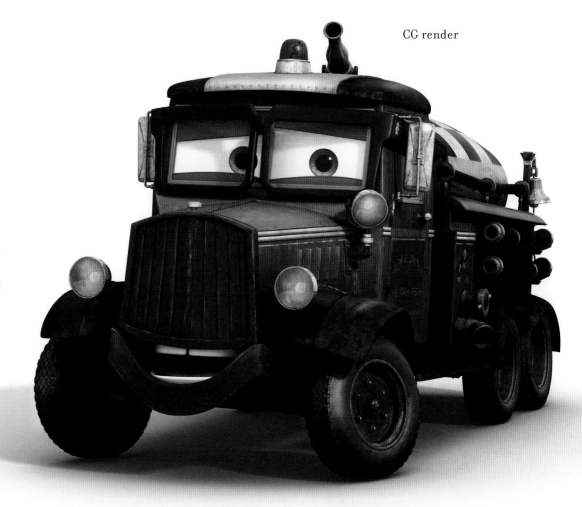

When Dusty makes the offer to help Mayday by training to be his partner in fire and rescue, it's an inclination that, as research shows, is actually part of his heritage. "We found that there was a group of crop dusters in Mendocino in 1955 that with modified equipment, became some of the first water dropping aircraft in the history of aerial firefighting. So it felt like a natural path that Dusty could follow this legacy. It's also a dramatic, emotional entry point for him to launch his pursuit of a new passion, since his first love of racing was no longer an option," explains director Bobs Gannaway.

Left: Toby Wilson, Digital

Right: Scott Fassett, Digital

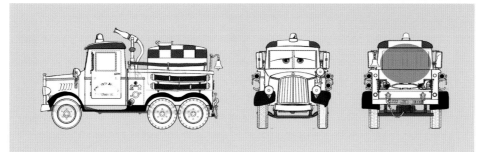

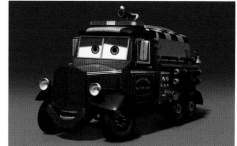

04

INTO THE FIRE

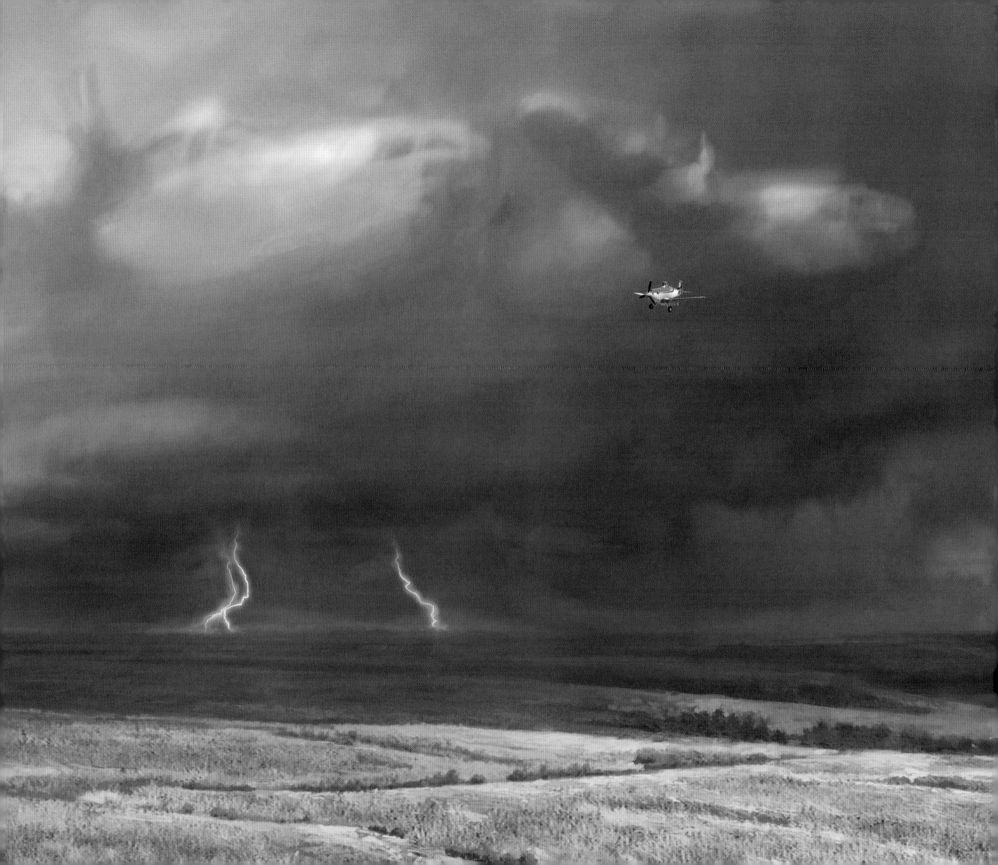

As Dusty takes wing upon the path of becoming a certified firefighter, it's a journey of hope and light. He sets out for Piston Peak National Park to train with one of Mayday's firefighting associates, ever mindful of his torque gauge but awed by the stunning landscape. Dusty is aglow in the morning light of this transition to a new location and new life, flying westbound as the sun rises through dramatic skies and over breathtaking vistas. "There are subtle bomber outlines in the thunderclouds, spark plug silhouettes apparent in the Badlands, and small towns laid out like radial engines," describes *Planes: Fire & Rescue* art director Toby Wilson, who ensures that an awareness of the "World of *Cars*" remains ever present but not overwhelming in its shape language.

What takes eons for Mother Nature to generate has to happen within a mere production calendar for an animation team. To make sure the crew was as geared up as possible for such a creative trek as crafting an entire national park, the team visited Yosemite. It was important for the artists to experience the scale and grandeur of the natural beauty in order to help properly translate it into the "World of *Cars*." While inspiration was also drawn from Yellowstone, Arches, and Sequoia national parks, Yosemite was an ideal location because it is a canyon, which suits the drama of the *Planes: Fire & Rescue* story perfectly.

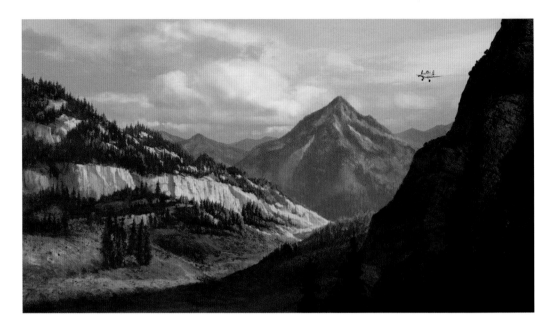

Lin Hua Zheng, Digital

Bobs Gannaway, Photo

Jim Schlenker, Graphite

Pages 112–113: Lin Hua Zheng, Digital

Page 115: Toby Wilson, Digital

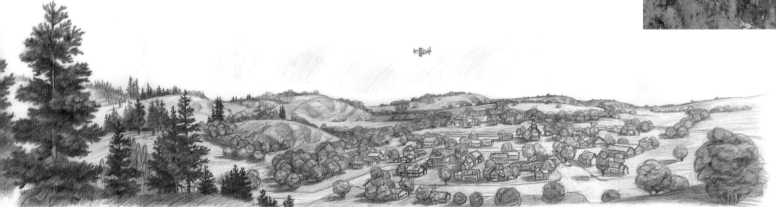

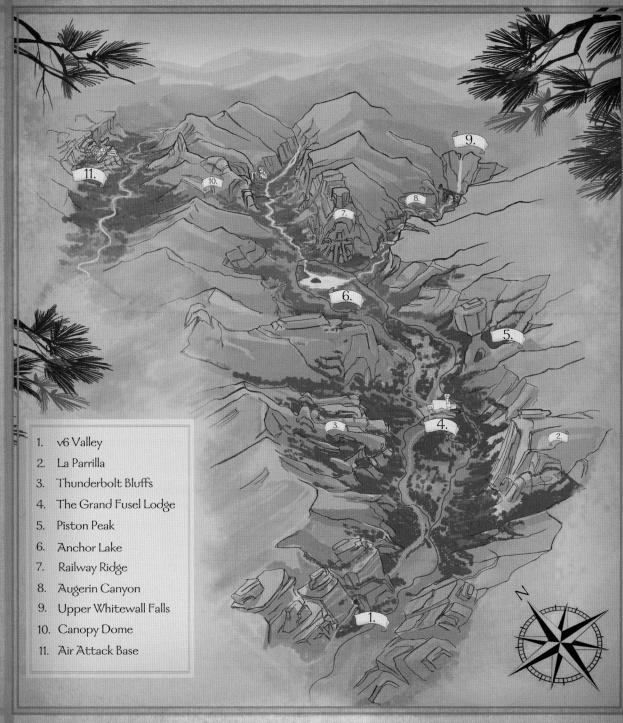

1. v6 Valley
2. La Parrilla
3. Thunderbolt Bluffs
4. The Grand Fusel Lodge
5. Piston Peak
6. Anchor Lake
7. Railway Ridge
8. Augerin Canyon
9. Upper Whitewall Falls
10. Canopy Dome
11. Air Attack Base

PISTON PEAK NATIONAL PARK

When Dusty flies into the park, the shots are cast in cool color and shadows, using morning light to illuminate the scene upon his arrival and feel like a big moment of discovery. And in Piston Peak National Park, there is plenty to discover. Perhaps the most remarkable feature of the park is the sheer quantity and variety of foliage present. Among the eighteen different types of vegetation are stylized versions of pine, cedar, birch, oak, maple, and buckthorn, and all told, there are nearly two million trees and bushes that exist in this forest. "Toby (Wilson) personally art directed every single piece of foliage. And then we took each design and created a green version, a dead version, and a burnt version of it, then produced multiple resolutions for each of those variations," recalls Doug Little, computer graphics supervisor. Little combined forces with a Disney research group in Zurich to bring movement to this forestry, wanting the millions upon millions of polygons that comprise everything from pine needles to majestic lodgepoles to portray as realistic movement as possible when they blow in the wind. To support the story, the palette of foliage conveys the fact that the park has had a really long dry season. "The greens are deep evergreen, and even when they are hit with the morning light, it's never a vibrant green. It's got a little bit more yellow hue to push the dry look," says *Planes: Fire & Rescue* art director Wilson.

While most of the foliage is seen from the air via Dusty's perspective, when firefighting scenes take place, the need for characters to interact amidst the trees becomes critical. For those shots, the crew built high resolution "stunt forests," which are essentially sound stages that can be inserted anywhere within the national park set as needed. "There are four different stunt forests, featuring creek beds, trails, meadows, and various combinations thereof," explains Little.

For floral designs, we turned the yellow pincushion into a radiator fan. We have the purple lupine, which is also very common in national parks, and we made those out of little engine cowlings and propellers. And then we have the Indian pink, which we made out of our version of a taillight, similar to Red's flowers in *Cars*.

—TOBY WILSON, art director

Jim Schlenker, Graphite

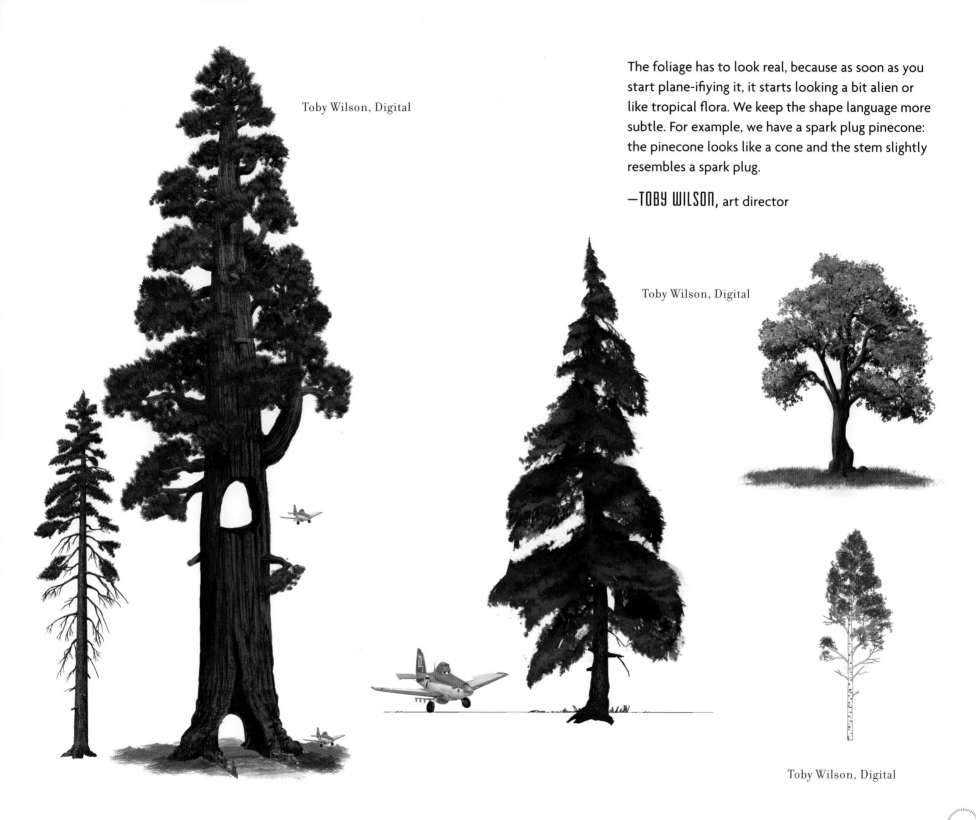

Toby Wilson, Digital

The foliage has to look real, because as soon as you start plane-ifying it, it starts looking a bit alien or like tropical flora. We keep the shape language more subtle. For example, we have a spark plug pinecone: the pinecone looks like a cone and the stem slightly resembles a spark plug.

—TOBY WILSON, art director

Toby Wilson, Digital

Toby Wilson, Digital

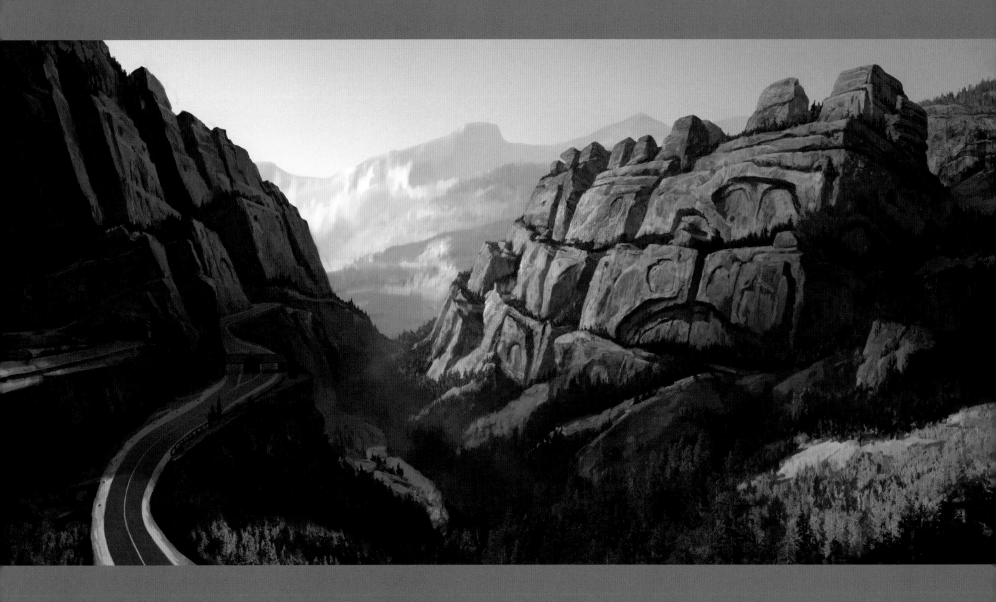

Ed Li, Graphite; Lin Hua Zheng, Digital

PISTON PEAK NATIONAL PARK

V-6 VALLEY

Entry to the canyon is through the V-6 Valley, which features rock formations shaped like a V-6 engine, with headers and other engine block motifs carved into the cliffs. "Even more important to the story, these rocks form the only entry and exit for the canyon, a bottleneck that makes a safe escape challenging for travelers when fire breaks out," explains art director Toby Wilson.

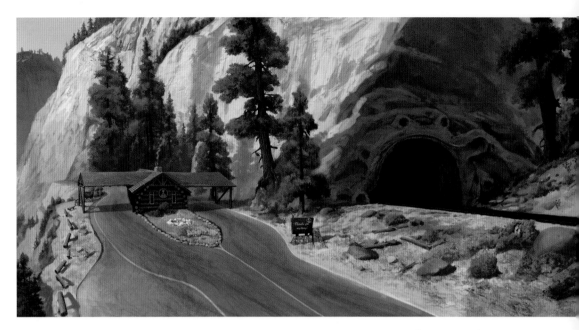

Jim Schlenker, Graphite;
Lin Hua Zheng, Digital

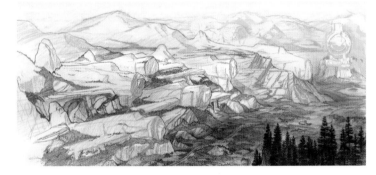

Jim Schlenker, Graphite

THUNDERBOLT BLUFFS

On the west side of the canyon, majestic granite rock has been chiseled by time and glacial scarring to resemble a squadron of warplanes, thus earning the name of Thunderbolt Bluffs. The choice of granite as the foundation for the park was well intentioned, because a neutral gray stone provides a strong read against foliage. "The texture of granite also beautifully reflects the lighting from different times of day, so we're not stuck with the gray looking environment: in the morning it will look almost yellow; midday shadows are going to give it a cool blue cast shadow; and during the sunset, it will look orange," explains Wilson.

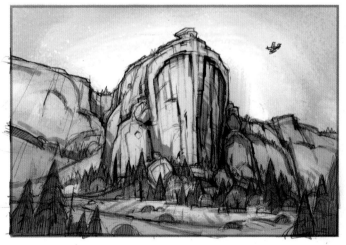

Ed Li, Graphite

LA PARRILLA

Across the valley from Thunderbolt Bluffs is La Parrilla, a granite monolith with a face resonant of both a 1930s Rolls Royce grille and El Capitan in Yosemite.

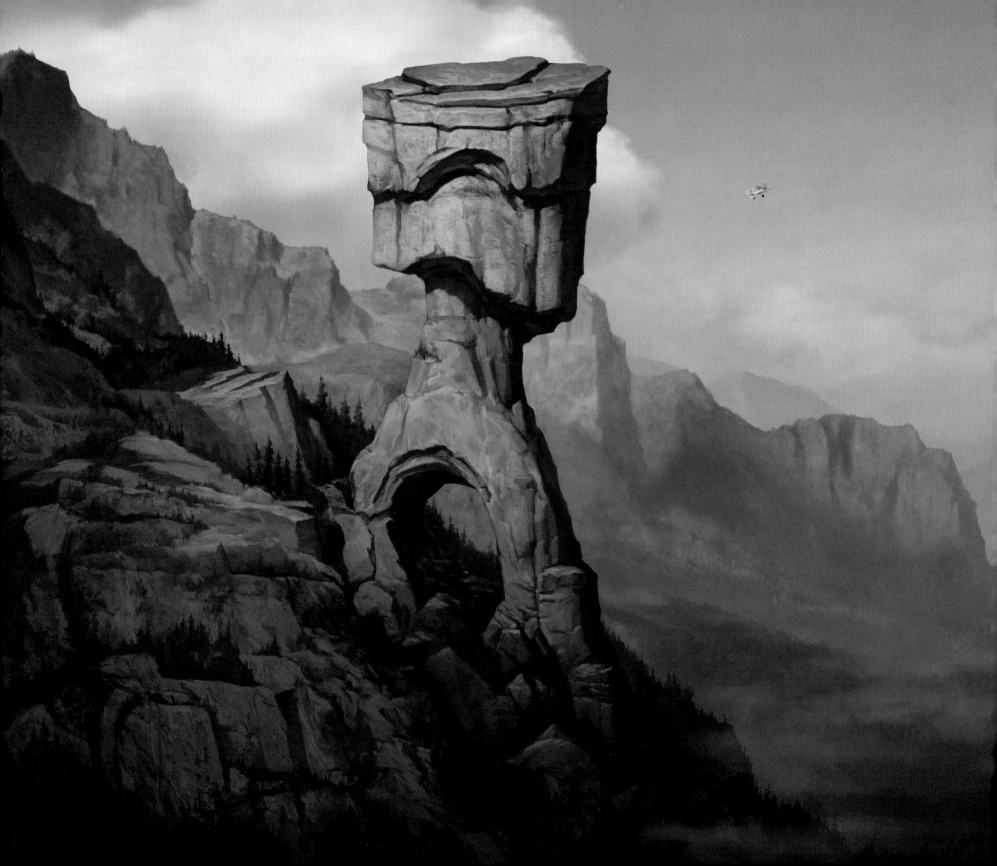

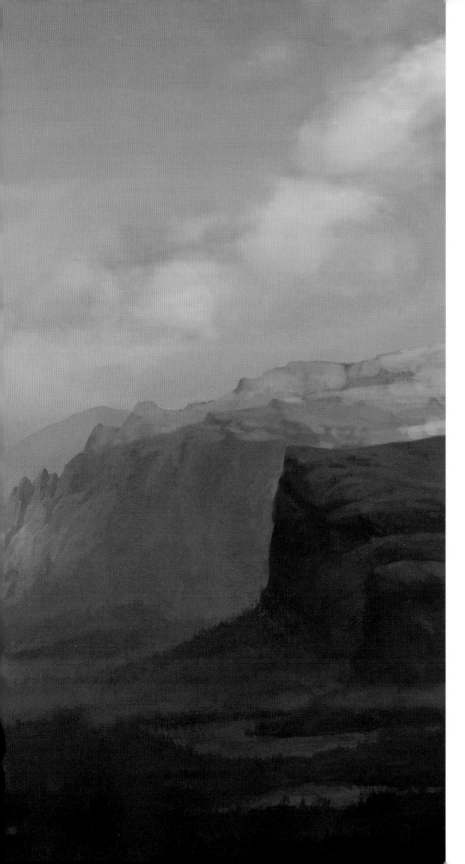

PISTON PEAK MONUMENT

Rising up from the canyon floor between Thunderbolt Bluffs
and La Parrilla is the namesake Piston Peak Monument. The key
to designing the iconic half dome was finding the right balance
between organic and vehicular shapes, requiring many versions
before honing in on the monumental final look.

Ed Li, Graphite

Art Hernandez, Photo
In photo: Toby Wilson

Ed Li and Lin Hua Zheng, Digital

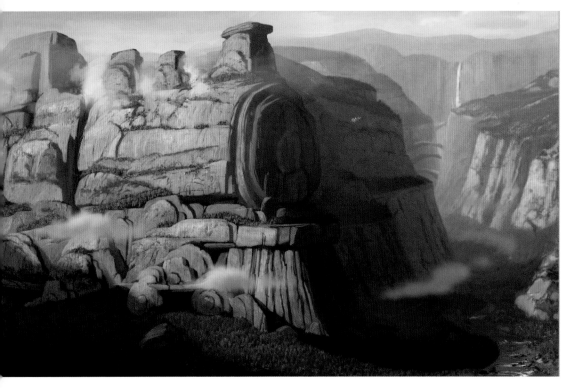

RAILWAY RIDGE

Deeper in the park is Railway Ridge, a rock formation that echoes the shape of a locomotive. "I had originally wanted to place some Yellowstone-like geothermal features near the wheels of the train to make it look like steam emerging," recalls *Planes: Fire & Rescue* director Bobs Gannaway. Even without such detail, the facing stands tall as an impressive backdrop for some dramatic moments in the story.

ANCHOR LAKE

Just below Railway Ridge lies Anchor Lake, the rare body of water in the canyon. Its position within the national park was well vetted for story purposes, not wanting to make water sources too accessible or too bountiful in a firefighting drama.

Ed Li, Graphite; Akiko Crawford, Digital

Because the park was intended for all vehicles, we were going to do the same thing for the lodge, which meant having Anchor Lake adjacent to it. But the problem with that is then there's an ample water source right there, so how can we endanger the lodge with fire having water so close? That's why we had to separate them and now there's only one lake, there's only one river, there's only one water source, and it's a dry season in the park.

—**TOBY WILSON**, art director

Ed Li, Digital

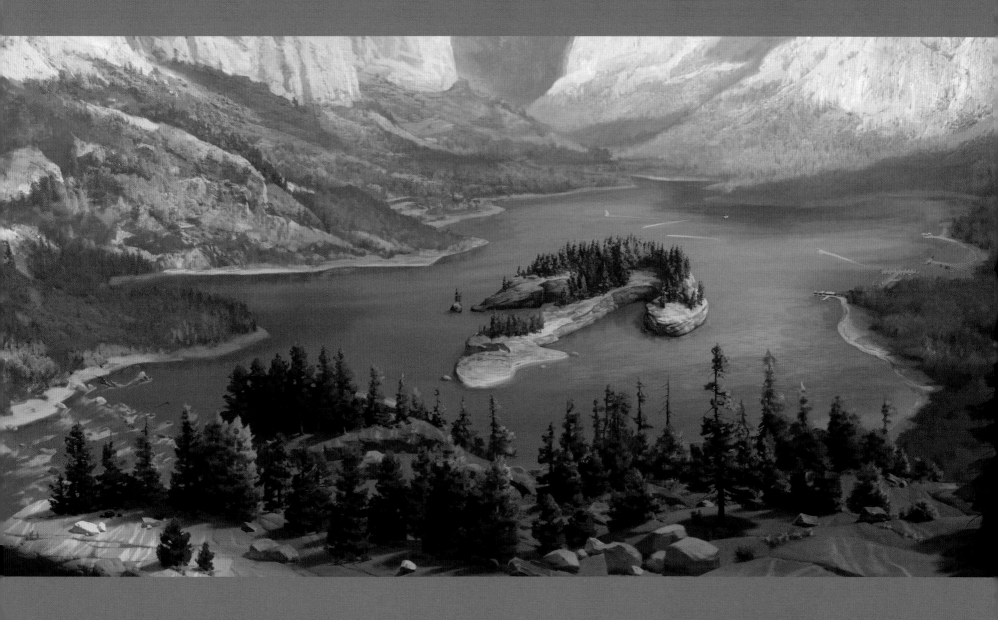

Jim Schlenker, Graphite; Sai Ping Lok and Lin Hua Zheng, Digital

CANOPY DOME

Another plane-ified rock formation appears at Canopy Dome, but this aviation shape is more subtle due to tree lines creeping through the landscape. The placement of foliage in this region of the park was a good artistic test in learning how to cluster trees, "to avoid the Chia Pet effect," jokes painter Akiko Crawford.

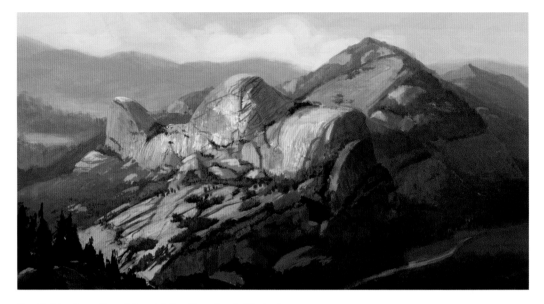

Jim Schlenker, Graphite; Akiko Crawford, Digital

Ed Li, Graphite

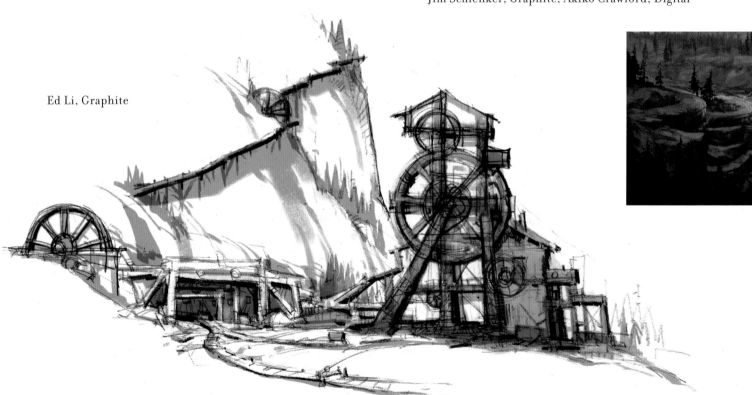

Jim Schlenker, Graphite;
Lin Hua Zheng, Digital

Page 125: Toby Wilson, Digital

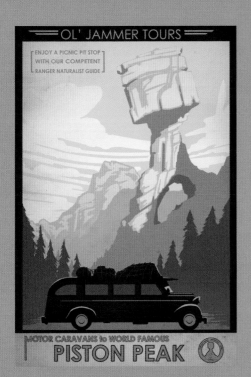

OL' JAMMER TOURS

[ENJOY A PICNIC PIT STOP
WITH OUR COMPETENT
RANGER NATURALIST GUIDE]

MOTOR CARAVANS to WORLD FAMOUS
PISTON PEAK

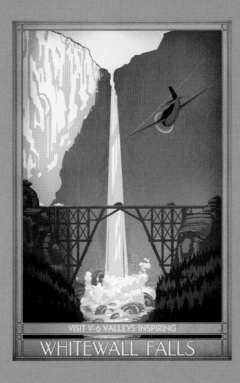

VISIT V-6 VALLEYS INSPIRING
WHITEWALL FALLS

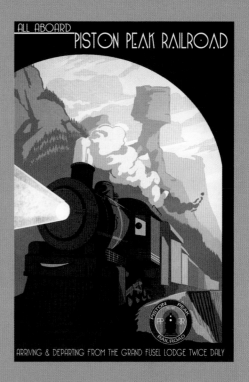

ALL ABOARD
PISTON PEAK RAILROAD

ARRIVING & DEPARTING FROM THE GRAND FUSEL LODGE TWICE DAILY

HEAR TALES FROM THE TAILGATE
ENJOY IGNITION POINT STAR GAZING

MOON
LIGHT
TOUR

2 HOUR SCENIC TOUR.
DEPARTS TONIGHT FROM THE FUSEL LODGE LOBBY

Brave the arches of
AUGERIN CANYON

BLOW A GASKET !
EVERY HOUR ON THE HOUR

180 FEET HIGH

GASKET GEYSER

Marty Baumann and Lin Hua Zheng, Digital

PARK STAFF

Ol' Jammer has served as the head of the tour bus team at Piston Peak National Park for over seventy-two years, and he knows every trail, stream, rock, and tree as well as his own tire treads. "His design is based off the old yellow tour buses at Yellowstone and Glacier national parks, and they're actually called jammers because their gears would always jam as they went up and down the mountain trails," explains *Planes: Fire & Rescue* art director Toby Wilson. Retaining the canvas top that is usually open on the real-world version of the tour bus, here it is interpreted as being full of supplies and thus rounded to mimic a ranger's cap. "He's also got the steel bumper/mustache detail just like Doc and Sheriff in *Cars*, to add to the older presence," adds Wilson. Pitties are key to keeping the park system in order, and the role of park ranger is well managed by these vehicles.

Jason Hulst, Graphite

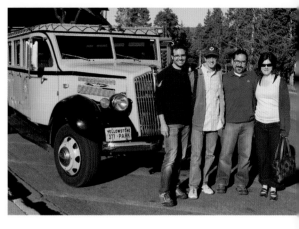

Paul Gerard, Photo
In photo: Ferrell Barron, Bobs Gannaway, Art Hernandez, Kate McCreary

Donna Prince, Digital

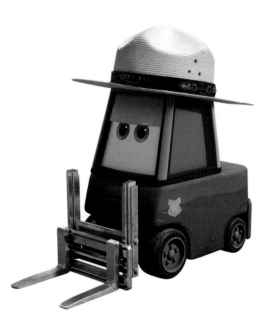

Donna Prince and Toby Wilson, Digital

WILDLIFE

Living within the forest of Piston Peak National Park are various forms of wildlife. Deer run wild, inspired by the famous green tractor equipment, with "faces that taper to match the shape of the mammal deer," says *Planes: Fire & Rescue* art director Toby Wilson. The shiny black grille suggests the dark, wet nose of mammalian deer, and the stags charge about with light racks in place of antlers. They leave deer tracks when they drive, due to the deer hoof markings in their tire treads. Flitting about the woods are flocks of red-propped balsa thrush. Inspired by the tiny rubber band–powered windup planes, these birdlike vehicles feature a delicate feather pattern.

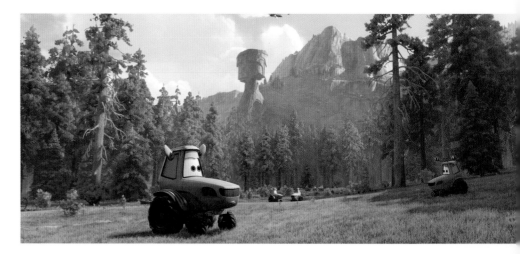

Film frames, Digital

Toby Wilson, Digital

HARVEY AND WINNIE

Piston Peak National Park is a treasure for all vehicles to enjoy, so tourists come in all shapes, sizes, and models. Cars, trucks, planes, boats, and even RVs, such as Winnie and Harvey, enjoy the beautiful scenery. "We wanted the national park to feel like a place that's been around for a long time, that it has a cherished history. So we created Harvey and Winnie and imagined them coming back to the park for their fiftieth wedding anniversary, after having honeymooned and shared their first kiss there," says *Planes: Fire & Rescue* director Bobs Gannaway.

Marty Baumann, Digital

Toby Wilson, Digital

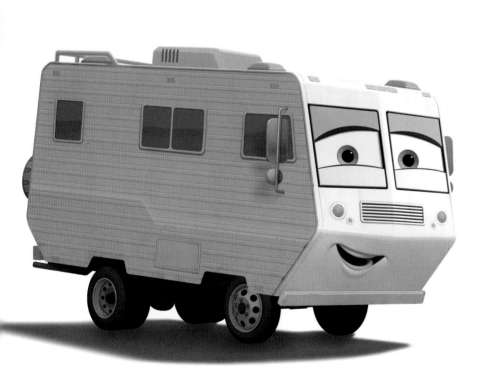

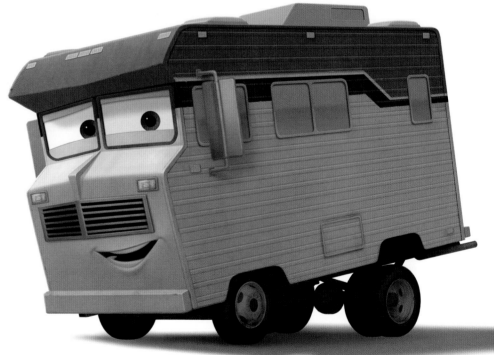

Chris Oatley, Digital

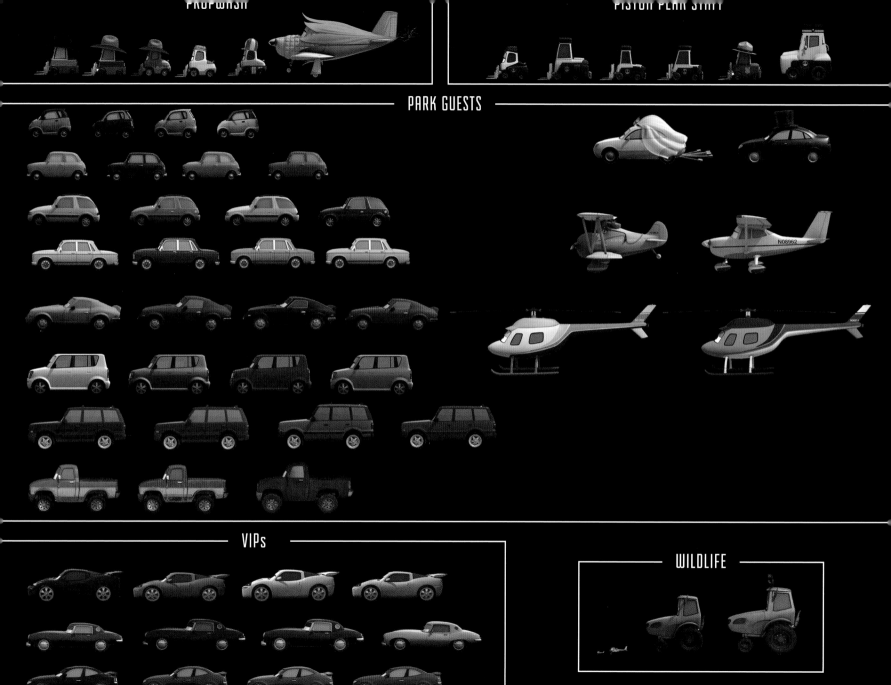

PROPWASH

PISTON PEAK STAFF

PARK GUESTS

VIPs

WILDLIFE

Piston Peak was always intended to be a national park for all vehicles to enjoy. That meant we needed to design vehicles of many different models, makes, shapes, sizes, and colors to visit the park and populate it. Hopefully when you watch the film, you can feel the hundreds of park guests we have in the background.

—TOBY WILSON, art director

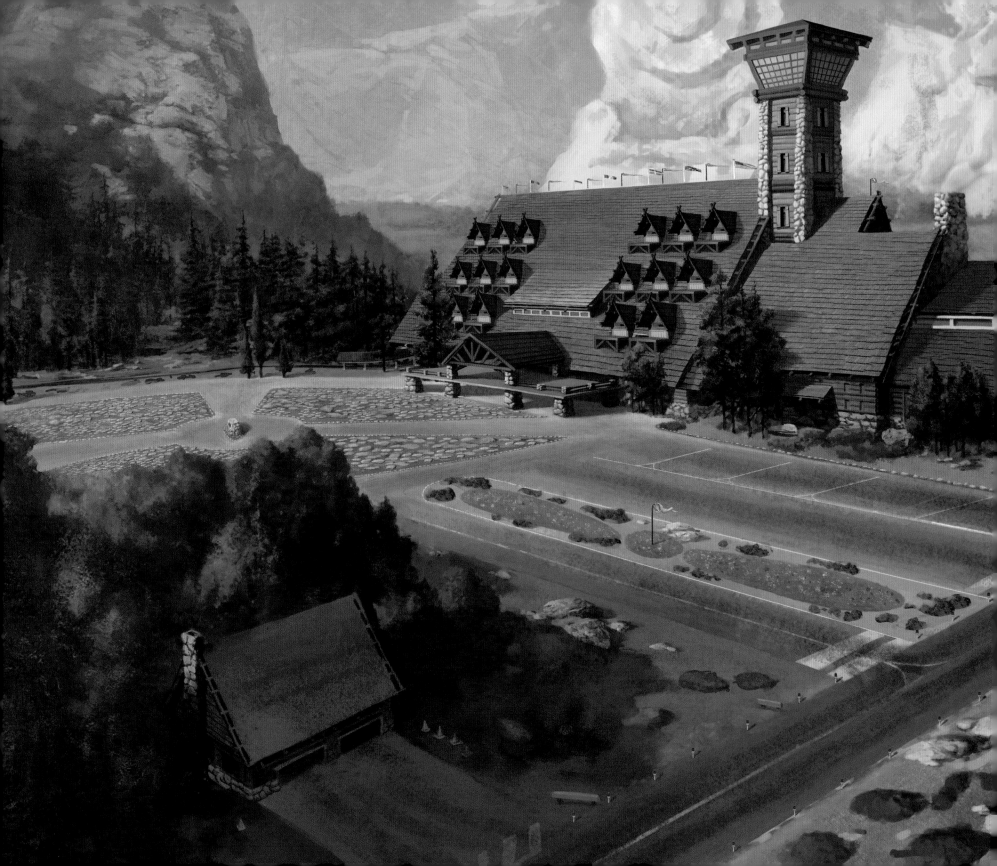

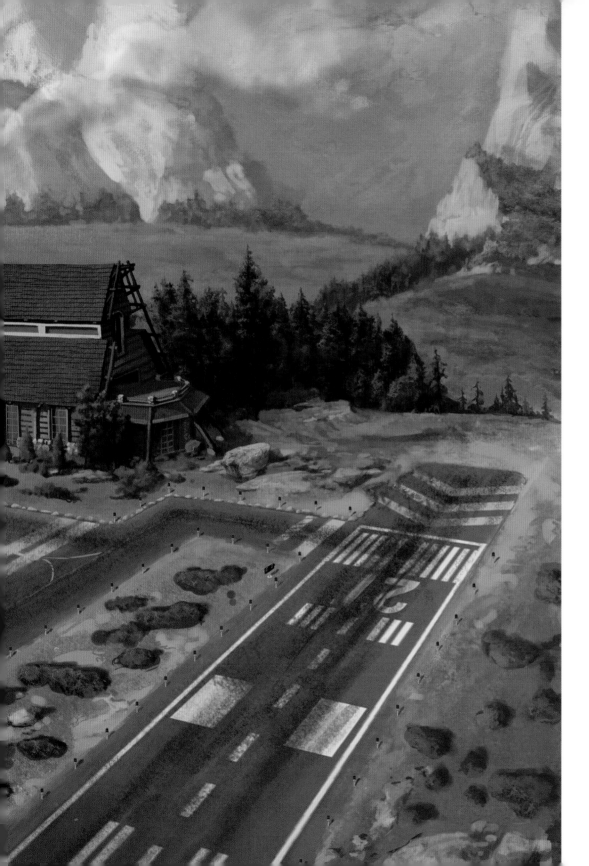

GRAND FUSEL LODGE

Built in the heart of Piston Peak National Park is the Grand Fusel Lodge, a rustic five-story hotel with an impressive wooden veranda. Planes touch down on its private airstrip, helicopters can enjoy the comfort of their own private landing pads, and other vehicles can drive their way into the newly restored resort along the canyon roads. The look of the hotel is inspired by other famous lodges, with influences coming from the Old Faithful Inn in Yellowstone, the Ahwahnee in Yosemite, and the Glacier Park Lodge. "The structural detail most important to the story, however, is that it's mostly made of wood, and can go up like a matchstick if fire reaches it," notes *Planes: Fire & Rescue* art director Toby Wilson.

Justin Thompson, Graphite

Jin Schlenker, Graphite; Lin Hua Zheng, Digital

133

Guests of the Grand Fusel Lodge enjoy a close view of Gasket Geyser, the volcanic centerpiece of the park. Inside the hotel, they can partake in special amenities that include the Gift Garage (a souvenir shop), Piston Perk (a coffee shop), and Details (a spa). Informational displays about the local flora and fauna as well as American Indian–inspired décor make for a welcoming lobby area. "We thoroughly discussed color schemes and shape motifs with an American Indian consultant so that we were respectful in our interpretation of that influence," says art director Toby Wilson. To find the right balance between plane-ifying this environment while using American Indian design, the main atrium center rug displays two pistons flanked by two aircraft, stylized to look like kachina dolls. The sawtooth pattern incorporates traffic cones, and down the center runs a double yellow line.

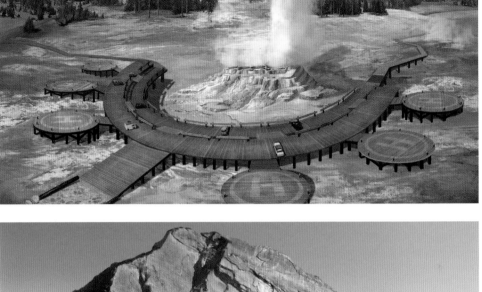

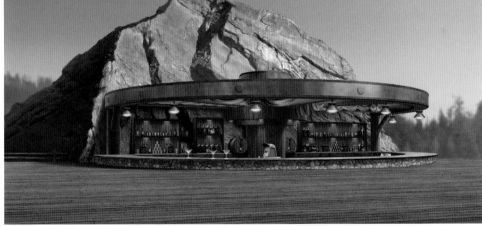

Top: Jim Schlenker and Akiko Crawford, Digital

Bottom: Ed Li and Scott Fassett, Digital

Toby Wilson, Graphite

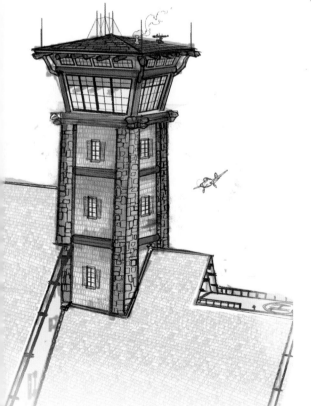

Jim Schlenker, Graphite

We had to figure out how to get a rustic lodge but still make it feel like an airport, so we built a control tower structure into it, and designed a terminal kind of vibe in the lobby.

—TOBY WILSON, art director

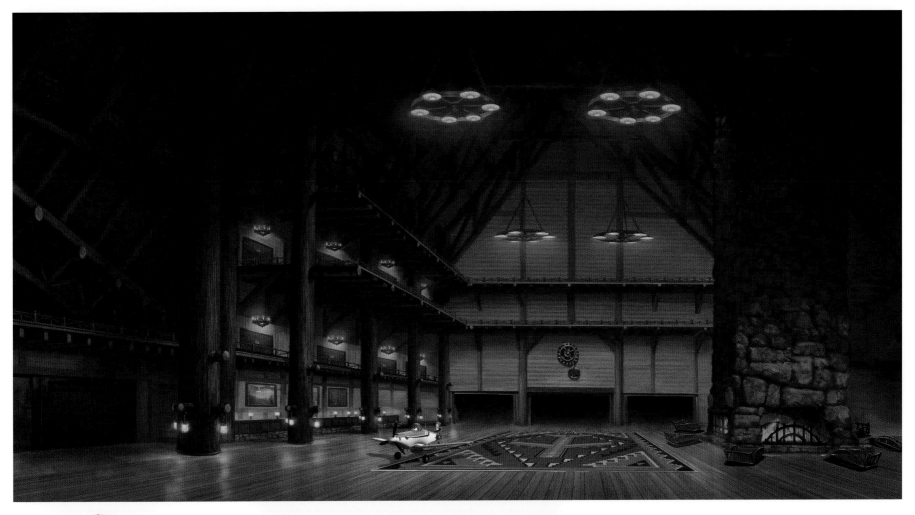

Above: Jim Schlenker, Graphite; Lin Hua Zheng, Digital

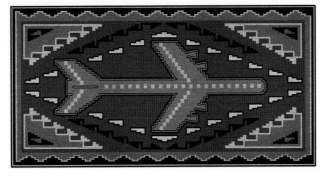

The interior of the lodge had to be large enough to accommodate tons of vehicles. We used a thick, dense atmosphere to create a sense of depth and scale so you feel like you are in a really grand space.

—AKIKO CRAWFORD, painter

Left: Toby Wilson, Graphite; Lin Hua Zheng and Scott Fassett, Digital Right: Ed Li, Digital

PISTON PEAK RAILWAY

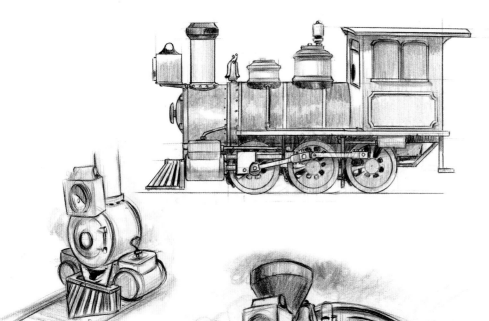

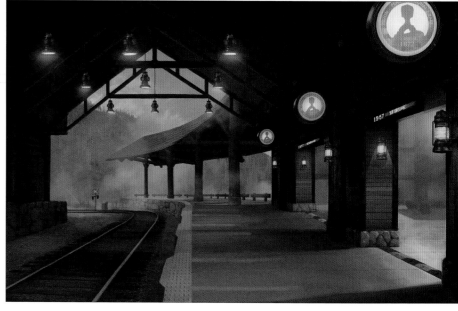

Ed Li, Graphite; Akiko Crawford, Digital

Scott Seeto, Digital

MOUTH PLACEMENT ON THE BOILER.

I wanted to connect the train to the lodge because there's a historical relationship there: lodges in national parks were built by the railroads, in an attempt to attract people from the East out to the West to see things like the Grand Canyon and to spend their vacation budgets in the United States instead of Europe.

—BOBS GANNAWAY, director

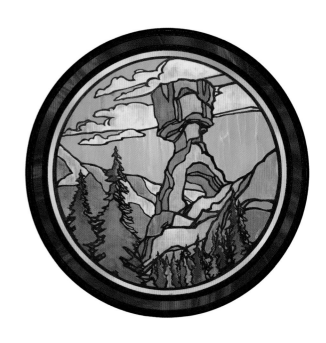

Akiko Crawford, Toby Wilson, and Lin Hua Zheng, Digital

CAD SPINNER

Park superintendent Cad Spinner is a luxury SUV whose tires have never gotten dirty: he seems much better suited to explore a country club than the countryside. "He's very slick, a managing-up sort of character more interested in self-promotion than any official park concerns. To reinforce our opinion of him, we tried to include a trash bin in every shot he's in, to visually associate him with being garbage," notes *Planes: Fire & Rescue* director Bobs Gannaway. Cad's top priority is to make the grand reopening of the lodge a success, and his own reputation even grander, no matter what the cost.

Scott Seeto, Graphite

Scott Seeto, Digital

We gave Cad an arrowhead and chrome-plated roof rails, which make it look like he has a widow's peak and thinning hair up there. And since he would never carry luggage, we also gave him a lackey named Andre.

—SCOTT SEETO, character designer

SECRETARY OF THE INTERIOR

The Secretary of the Interior "is as comfortable being behind a desk as he is being out in nature . . . or maybe more so being out in nature, since he's a rugged vehicle," says *Planes: Fire & Rescue* head of story Art Hernandez. Invited as Cad's special guest for the grand reopening of the lodge, the Secretary was originally more of a "suit," designed to look like a full-size luxury car with a shiny dark paint job and a canvas top reminiscent of well-groomed salt-and-pepper hair. But John Lasseter suggested the evolution, saying he wanted to like this character the way he's not supposed to like Cad: he should be an SUV that actually goes off-road. It's clear that the Secretary is a respectable kind of guy: he trusts Ol' Jammer's opinions more than he trusts Cad's.

Chris Oatley, Digital

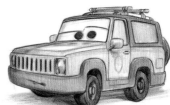

Scott Seeto, Graphite

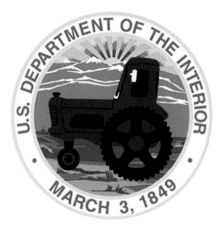

Marty Baumann, Digital

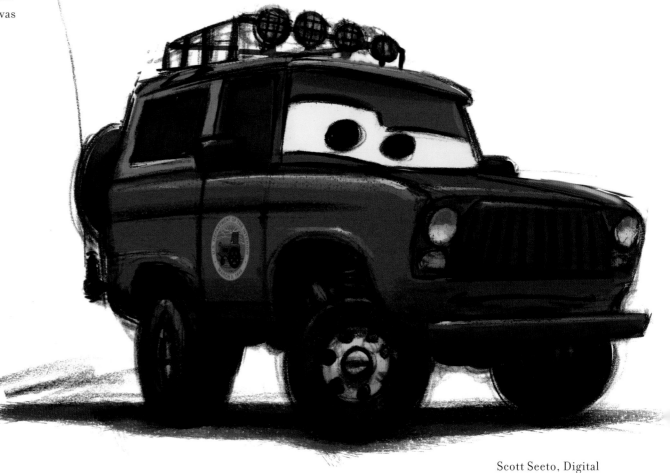

Scott Seeto, Digital

The Secretary has a logo on his side that's based off the actual seal of the U.S. Department of the Interior. Where it's a buffalo on the real insignia, we, of course, have a tractor.

—TOBY WILSON, art director

PULASKI

Pulaski is the structural fire engine for the park. He's a tough, no-nonsense kind of vehicle, and his name is an homage to firefighter Edward C. Pulaski, who saved his crew in the Great Idaho Fire of 1910 by forcing them to hole up in a mine while the fire passed by outside, an example of heroic thinking that also inspired a key moment in the storyline of *Planes: Fire & Rescue*. Pulaski also has his own pitty who rides along with him to hook up his hoses and address any other basic tasks.

Ron Velasco, Graphite

Ron Velasco and Scott Fassett, Digital

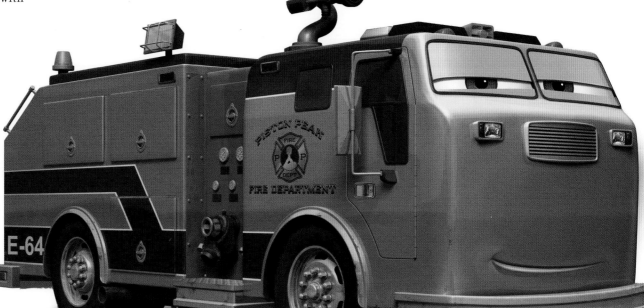

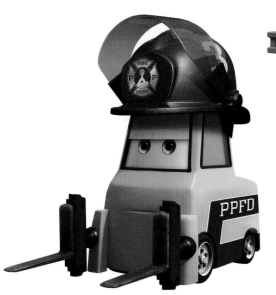

Scott Fassett, Digital

The real-life Pulaski story is so important in the world of firefighting that it even led to a ground crew tool being named after him: on one side it's a steel hoe and on the other it's a pickax.

—TOBY WILSON, art director

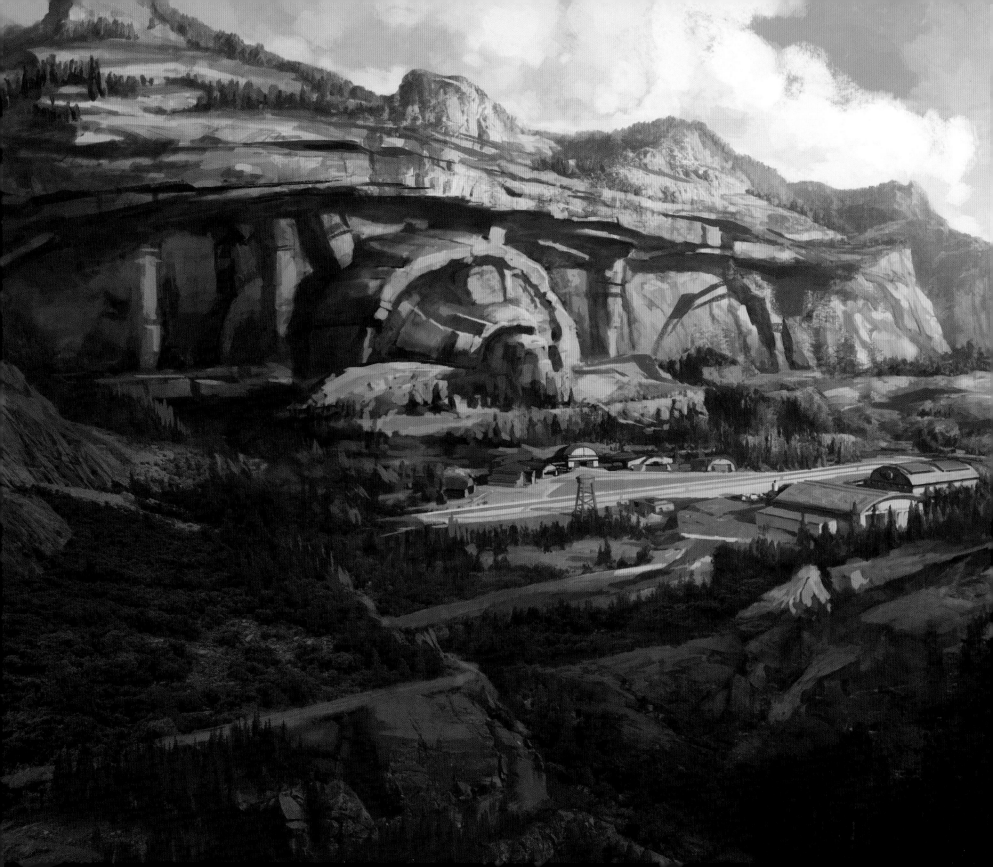

PISTON PEAK AIR ATTACK BASE

Dusty's ultimate destination on his journey to Piston Peak National Park is the Air Attack Base, where he will train to be a firefighter under the guidance of Mayday's associate, Blade Ranger. The base stands west of Canopy Dome, on the outskirts of the park. The location of the base was intentionally separated from the park proper so that the firefighters could never be mistaken for stepping into the fire and risking their lives because they themselves are already in danger. "It needed to be clear that they are making the distinct decision that there are people who need their help and they are putting themselves in danger to help them," explains *Planes: Fire & Rescue* director Bobs Gannaway.

In order to get a sense of what life is like on an air attack base, the crew visited the Cal Fire Hemet-Ryan base in Southern California. Perhaps the biggest impression they left with was the creative repurposing of structures and reusing of materials, generally attributed to a lack of proper funding. "There was a lot of wear and tear on everything, but it was clear that it was all well taken care of. That greatly helped inform our basic construction and texture choices," recalls set designer Ed Li. This fact also inspired a key story point, in that everything and everyone can aspire to a second chance, a new purpose in life.

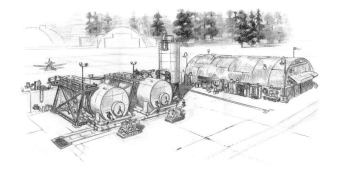

Above: Jim Schlenker, Graphite

Left: Ed Li, Graphite; Lin Hua Zheng, Digital

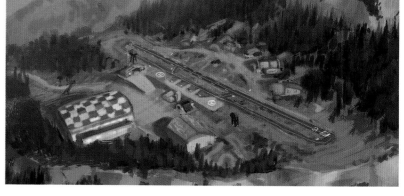

Jim Schlenker, Graphite; Lin Hua Zheng, Digital

Toby Wilson, Digital

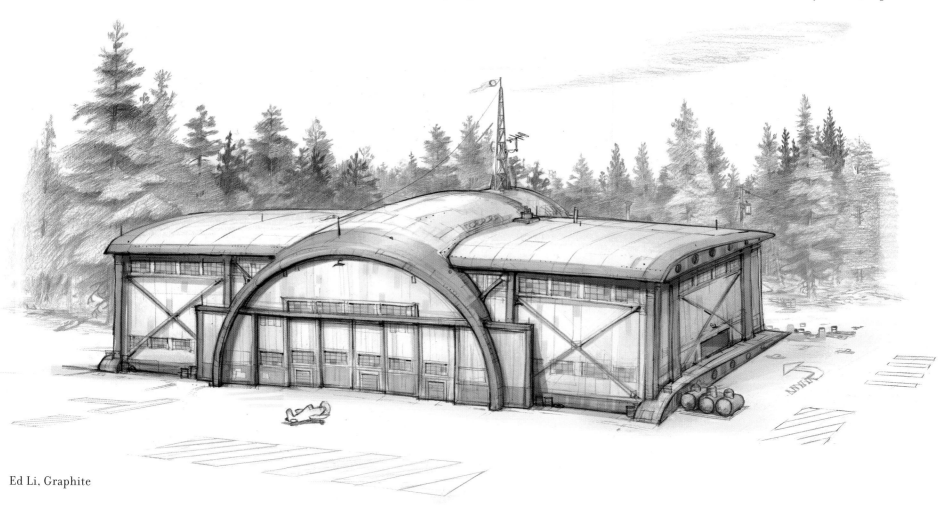

Ed Li, Graphite

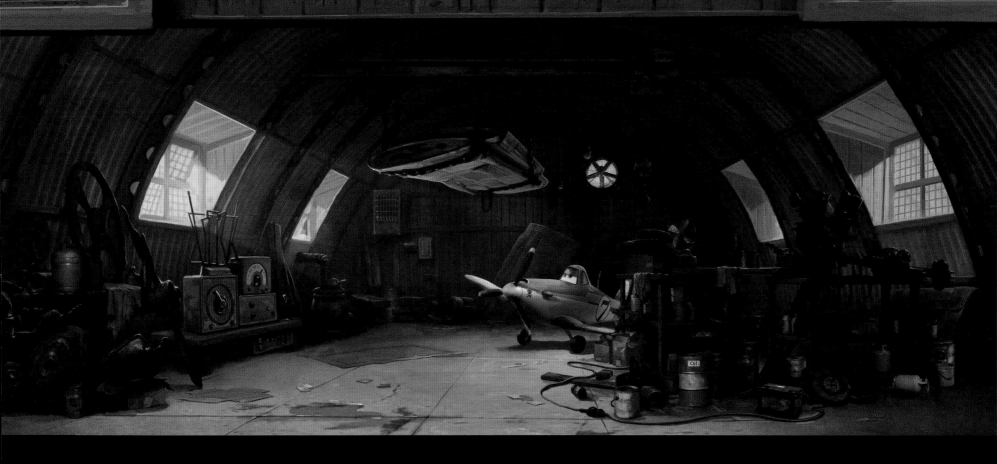

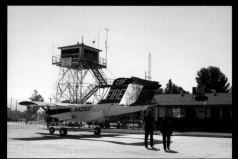

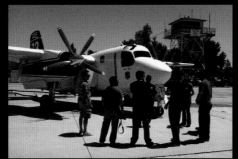

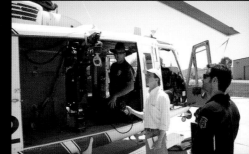

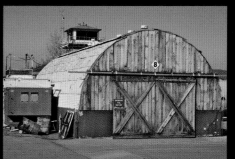

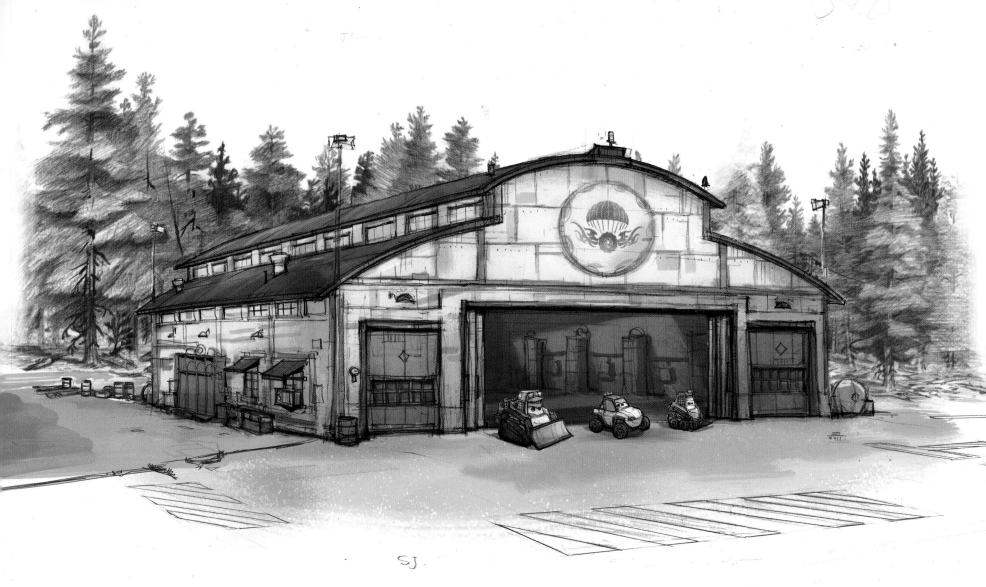

SJ

Ed Li, Graphite

Each member of the air attack team has his or her own hangar around a circular neighborhood pattern. "This layout was also largely influenced by the wonderful sense of community we got when we visited the ranger and staff residences in Yosemite," notes *Planes: Fire & Rescue* head of story Art Hernandez. Shape language reflects this warm, welcoming atmosphere: "We use rounder, friendlier shapes at the air attack base, as opposed to more angled, formal shapes at the lodge," explains art director Toby Wilson.

Marty Baumann, Digital

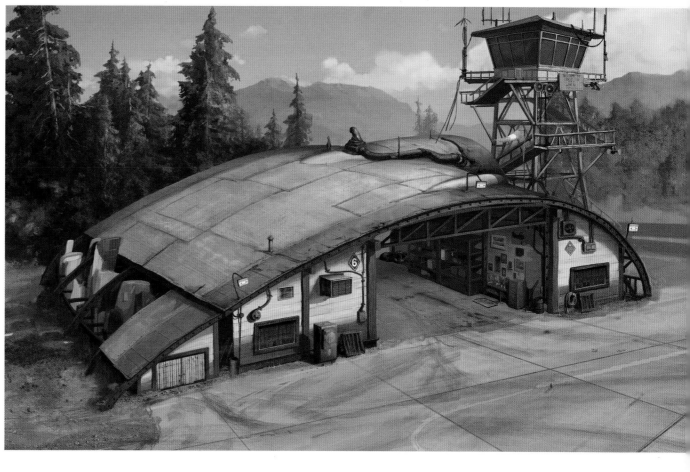

Ed Li, Graphite; Lin Hua Zheng, Digital

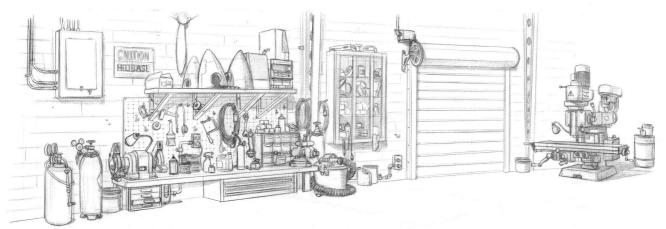

CAUTION
HELIBASE

Jim Schlenker, Graphite

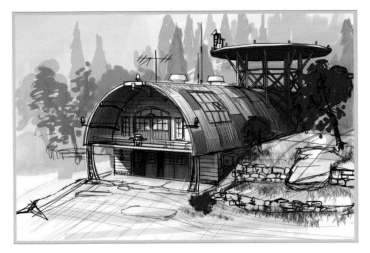

Ken Harsha, Digital

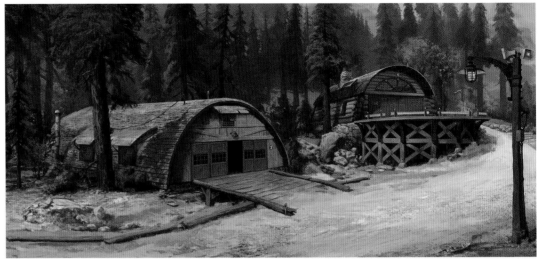

Toby Wilson, Graphite; Lin Hua Zheng, Digital

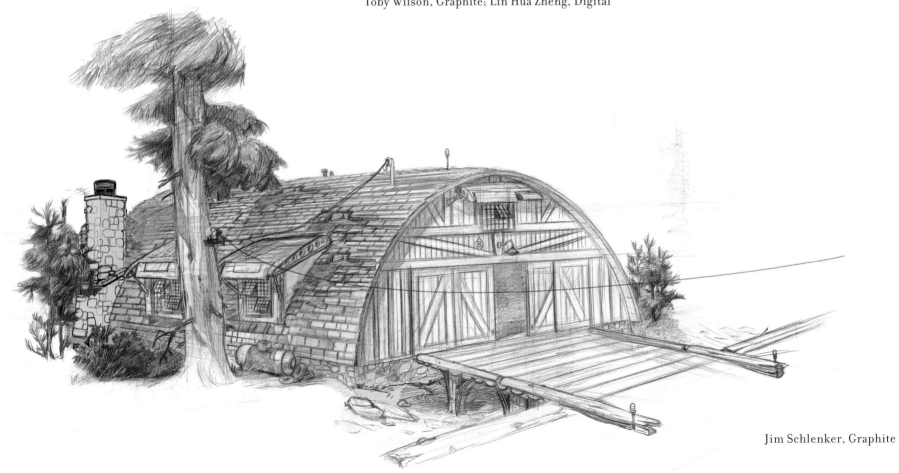

Jim Schlenker, Graphite

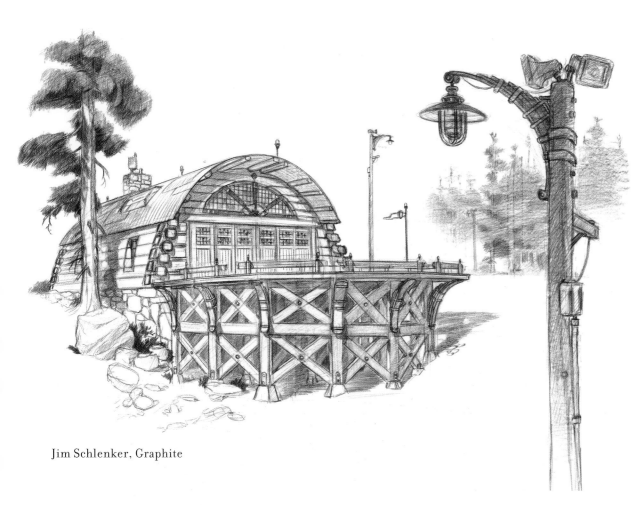

Jim Schlenker, Graphite

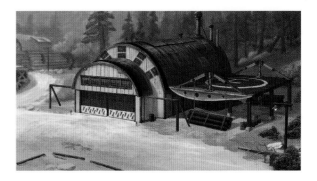

Ed Li, Graphite; Akiko Crawford, Digital

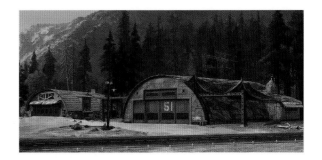

Ed Li, Graphite; Lin Hua Zheng, Digital

Ed Li, Digital

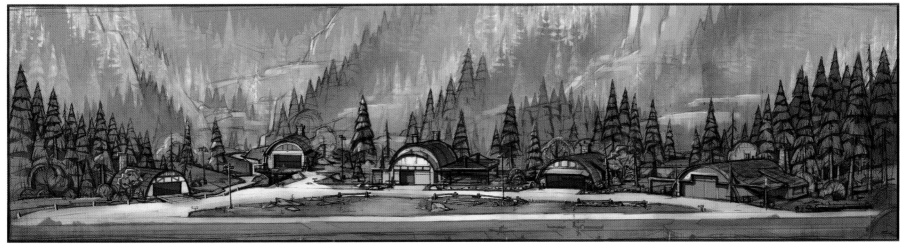

AIR ATTACK CREW

The air attack crew is a mixed group of planes and vehicles with greatly diverse personalities, but together they share "an undercurrent of second chances, since this line of work is a second job for all of them," says writer Jeff Howard. They also share a finely tuned sense of focus and professionalism that complements their unwavering heroics when on the fire lines. In crafting the Piston Peak team, the creative crew of *Planes: Fire & Rescue* hopes that they pay proper homage to the firefighters they have met in the process of developing the film, having been so impressed by these real-life heroes.

"We wanted the air attack crew members to each have their own presence on-screen, but we also needed to give the team a sense of unity. To that end, Toby (Wilson) and I came up with the visual motifs of a chevron and three white stripes on them in one form or another," says character designer Scott Seeto.

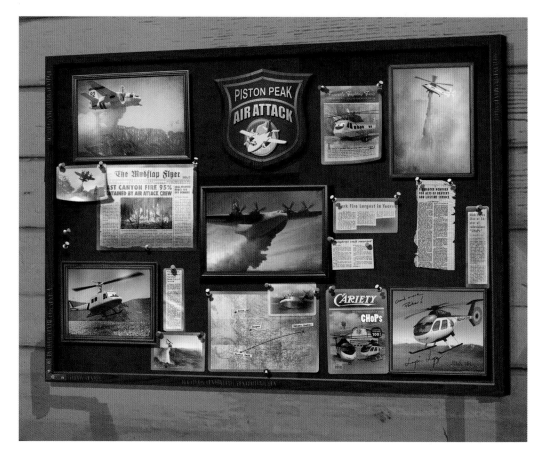

Toby Wilson, Scott Fassett, and Akiko Crawford, Digital

The visual goal is to try to make the aircraft look busy, to break up the space, and to really stand out against the forested hillsides, which is why they are painted red, black, and white, really high-contrast colors. The three white stripes detail was a look we noticed specifically when we went to Hemet-Ryan.

—TOBY WILSON, art director

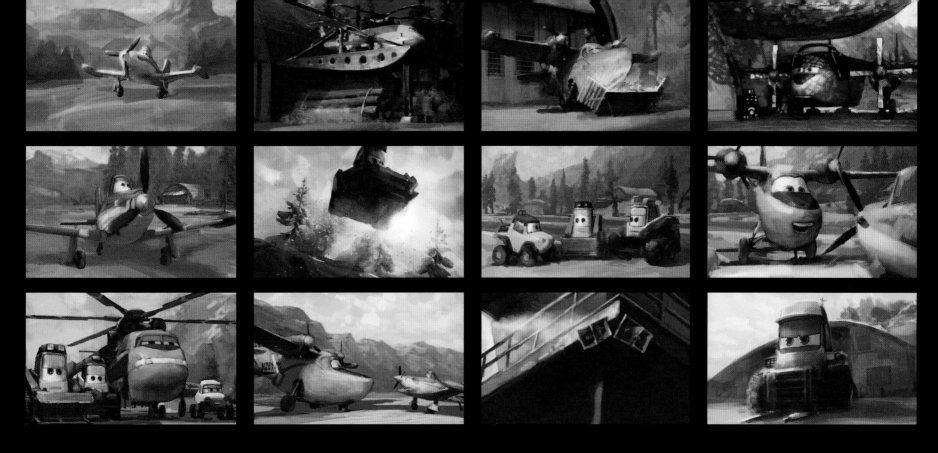

Toby Wilson and Lin Hua Zheng, Digital

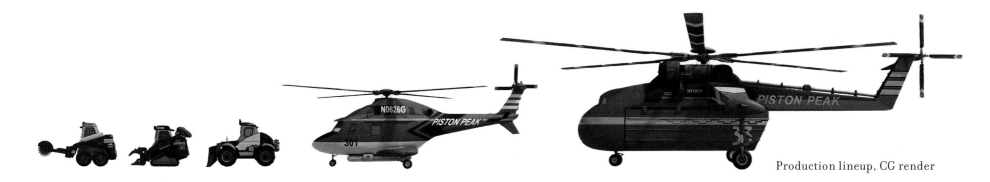

Production lineup, CG render

BLADE RANGER

Toby Wilson, Digital

As the leader of the Piston Peak air attack team, Blade Ranger is demanding, but he's the best at what he does and expects nothing less from his team. *Planes: Fire & Rescue* producer Ferrell Barron explains, "Blade serves as a tough-love life coach for Dusty. When Dusty hits his lowest point over having to finally face the fact that he will never race again, it's Blade who teaches him there's much more to life, and this presses Dusty to embrace a second chance in a new and even more meaningful existence."

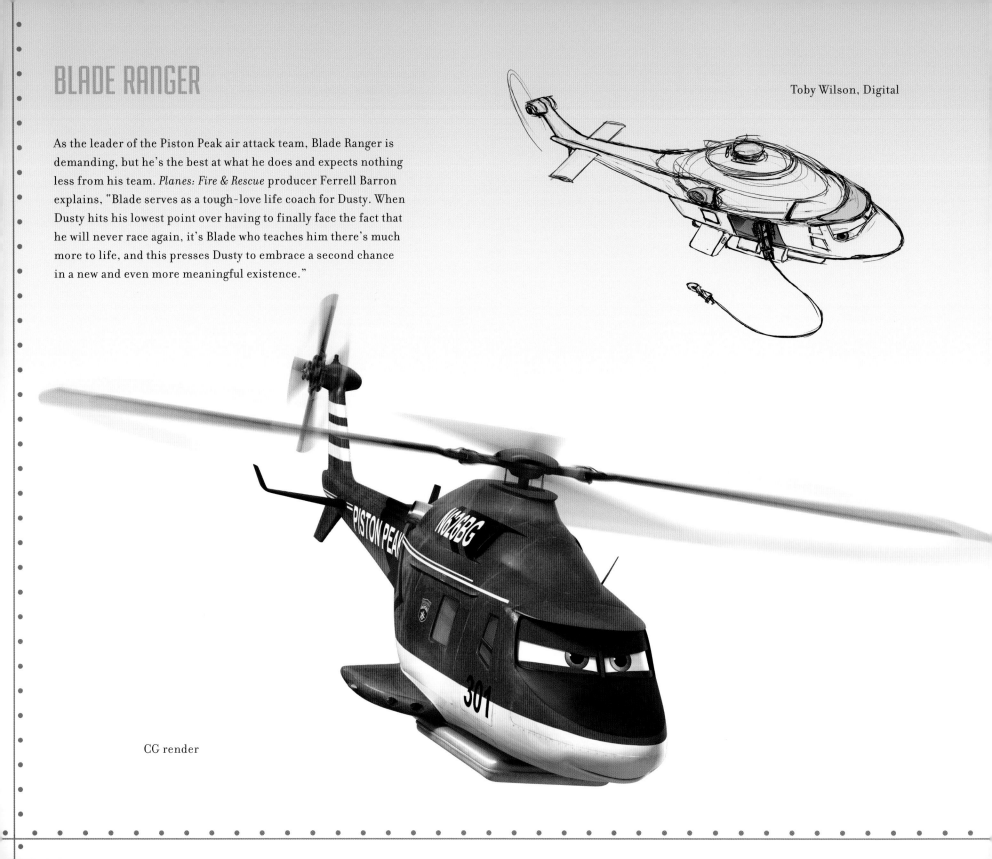

CG render

Blade is an all-purpose helicopter equipped with a drop tank and hoist, custom designed by the team of Scott Seeto and Toby Wilson. "We did a lot of research on the rotor hub to make sure it looks pretty accurate, and we gave Blade the designation number 301 as homage to the Hemet-Ryan air attack chopper," says Seeto.

Blade's hangar is on the highest perch in the air attack team's residential circle, out of respect for his authority. It features a front deck helipad, built for easy accessibility when the alarm sounds, so he can just roll out his door and take off, jumping into immediate action.

Chuck Puntuvatana, Graphite; Donna Prince, Digital

Scott Seeto, Graphite

Toby Wilson, Digital

Blade's story is a twist on the classic "I'm not really a doctor but I play one on TV." He used to pretend to save lives, but now he does it for real.

—BOBS GANNAWAY, director

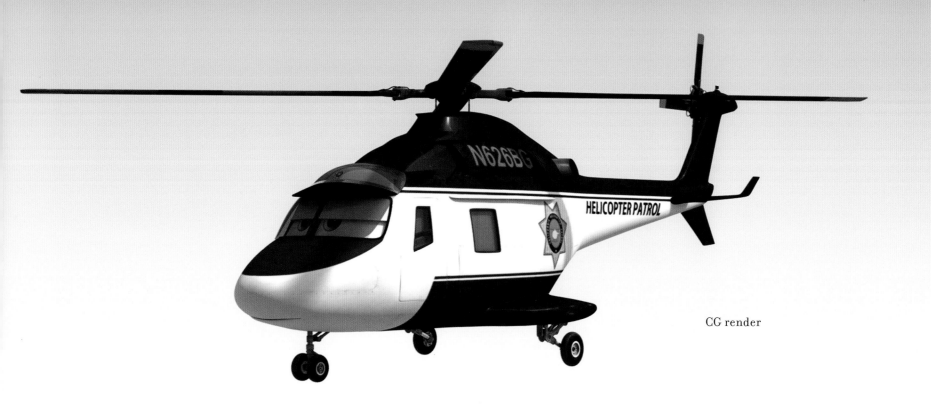

CG render

CHoPs

In his previous career, Blade starred as Blazin' Blade Ranger on the hit television show *CHoPs (California Helicopter Patrol)*. While his current team highly respects Blade, they also enjoy the entertainment of looking back at his past persona on a secret Beta tape of the TV series to see him and his fellow cast members decked out in the plane-ified versions of "biker cop shorts, helmets, and 1970s aviator glasses," as art director Toby Wilson describes their wardrobe. "It was fun to re-create Los Angeles in the seventies, then to show it through an old TV look of desaturated color and scratches on the film," recalls set visual development artist Lin Hua Zheng. The crew also looked to the talents of aerobatic aviator Chuck Aaron, the only known pilot who can roll and pull a loop maneuver in a helicopter, to conceive the signature move for Blade's co-star, Nick Loopin' Lopez.

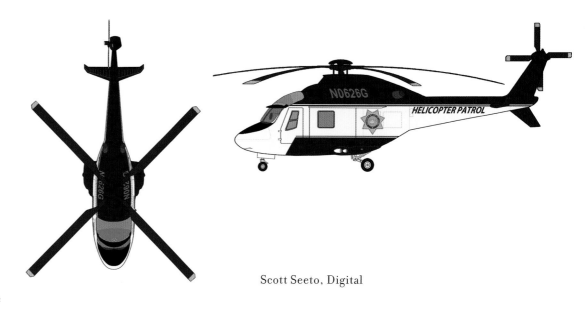

Scott Seeto, Digital

For the 1970s era *CHoPs* footage, we had fun creating smog-filled skies over Club 4x4, a location to parody Studio 54 by way of a stucco building shaped like an off-road truck. This is the structure that catches fire and brings Blazin' Blade Ranger to the rescue.

—TOBY WILSON, art director

Scott Seeto, Digital

Marty Baumann, Digital

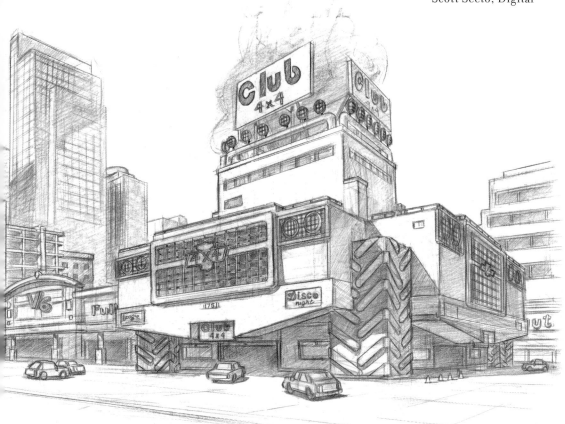

Jim Schlenker, Graphite

Chris Oatley and Scott Fassett, Digital

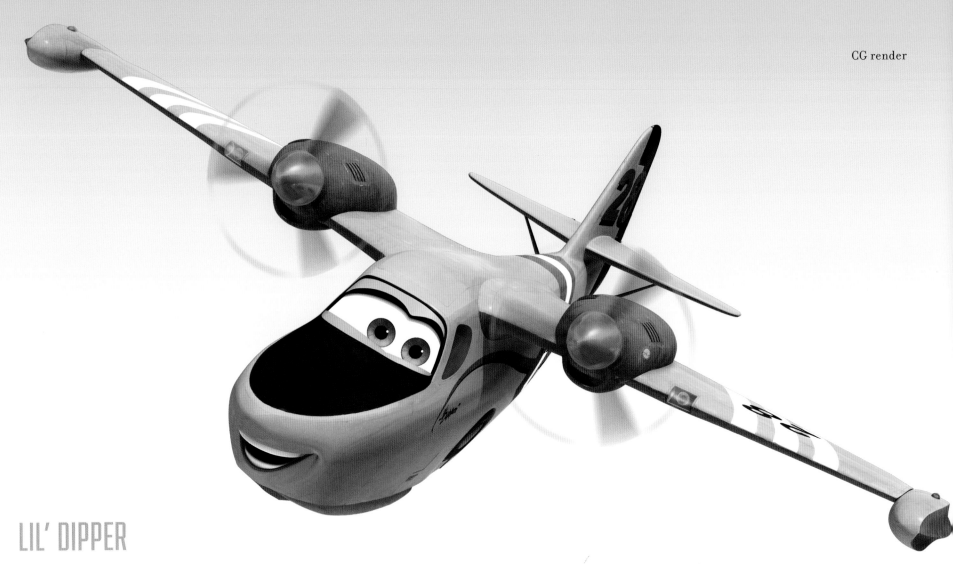

LIL' DIPPER

A custom designed super scooper aircraft, Lil' Dipper also happens to be an über-fan of Dusty, so she's thrilled when he shows up at her air attack base. Before coming to Piston Peak, Lil' Dipper hauled cargo up in Alaska, but now she keeps herself busy by fighting fires and by imagining herself dating Dusty. She goes through all the phases of a relationship with Dusty—touching upon the "I should get to know your friends" and "Why don't you do things like that anymore?" attitudes, for example—but Dusty remains quite unaware of or, at least, unfazed by her romantic endeavors.

Scott Seeto, Graphite

Lil' Dipper's design went through numerous evolutions, ranging in inspiration from a Canadian air tanker, to a Catalina PB-Y, to a Grumman Goose. Now a unique plane all to herself, Lil' Dipper had to be "squished, shortened, and given different edges in order to best complement Dusty," recalls character designer Scott Seeto. She also needed to have functional drop tank doors and scoops. But the biggest challenge with Lil' Dipper, mechanically speaking, was to figure out how retracting landing gear could be built.

Compared with the other hangars on the base, Lil' Dipper's clearly has more of a feminine feel to it, with cheerful bright blue paint, wildflowers, and window boxes made of old tires. "My favorite detail is the lawn art, an excavator styled to look like a pink flamingo," laughs set designer Jim Schlenker.

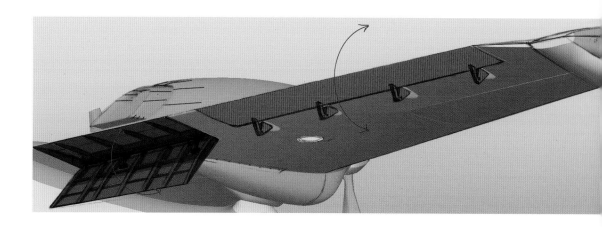

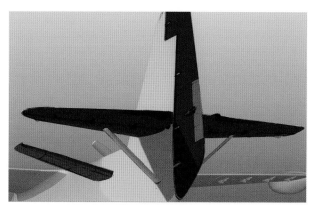
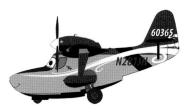

Scott Seeto, Digital

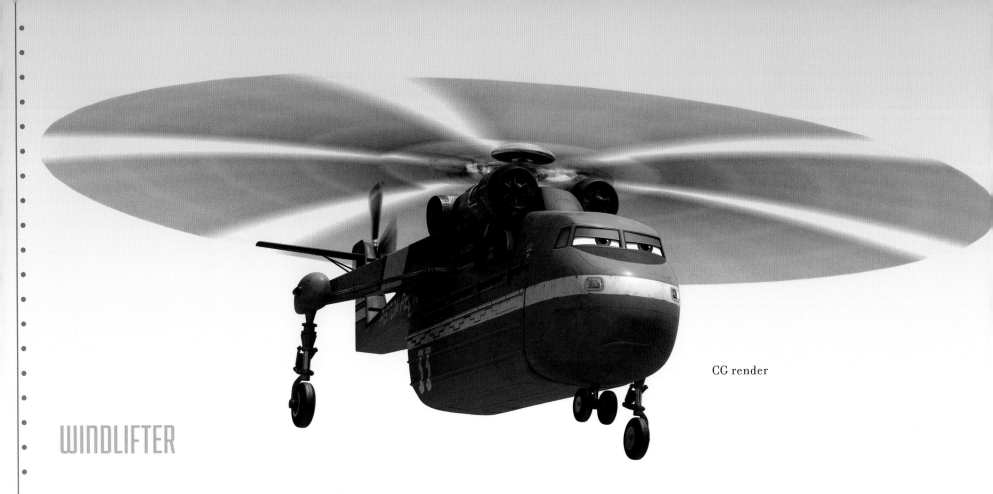

CG render

WINDLIFTER

Capable of hoisting a huge tank of fire retardant or clearing away dozens of fallen trees, Windlifter is a former lumberjack and is all muscle. Inspired by heavy-lift helicopters, including the Sikorsky Skycrane, the Mil Mi-10 heavy-lift helicopter, and the Chinook, "Windlifter has a detachable tank, two hoists, and twin turbine engines that are completely exposed, which makes him look even tougher," says *Planes: Fire & Rescue* art director Toby Wilson. At one point in story development, he was going to be named Vladimir to play to a Russian character who was once a former heavyweight lifter. But the thought of having a character of American Indian descent in the Pacific Northwest made more sense, and thus he became Windlifter, who is "one with the land" and at times offers bits of folklore to express his thoughts. "He displays feather paint on his rotor blades to mimic a headdress, and the white stripe and black stepped pyramid on his side together represent thunder clouds," explains Wilson.

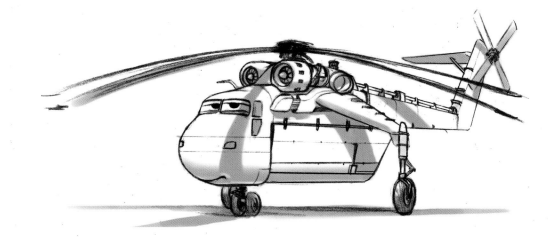

Scott Seeto, Graphite

His hangar is elongated a bit to give it almost a longhouse feel, and it features a repeated pattern of tailfins, laid out in a style often evident in American Indian tapestry. On the side yard, Windlifter also has a cable and pulley system that encases giant logs that he can use for weight-lifting workouts.

Jim Schlenker and Akiko Crawford, Digital

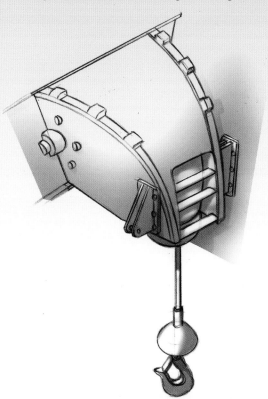

Scott Seeto, Graphite

Rob Roesch, Graphite; Scott Fassett, Digital

Windlifter has a deep connection with nature. He can tell you the speed of the wind just by looking at the way the pine needles move.

—BOBS GANNAWAY, director

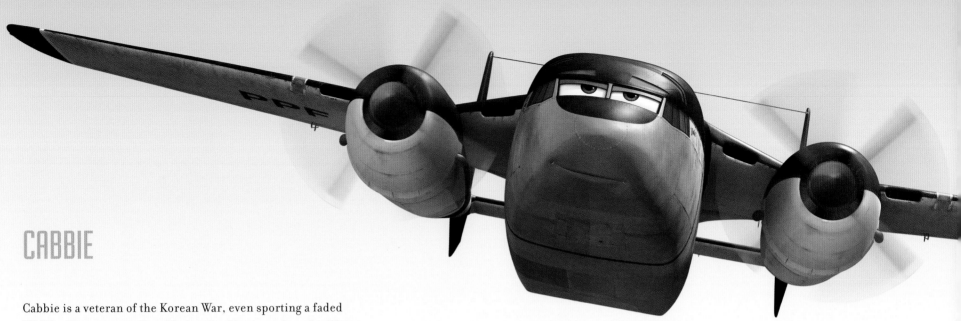

CABBIE

Cabbie is a veteran of the Korean War, even sporting a faded USAF military tattoo. Roughly inspired by a number of military planes, including the Antonov AN, the Fairchild C-119J Boxcar, and the OV-10 Bronco, Cabbie is big enough to carry the entire smokejumper team. "But to access his cargo space, we ended up putting in a long ramp platform, not just having a back end that opens like a clamshell," explains character designer Scott Seeto, who also swapped out the engines and made a few aesthetic changes around Cabbie's face area.

Cabbie's hangar displays camouflage décor. "We knew he would definitely feel at home in an ex-military Quonset hangar, and we gave him a ham radio with a huge antenna, imagining that he might stay in touch with his wartime buddies," notes *Planes: Fire & Rescue* art director Toby Wilson.

CG render

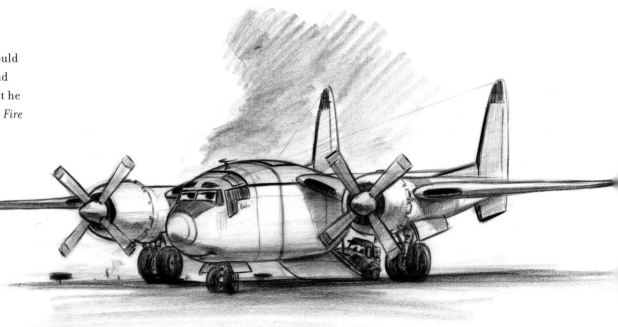

Scott Seeto, Graphite

Cabbie had a really distinguished military career but doesn't talk about it too much. He's proud of it, he did his time, and now he's doing this. I believe that he thinks firefighting is as important as what he did during his military service, if not more.

—ART HERNANDEZ, head of story

Chuck Puntuvatana, Graphite; Donna Prince, Digital

Scott Seeto, Graphite

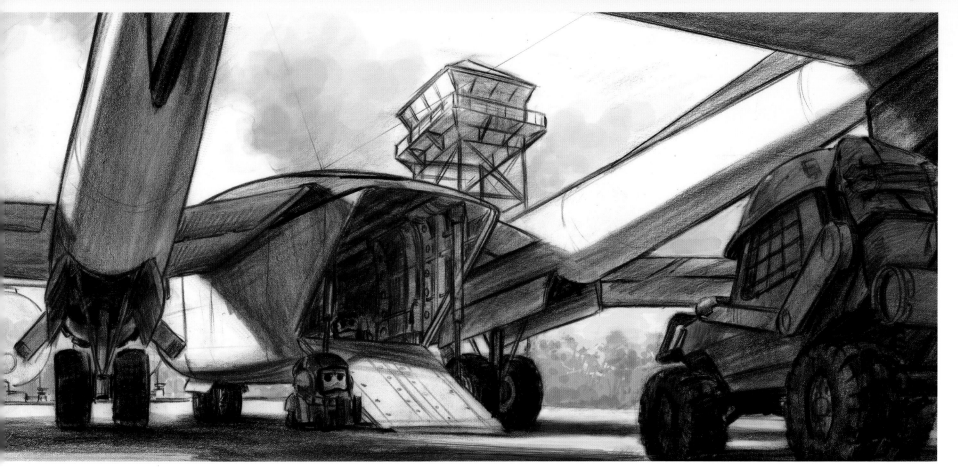

SMOKEJUMPERS

The smokejumpers are a team of five all-terrain heavy-duty vehicles who parachute from Cabbie's cargo hatch to fight fires on the ground. Earlier versions had only three such vehicles on the team, and they were more ATV-like extreme sports type of characters than compact utility vehicles, but John Lasseter suggested that the team step up its level of machinery to be more compatible with the strength and professionalism of the air team. Like the air attack crew, this team contains five unique personalities but must look and act unified when on duty. "The smokejumpers are tied together through their color palette, reflective stripes, and a team logo," explains character designer Scott Seeto.

Toby Wilson, Digital

Scott Seeto, Digital

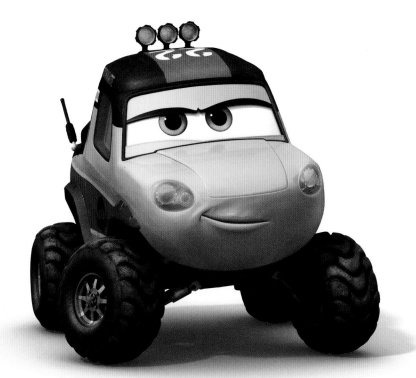

CG render

DYNAMITE

Dynamite is the strong leader of the smokejumpers, so named because you don't want to set her off. Equipped with a radio, she calls the shots on the ground and makes requests for drops from the aircraft. Though she rules over her gang with a sharp tongue, she's also fiercely protective of them.

Scott Seeto, Digital

CG render

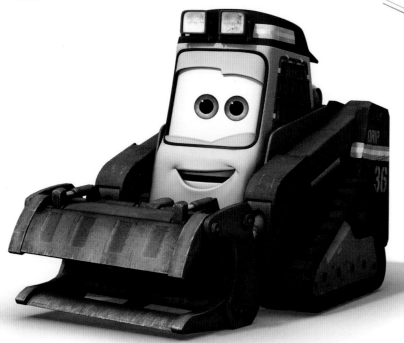

Toby Wilson, Digital

DRIP

Drip is an outgoing dude who's always leaking oil. He's not the sharpest tool in the shed, but he knows how to use his skid-steer claw to clear fallen trees and brush effectively.

BLACKOUT

Tough and overeager for action, Blackout earned his call sign when he accidentally sawed down an electrical line and cut power to the lodge for three weeks. During that incident, he was electrocuted and now has trouble remembering things.

Scott Seeto, Digital

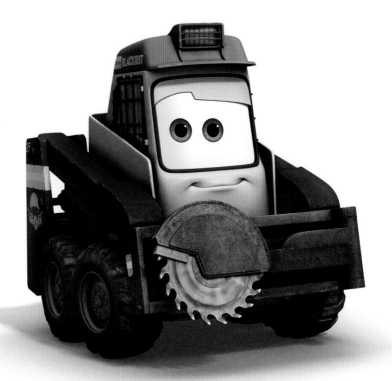

CG render

PINECONE

Pinecone is a southern, easygoing soul. She collects pinecones and can name every tree in the forest. She uses a rake tool to clear brush and debris.

CG render

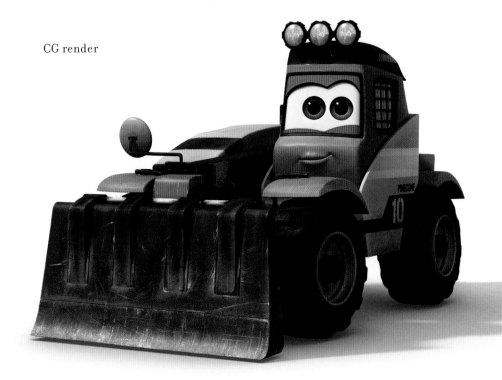

Scott Seeto, Digital

Scott Seeto, Graphite

AVALANCHE

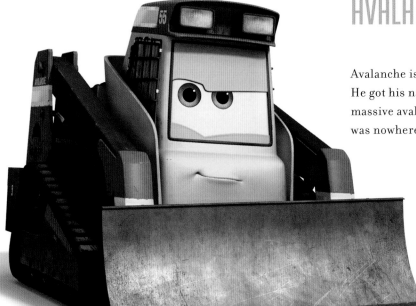

Avalanche is a burly, friendly bulldozer and a loud talker. He got his name because he supposedly once caused a massive avalanche with his shouting, but he claims he was nowhere near that snow bank.

CG render

MARU

Maru, the expert mechanic that keeps the air attack team in tip-top shape, is a combination of a tug and a heavy forklift. His horizontal fork is actually two forks that can be split apart, which makes Maru the first pitty in the "World of *Cars*" to have a thumb—a handy bonus to a character so key to the well-being of all the other vehicles in his realm. "We discovered an interesting fact at Hemet-Ryan: none of their equipment is new. Everything is secondhand. They have a huge workshop where they make most everything they need out of whatever they have lying around. Maru is the ultimate embodiment of that. We gave him a catchphrase to proudly describe anything he makes as 'better than new,'" notes *Planes: Fire & Rescue* producer Ferrell Barron.

Maru's workspace is an airfoil shaped hangar with an open door garage to make the constant wheeling in and out of aircraft more efficient. By the looks of his space, Maru is a pack rat, and "all of the shelving is pallet-based, since that's the way forklifts manage storage," adds *Planes: Fire & Rescue* art director Toby Wilson. From his garage, Maru can oversee the whole base in his perchlike location, and he also maintains the Wall of Heroes, a tribute to the fallen members of the team.

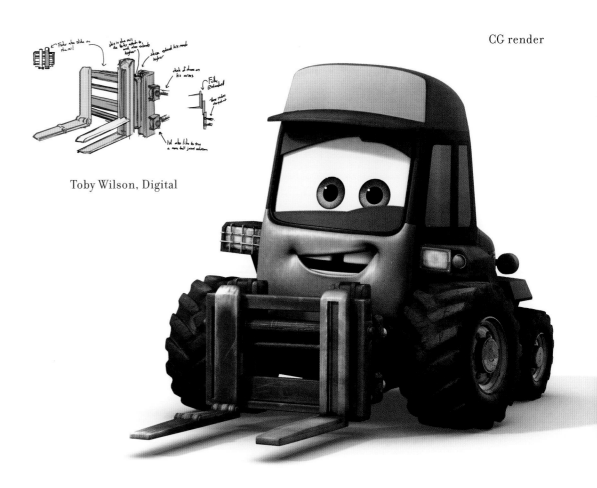

CG render

Toby Wilson, Digital

IF IT AIN'T BROKE WE **FIXED** IT!

Marty Baumann, Digital

AIR-MAX HEAVY DUTY OIL SEALS AND GASKETS MAINTENANCE

AIR-MAX AVIATION PRODUCTS, INC.

Ed Li, Graphite

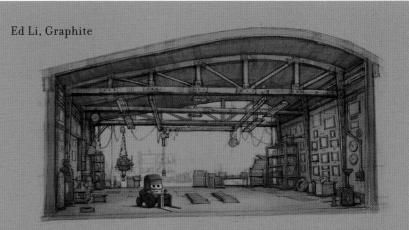

Marty Baumann, Digital

Ed Li, Graphite

PATCH

Patch is an aircraft tug who serves as the dispatcher at the base. She never leaves her tower, from which she mans the radio and scans the skies, ready and waiting to sound the Klaxon to call the team to action. In her downtime, she's a bit obsessive about keeping her tower windows clean, and she uses the PA to broadcast her favorite vinyl albums across the base. Graphic designer Marty Baumann quite enjoyed the task of brainstorming and designing the albums in her collection, with a bent toward 1970s heavy metal and soft rock.

Chris Oatley and Donna Prince, Digital

Ed Li, Graphite

DUSTY WITH PONTOONS

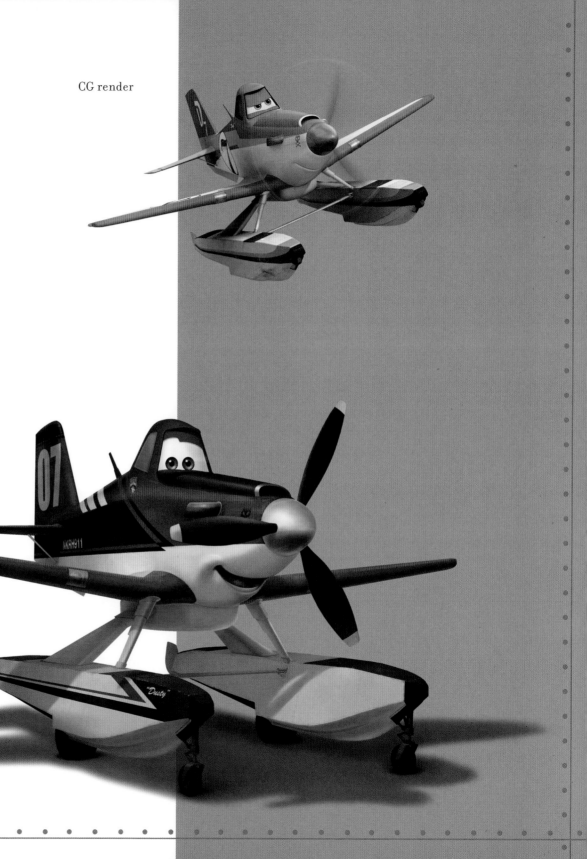

CG render

In order to get Dusty suited up to fly with the air attack team, character designer Scott Seeto undertook a great deal of research to figure out how to add pontoons and other equipment to him. And once Dusty was properly outfitted, the animation team had to teach themselves a whole new way of maneuvering him that resembles Bambi's first steps onto the iced-over pond. "When Dusty's a racer, he's a bit more agile. But when he gets modified with pontoons, not only is he on four tires, which affects his pivot points, but he also has to adjust to how he moves with water inside of him, or not," explains *Planes: Fire & Rescue* animation lead Ethan Hurd. Adding pontoons was actually beneficial to the cinematography due to the eradication of the "tail-dragger" stance: "In the first film and the beginning of this one, Dusty's tail is on the ground because of his forward landing gear, which means his nose is always angled up, making it difficult to shoot over the fuselage to get the eyes and still make a face. But once Dusty joins the air attack team, his landing gear is swapped out for pontoons, which sort of levels him, thus eliminating the tail-dragger issue," explains *Planes: Fire & Rescue* pre-visualization lead John Bermudes.

Scott Seeto, Digital

FIRE AND SMOKE

Never before in a Disney animated film has fire played a role as integral as in *Planes: Fire & Rescue*. "We treat fire as a character and discovered how it is such an immensely powerful natural force, feeding off itself, creating its own weather conditions," says producer Ferrell Barron. To get it right and worthy of the respect that such a phenomenon should incur, the team spent over twenty months in research and development before the first fire shot was produced. They developed a library of specific fire applications for tree trunks, canopies, tree tops, and the ground, at various levels of resolution; but more often than not, custom fire effects were necessary to reach the desired level of performance by this intense character.

Smoke is also an extremely important effect and atmospheric treatment. "We use the smoke as a compositional tool, as well as for transitions between shots. For example, at one point we have a twenty-three-second shot which is full of fire and smoke, so we split it up by having Dusty fly through smoke columns here and there so that they can split the rendering in those moments into several separate shots, even though it appears to be one scene," explains pre-visualization flight lead Jason McKinley.

The exposure to fire and smoke is a gradual build in the film, starting with small campfires and leading up to a fully destructive blaze at the climax of the story. Playing through these effects are some extremely complicated flight sequences. "It's almost this aerial ballet that we have to compose, and it can be very complex. There are different planes, at different altitudes, going different directions, each with very specific flight patterns when they do their aerial drops. And when fires get so big they actually create their own weather systems, that might involve downdrafts, wind shears, or updrafts, which makes for a very dangerous type of flying. They lose three or four planes a year to this in the real world," says McKinley.

Toby Wilson, Digital

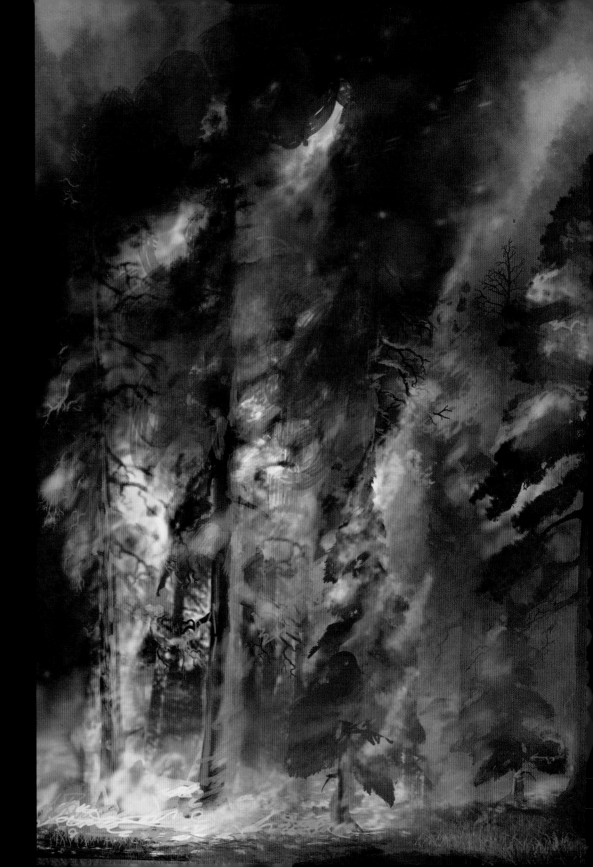

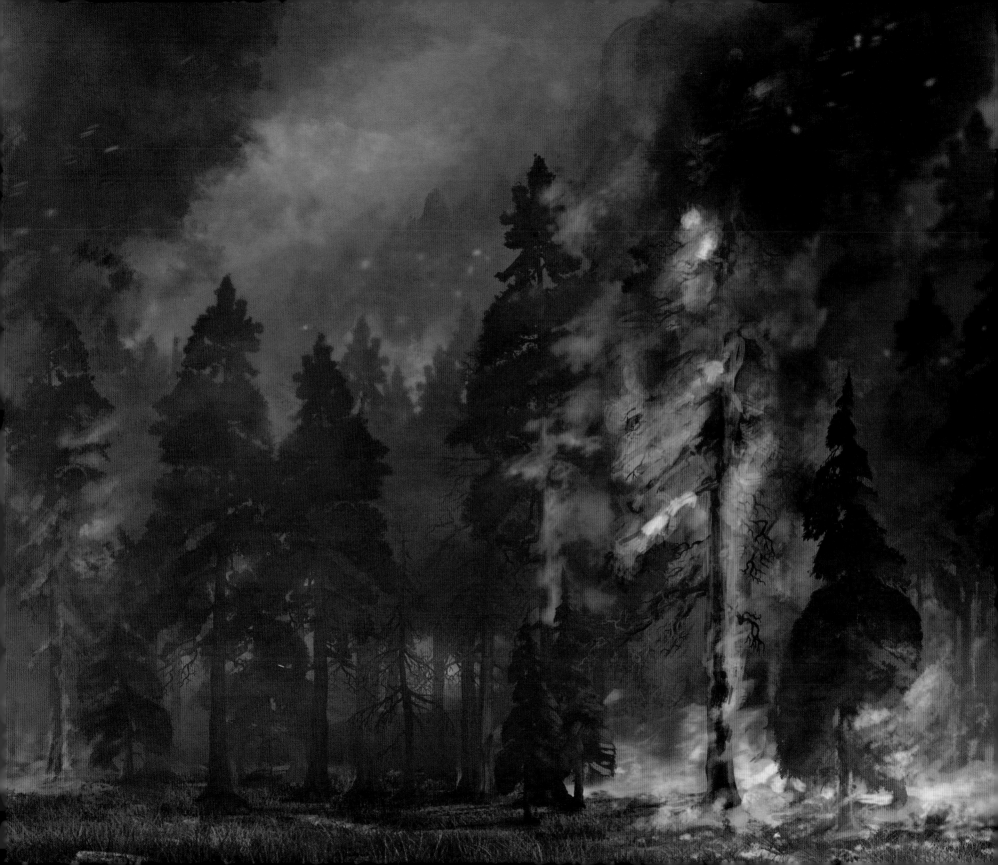

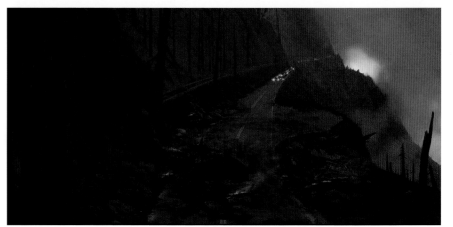

Jim Schlenker, Graphite; Akiko Crawford, Digital

In crafting the global color script, we go from blue and green in Act One, to the end of Act Three, where it's just a bunch of oranges and reds and yellows and purples. So what it shows is that we go from nice, cool, happy skies to this really hot, intense disaster.

—TOBY WILSON, art director

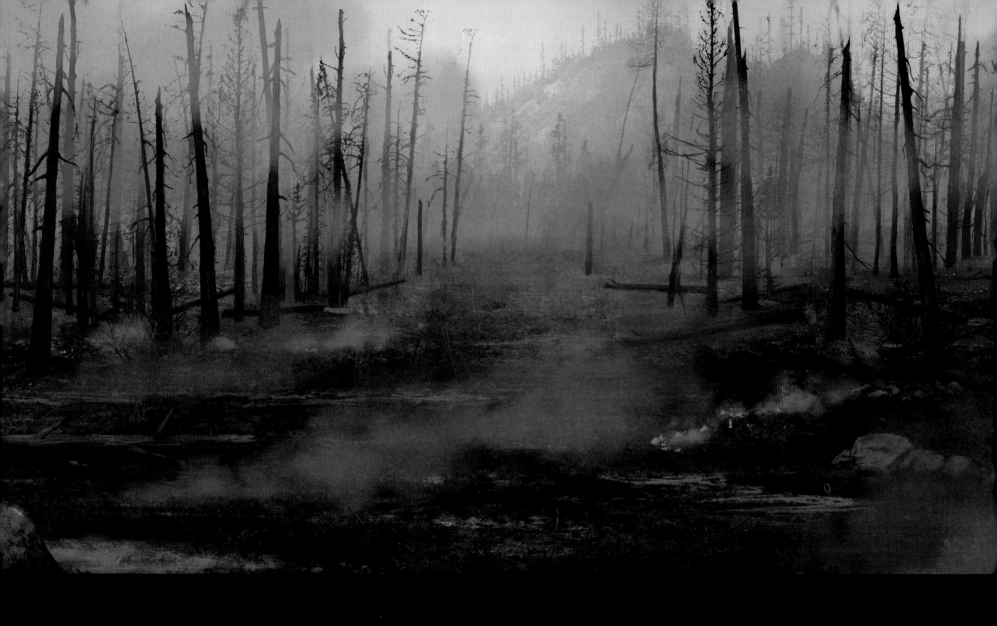

It's always nice to see everything that you worked hard
on burn to the ground.

—JIM SCHLENKER, set designer

Toby Wilson, Graphite; Akiko Crawford, Digital

AUGERIN CANYON

The most dramatic sequence in *Planes: Fire & Rescue* takes place in one of its most scenic locations, Augerin Canyon. The name itself suggests drama: in aviation terms, "auger" means "crash," as in hitting the ground in a rotating motion like an auger. The location design clearly supports the danger factor since it's a box canyon filled with granite arches that get tighter and tighter on the approach to the water source, Whitewall Falls. As Dusty tries to scoop water from the river flow, he finds granite pillars that he must weave through, plus boulders and driftwood along the surface, plus avalanches and falling trees coming down at him along the flight. All the while, visibility decreases as the smoke level increases. He finally has to pull an unbelievably heroic maneuver to access the water supply.

"Whitewall Falls was custom designed to suit the needs of the story and the capabilities of a plane like Dusty," explains computer graphics supervisor Doug Little. The suspension bridge in front of the falls, a key element in the stakes of heroism in the sequence, is inspired by the leaf suspension system on a vehicle. "The bridge was conceived as a highly flammable timber trestle design that evolved into a more and more extreme scale as we analyzed the needs of the story," adds set designer Jim Schlenker.

Ed Li, Graphite

Jim Schlenker, Graphite; Akiko Crawford, Digital

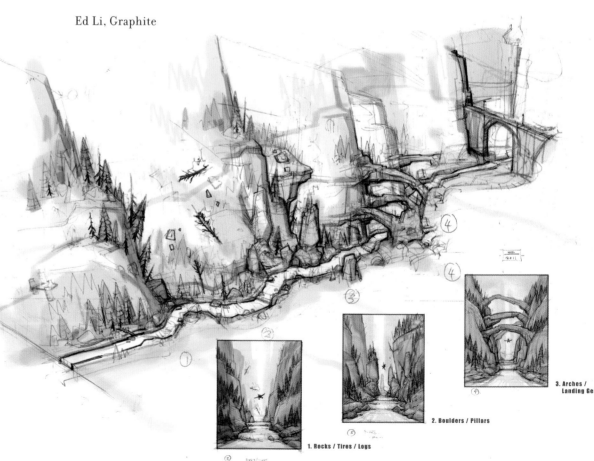

1. Rocks / Tires / Logs

2. Boulders / Pillars

3. Arches / Landing Ge[...]

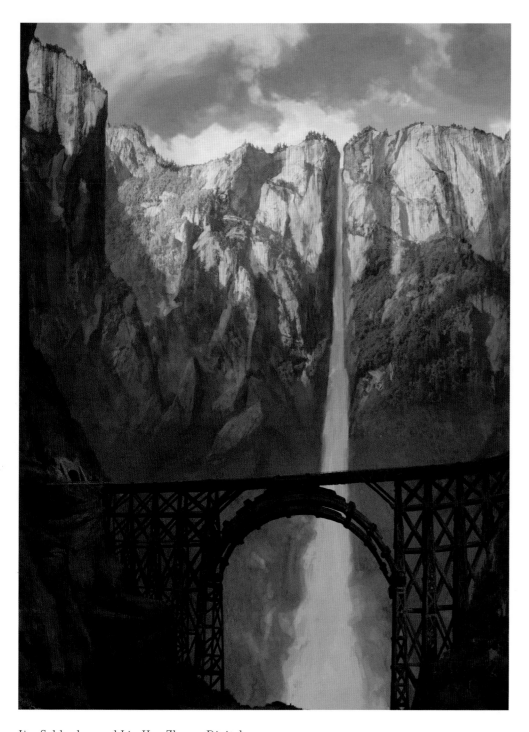

Jim Schlenker and Lin Hua Zheng, Digital

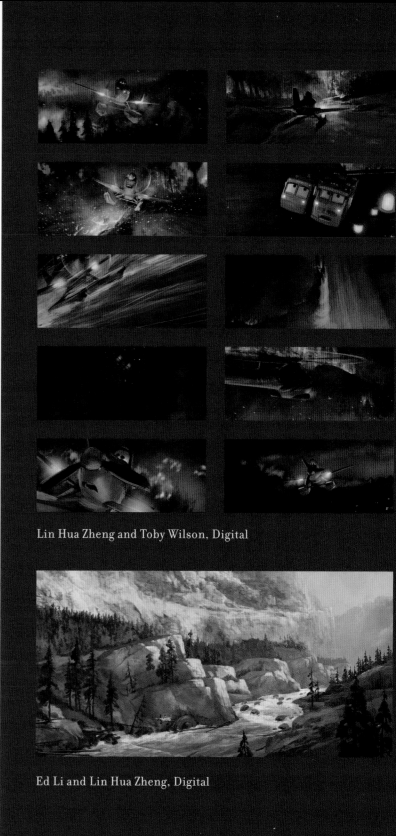

Lin Hua Zheng and Toby Wilson, Digital

Ed Li and Lin Hua Zheng, Digital

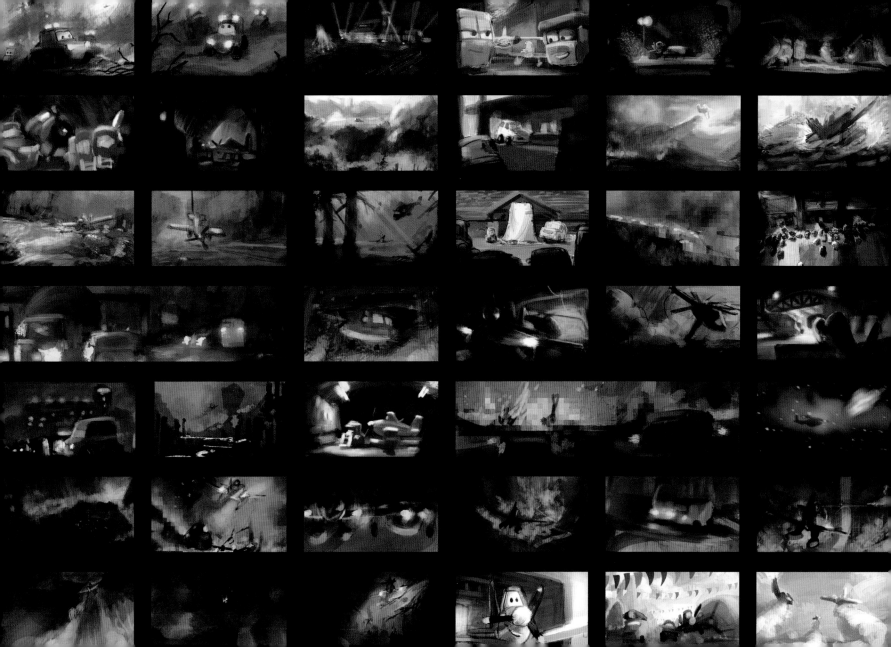

CONCLUSION: HAPPY LANDINGS

Once Dusty proves himself a worthy air attack team member, he takes his new accreditation and confidence back to Propwash Junction to share his success with the celebrants at the Corn Festival. His second chance at finding happiness revitalizes his spirit and that of his entire hometown, especially Mayday.

Dusty's happy landing also sets an example for the audience of how anything is possible in life . . . how it's always best to aspire to new heights, and how any flight pattern can lead to blue skies.

Marty Baumann, Digital

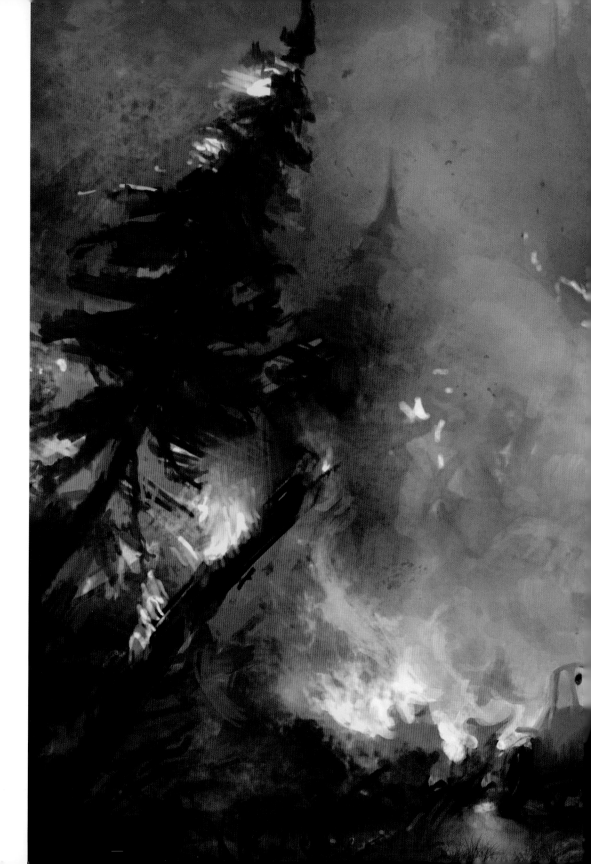

Jason Merck, Digital

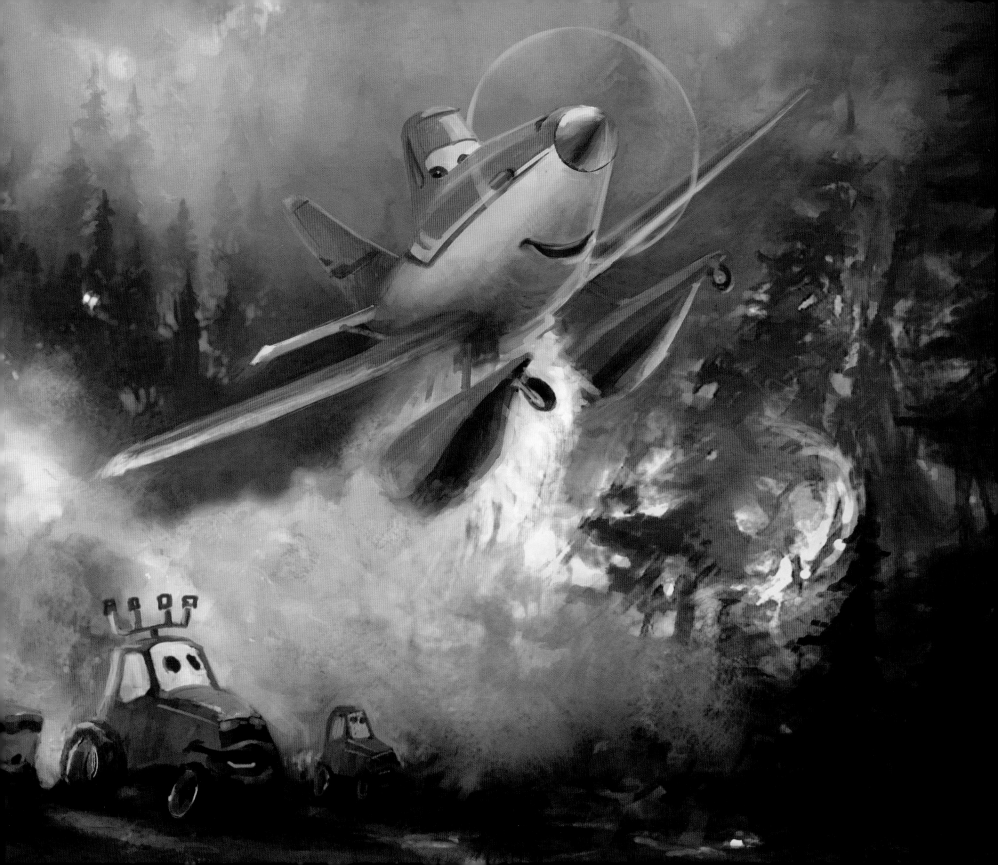

ACKNOWLEDGMENTS

I offer my highest respect to the filmmakers at DisneyToon Studios for making me feel like a first-class passenger on their exciting journey. I am especially grateful to Klay Hall, Bobs Gannaway, Ryan Carlson, and Toby Wilson for generously sharing their time and insight, and to Paul Gerard for serving as a trusted navigator in mapping out the plan for this literary flight. I give props to Stephen Marks and Susie McKinley for their coordination in making our ambitious interview efforts possible. I am ever so thankful for the art management skills of Kip Lewis, James Hathcock, Caroline Keichian, Adam Iscove, and Kari Porter—all of whom are amazing stewards of organization.

This project could not have gotten off the ground without the teamwork of Renato Lattanzi, LeighAnna MacFadden, and Sarah Malarkey. I couldn't have asked for a better copilot than our editor, Beth Weber.

Special thanks to Joanna Samija, whose transcriptional skills propelled my progress better than any tail wind ever could.

I continue to appreciate the support of my family and friends who are more than just the wind beneath my wings. I dedicate this book to my boys, Josh and Ryan, for all the high-flying fun they bring to my life.

—Tracey Miller-Zarneke

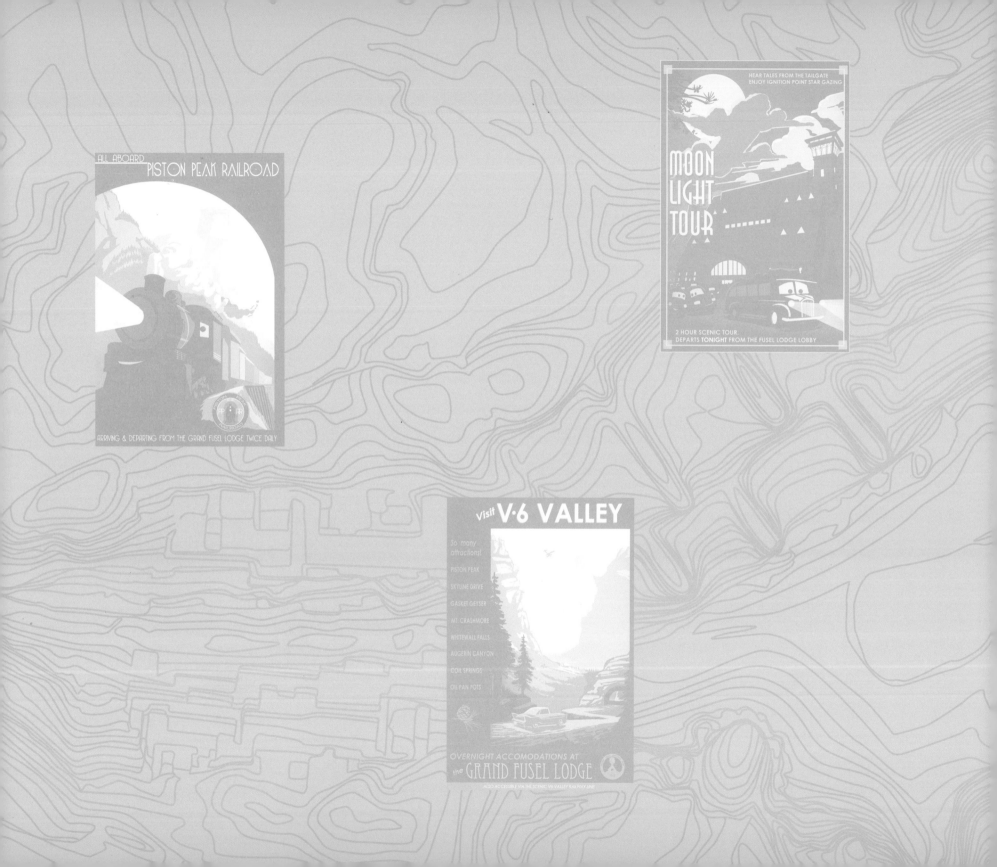